Foreigners in Ancient Egypt

Bloomsbury Egyptology

Series editor: Nicholas Reeves

Foreigners in Ancient Egypt: Theban Tomb Paintings from the Early Eighteenth Dynasty (1550–1372 BC)

Flora Brooke Anthony

Bloomsbury Academic

An imprint of Bloomsbury Publishing Plc

B L O O M S B U R Y

LONDON · OXFORD · NEW YORK · NEW DELHI · SYDNEY

Bloomsbury Academic

An imprint of Bloomsbury Publishing Plc

50 Bedford Square
London
WC1B 3DP
UK

1385 Broadway
New York
NY 10018
USA

www.bloomsbury.com

BLOOMSBURY and the Diana logo are trademarks of Bloomsbury Publishing Plc

First published 2017

© Flora Brooke Anthony, 2017

British Library Cataloguing-in-Publication Data

A catalogue record for this book is available from the British Library.

ISBN: HB: 978-1-4742-4158-8
 PB: 978-1-4742-4157-1
 ePDF: 978-1-4742-4160-1
 ePub: 978-1-4742-4159-5

Library of Congress Cataloging-in-Publication Data

Names: Anthony, Flora Brooke, author.
Title: Foreigners in Ancient Egypt : Theban tomb paintings from the early Eighteenth Dynasty (1550-1372 BC) / Flora Brooke Anthony.
Other titles: Bloomsbury Egyptology.
Description: London, UK ; New York, NY : Bloomsbury Academic, 2016. | Series: Bloomsbury Egyptology | Includes bibliographical references and index.
Identifiers: LCCN 2016019108 (print) | LCCN 2016020913 (ebook) | ISBN 9781474241588 (hardback : alk. paper) | ISBN 9781474241571 (pbk. : alk. paper) | ISBN 9781474241601 (ePDF) | ISBN 9781474241595 (ePub) | ISBN 9781474241601 (epdf) | ISBN 9781474241595 (epub)
Subjects: LCSH: Mural painting and decoration, Egyptian--Egypt--Thebes (Extinct city) | Mural painting and decoration, Ancient--Egypt--Thebes (Extinct city) | Mural painting and decoration, Egyptian--Egypt--Thebes (Extinct city)--Themes, motives. | Mural painting and decoration, Ancient--Egypt--Thebes (Extinct city)--Themes, motives. | Aliens in art. | Symbolism in art. | Egypt--History--Eighteenth dynasty, ca. 1570-1320 B.C.
Classification: LCC ND2865.T46 A58 2016 (print) | LCC ND2865.T46 (ebook) | DDC 751.7/30932--dc23
LC record available at https://lccn.loc.gov/2016019108

Series: Bloomsbury Egyptology

Cover image: 'Nubian Dancing Girl', Nina M. Davies and Alan H. Gardiner from *Ancient Egyptian Paintings*, vol. 1 pl. XL. Courtesy of the University of Chicago Press.

Typeset by RefineCatch Limited, Bungay, Suffolk
Printed and bound in India

For Carter and Serafina my rocket scientist and astronaut (no pressure)

Contents

Illustrations

Plates

Figures

Preface

I spent my summers with my *abuelita*, who taught me how to be a proper Puerto Rican lady, telling me in her thickly accented loud voice about her strange, antiquated social notions. She taught me the rules of what it was to be a woman. I must take off the boots of the men, stand when they come in the room and go and cook for them when they are around. I can still remember her telling me I would never find a man to marry me if I did not make the bed, and a million other anecdotes I laugh about now. *Abuelita*, I still do not make the bed.

She did not let me learn her native language because it would make me different, and she wanted to erase any sort of bias people would have against me. Yet, she separated our world into us versus them. We, of course, were the Puerto Ricans.

So, naturally, because I grew up hearing lots of stories of discrimination that happened to her and my mother I got involved with minority-related causes only to find that I was not accepted as a minority by others. I am white, I do not speak Spanish, I only understand it, and then only if it is a Puerto Rican speaking. In graduate school I started thinking about race construction – who creates it? What for? Who uses it? And, why doesn't anyone believe I'm Puerto Rican?!

While doing research on foreigners in ancient Egypt for a term paper in graduate school I began applying these questions in order to, I suppose, find out more about myself, and about my world. I found foreigners in ancient Egypt who assimilated, for example, Benia (Theban Tombs (TT) 343). Foreigners whose only vestige of being foreign was their name and their parents' names, even though they had tried to rectify that by giving themselves an Egyptian name as well. I also found that otherness was used against people in order to subjugate them and to create internal solidarity. This book is the end of a long journey that led me to those conclusions.

Dr Gay Robins once asked me, 'What is it with "the other" that so-fascinates you?' I couldn't articulate it at the time. How could a white woman of Puerto

Rican (and thus colonial) descent living in the American South during the election of the first Black (or bi-racial) president not be fascinated by the issue of otherness?

Race is not a concept rooted in ancient Egypt, but the differentiation of self versus non-self is the very foundation of every culture. Indeed, the use of such a notion for self-serving purposes is a very, unfortunately, human trait. I hope that in these pages you are able to look into the culture of the ancient Egyptians and see in this most exotic of non-western cultures a glimmer of yourself.

Acknowledgements

This book would not have been possible without the involvement and encouragement of Dr Gay Robins and Dr Nicholas Reeves. I am also quite thankful for my editor Alice Wright and her assistant Lucy Carroll, who helped shape the book and assisted me over the biggest hurdle of all, image permissions. Egyptologists Melinda Hartwig, Salima Ikram, Mariam Ayad, Peter Lacovara, Catharine Roehrig, Nigel Strudwick and conservator Renee Stein have also helped me along the way with all of my random queries over the years. I appreciate all of their patience and kindness.

While the shape and direction of this manuscript is quite new, most of the research for it was gathered when I was finishing my PhD at Emory University with support from the Dolores Zohrab Liebmann Fellowship, the Center for Women at Emory Fellowship, the On Recent Discoveries by Emory Researchers Fellowship (ORDER) and the Emory Graduate Diversity Fellowship. Needless to say I appreciate all of the opportunities given to me at Emory University. These fellowships helped shape how I see the world, how I think and how I teach.

I would like to thank my husband, Clay Anthony, who has helped me along every step of the way. He is the kind of guy who indulges my need to collect all of the Playmobil ancient Egyptian playsets and then notices that the sarcophagi look "Amarna-ish." Without his love and support this work would not have been possible. I am greatly indebted to the kindness of my parents and in-laws Karen Hesse, Kathy Lee, Charles Lee, Cathy Walls and Steve Anthony and Rene Hesse who have spent countless hours babysitting our two little ones so that I can work on this project. I am also thankful to and for my children, Carter (6) and Serafina (2). Both have been a part of me while I have been mulling over the issues in this book. I like to believe that they helped me think things through.

I would also like to thank my honorary extended families – the Joyces and the Cases, Dona Stewart and Sirka Hummel-Levy. Without their guidance,

kindness and encouragement I'm not sure where I'd be in life. Most of all I would like to thank my advisor, Dr Gay Robins. I have really enjoyed working under her tutelage and could not have asked for a better advisor and mentor. Thank you.

Abbreviations

ÄA	*Ägyptologische Abhandelungen.* Wiesbaden.
ASAE	*Annales du Service des Antiquités de l'Égypte.* Cairo.
AV	*Archäologische Veröffentlichungen*, Deutschen Archäologisches Institut, Abteilung Kairo. Vol.1–3, Berlin; vol. 4ff, Mainz.
BAR	J. H. Breasted, *Ancient Records of Egypt* 5 vols, Chicago: University of Chicago Press, 1906–7.
BIFAO	*Bulletin de l'Institut Français d'Archéologie Orientale.* Cairo.
BMMA	*Bulletin of the Metropolitan Museum of Art.* New York.
CAH	*'The Cambridge Ancient History,* 3rd ed., 1970–2001. Cambridge: Cambridge University Press.
DIE	*Discussions in Egyptology.* Oxford.
JARCE	*Journal of the American Research Center in Egypt.*
JEA	*The Journal of Egyptian Archaeology.* London.
JNES	*Journal of Near Eastern Studies.*
JSSEA	*Journal of the Society of the Study of Egyptian Antiquities.* Toronto.
LÄ	*Lexikon der Ägyptologie*, 7 vols, ed. W. Helck, E. Otto, W. Westendorf, 1972–92, Wiesbaden: Harrassowitz.
LAAA	*Annals of Archaeology and Anthropology.* Liverpool.
MDAIK	*Mitteilungen des Deutschen Archäologischen Instituts, Abteilung Kairo. Before 1944: Mitteilungen des Deutschen Instituts für Ägyptische Altertumskunde in Kairo.* Berlin; Wiesbaden; Mainz.
Memnonia	*Memnonia: Bulletin édité par l'Association pour la sauvegarde de Ramesseum.* Cairo; Paris.
MMAEE	*Metropolitan Museum of Art, Egyptian Expedition.* New York.
MMAF	*Mémoires publiés par les membres de la mission archéologique française au Caire.* Paris.
MSS	*Münchener Studien zur Sprachwissenschaft.*

OEAE	Donald B. Redford, *The Oxford Encyclopedia of Ancient Egypt.* Oxford; New York: Oxford University Press, 2001.
RdE	*Revue d'Égyptologie.* Paris.
SAK	*Studien zur Altägyptischen Kultur.* Hamburg.
Urk	Kurt Sethe, *Urkunden der 18. Dynastie*, 4 vols (fasc. 1–16), 2nd ed., Berlin, 1955–61.
ZÄS	*Zeitschrift für ägyptische Sprache und Altertumskunde.* Berlin; Leipzig.

Introduction

European and American Egyptologists in the late 1800s until at least the mid-1900s were fascinated with the ancient cultures that interacted with the Egyptians.[1] They were specifically interested in the people from the Levant and the Aegean. Early scholars were drawn to the cultures that inspired the Bible and the Homeric Epics, the mainstays of the classic European education. As Pritchard states, 'The paintings upon the walls of the New Kingdom tombs at Thebes constitute the principal source for our knowledge of the appearance of the inhabitants of Palestine, Syria, and the Upper Euphrates during the second half of the second millennium B.C.'[2] Early Egyptologists used these scenes to try to identify lost cultures and their exact geographical locales, and specific hairstyles, attire and accoutrements. However, the record the Egyptians left is not one of historical accuracy, leaving pursuers of this line of inquiry frustrated and confused.

These Theban tomb paintings, which have always been taken at face value as historically correct images, have served, as Pritchard stated, as our main source of information about these cultures. And yet, what function did they serve within the tomb setting? Why would a tomb owner want these individuals depicted on their eternal resting place?

In ancient Egypt the images of foreigners represented the concept of chaos (*isfet*) in the Egyptian cosmos. It is also known that chaos or potential threats are not welcome within a tomb context because the dead must be protected in the afterlife. Why then would images of foreigners be painted on tomb walls? How could these images be rendered harmless enough to be rendered within a tomb setting?

Since at least the Proto-dynastic period of ancient Egypt (*c*. 3100 BC), foreigners were depicted being destroyed by the king, as can be seen in the

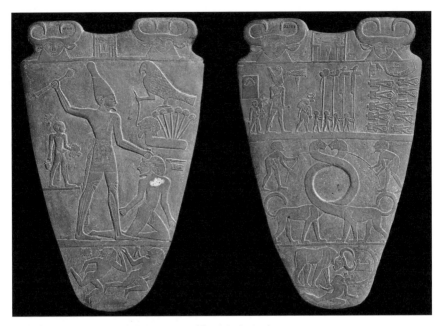

Figure 1 The Narmer Palette. Accessed via Wikimedia.

iconic Narmer Palette (Fig. 1). This imagery is a symbol of the cosmic role of the king who destroys chaos, which is here represented by foreigners, and establishes order (*maat*).[3] In royal Egyptian ideology, foreigners are very similar to animals, and in scenes showing the king destroying chaos, the depiction of animals may be substituted for the depiction of foreigners. In a box from King Tutankhamen's tomb, decoration on the sides shows the king fighting Nubians and Levantines, while on the lid he hunts wild animals. The composition of all the scenes is similar, with hunting dogs appearing in all of them, taking down foreigners and animals alike (Pl. 1).

For over 1,500 years, foreigners in a royal context were represented as being bound, trampled or hit over the head by the king. This is a tradition that continues into the imperialist period of the early eighteenth dynasty (1550–1372 BC). Such images show foreigners, as captives and agents of chaos, in the process of being destroyed. Examples include depictions of foreigners as decorative aspects of the palace and royal attire. For instance, a pair of King Tutankhamun's sandals shows Levantine and Nubian men, both bound with their arms behind them, who were literally trampled upon every time the king

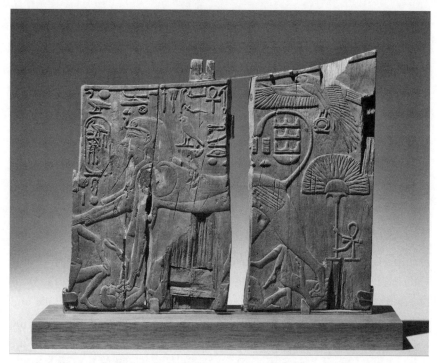

Figure 2 Once gilded throne arm of Thutmose IV. Courtesy of the Metropolitan Museum of Art, Open Access for Scholarly Content. www.metmuseum.org.

took a step (Pl. 2). Foreigners are also tied up as part of the decoration on the arm of the once gilded throne of Thutmose IV (Fig. 2).[4]

Images of bound and/or trampled captives survive in tomb wall paintings from the necropolis of Thebes, the burial place of the Egyptian elite. These tombs provide surviving physical spaces where there is a concentration of different types of foreigner images. During this period, many elite non-royal men built their tombs in the necropolis on the west bank of Thebes, near the Valley of the Kings. Tombs in the Theban necropolis varied in layout, but by the reign of Thutmose III (1479–1425 BC) they often included a rock-cut tomb chapel that was usually a variation on an inverted 'T' shape (Fig. 3).[5]

These tomb chapels had wall paintings that memorialized the owner and were visited by the living, in order to perpetuate the funerary cult. Tomb paintings were also intended to aid the deceased in the transition to the next world.[6] Within this physical setting, images of foreigners are found almost

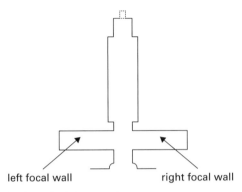

Figure 3 Plan of a 'T-shaped' Theban tomb.

exclusively on the walls in the transverse room that were first seen by visitors entering the tomb chapel, where light would enter the tomb from the door (see Fig. 3).[7] The painted decoration on this wall was highly symbolic and was created to perform multiple functions and to encourage visitors to the chapel to recite an offering prayer on behalf of the deceased. Primary among these alluring images are scenes where the king is seated in his kiosk in the palace with bound and trampled foreigners adorning the footstools, throne arms and dais of the king. In these tombs from the early eighteenth dynasty (1550–1372 BC), a time of Egyptian expansion, these scenes are sometimes shown with another type of foreigner image, depicting foreigners as tribute bearers. These tribute-bearing foreigners are not used as palatial decoration or royal accoutrements.

This project focuses on eighteenth-dynasty Theban tombs decorated before the reign of Akhenaton and the Amarna revolution (1550–1372 BC). In this way I have been able to isolate a discrete set of tombs that were created according to the same religious beliefs. Therefore I use the term 'early eighteenth dynasty' to refer to the above date range. During this time, and indeed throughout the eighteenth dynasty, there was a powerful 'international' culture that fostered trade and diplomacy, and artistic motifs throughout the eastern Mediterranean.[8] Since there has been an intense interest in the historical records of these cultures and their contact and relations with one another, Late Bronze Age foreign policy and interactions are a topic of heated discussion by scholars.[9] The debate over exact dating and archaeological

comparanda has received much attention.[10] New findings in this field are tied very closely with new archaeological finds and the chronological contexts in which they are found.

In ancient Egypt, there was the official ideological Egyptian version of reality, the reality as viewed by the peoples and kingdoms of the other various groups of peoples, and the reality of the physical artefacts exchanged in Late Bronze Age trade. This last reality, relayed through archaeological sites and artefacts, records some of what actually happened in ancient history. However, the history as relayed by artefacts is not the reality that the ancient Egyptians promoted. This work is concerned with how the official Egyptian ideological version of reality impacts the ways in which images of foreigners are used in ancient Egyptian tomb chapels.

The images of foreigners on Theban tomb walls are often analysed and discussed in terms of historicity. They bring objects, and the discussion is usually based on the objects being carried. The Aegean and Levantine comparanda have been catalogued and discussed in numerous publications.[11] The archaeological materials from various sites in Egypt and abroad continue to provide more information with every excavation, and what is written now will quickly be outdated as more research on various sites is published. For instance, Alaa El-Din M. Shaheen wrote his entire dissertation on the historicity of Levantines and Nubians in the eighteenth-dynasty Theban tombs, but this study is now outdated by new information from excavations.[12]

Of the foreigners known to the Egyptians, Libyans are rarely depicted in these tomb scenes, and unfortunately little is known about them.[13] In addition, there are occasionally representations of people from Punt. However, the surviving evidence concerning the land of Punt is not specific enough to allow Egyptologists to pinpoint its precise geographic locale.[14] Less research has been done concerning the Nubians than the Levantines, and the goods brought by them to Egypt were mostly natural materials and animals, which have not survived down to the present.

The aim of my research is to interpret these paintings of foreigners with the understanding that Egypt was in contact with the various people types surrounding Egypt. Further, the relationships between the Egyptian state and the various peoples of the Levant, Nubia, the Aegean and Punt were very complex, and these interconnections are not well understood.

The Egyptian ideological view of history and foreigners is the lens used to analyse these scenes. My focus is sharpened to interpret these images in terms of meaning that would have been recognizable to the ancient Egyptian viewer, tomb owner and artists. Since historical accuracy was not, in my opinion, the purpose of the images, this will not be the focus of the study. Instead, the reader will be directed to see what the intended viewer would have seen in the images of foreigners in these monuments of memory and identity.

Background

Previous research

A number of scholars have discussed representations of foreigners in ancient Egyptian contexts. The earliest of these discussions is by Max Müller from 1893 in his book, *Asien und Europa nach altägyptischen denkmälern.*[1] This text is incredibly ambitious as the author places essentially no limits on his intellectual curiosities. He discusses various historical groups such as the Phoenicians, Palestinians, Canaanites and Puntites and their relationship to ancient Egypt through textual evidence. This source is quite dated but shows that Egyptologists have long held an interest in the history of the interactions between Egypt, the Aegean and the Levant.

The entry 'Fremdvölkerdarstellung' by Wolfgang Helck in the *Lexikon der Ägyptologie*[2] focuses specifically on what each foreigner type looks like. This lexicon entry covers the span of Egyptian history. Because of the format, this reference is necessarily brief. However, it reduces images of foreigners in the Theban tombs to a one-to-one historical relationship based on their clothing and attributes. Therefore, if a figure is dressed a certain way and labelled as a specific people type – say 'Hurrian' – then all Hurrians can be identified by those same attributes. This seems like a logical conclusion, but it does not correlate with the system of labelled images of foreigners in the Theban tombs, as explored in this study.

In this article Helck also attributes the visual confusion of Aegean traits with Levantine ones to a historical source: the end of the Egyptian connection with Knossos. I deal with this same issue in the section on symbolism and historical accuracy in Chapter 8. The *Lexikon der Ägyptologie*'s entry on foreigner imagery is in direct contrast to the iconographical interpretation that I undertake in this

work, as it takes the Egyptian images at face value, without consideration for their context, function or intended meaning of these tomb paintings.

Another book related to my research, and focused specifically on the same tomb walls that are covered in this research, is *Tomb Painting and Identity in Ancient Thebes, 1419–1372 BCE* by Melinda Hartwig.[3] In this work, the author provides an in-depth analysis of Theban tomb paintings from an art historical perspective. She discusses painting workshops, the tomb owner as patron, the function of tomb images, and the tomb as a monument to identity. Hartwig also examines the various types of scenes rendered on the focal walls of the tomb chapels. Her focus is on different scene types and their associations with the palace and the temple workshops. While she describes tribute scenes in her book on iconography in the Theban tombs, these specific images were not the primary focus of her study.

The 'tribute' icon section in *Tomb Painting and Identity in Ancient Thebes, 1419–1372 BCE* is in a chapter devoted to the 'intersection of iconography, symbolism, magic, and commemoration'.[4] In this same chapter Hartwig discusses the royal kiosk, registration, gift, award of distinction, offering table, banquet, fishing and fowling, natural resources, worshipping Osiris, and funerary rites icons. The line drawings of the focal walls in her study are quite useful for this project, as is her discussion of the importance of the imagery on the focal wall to the ancient viewer. In this study I incorporate her idea of the use of visual hooks in depicting foreigners to draw in the viewer, such as the Nubian dancing girl imagery sometimes found in tribute-bearer scenes.

Artistic representations of foreigners are also the focus of Charlotte Booth's work, though her resulting conceptual framework may be too simplistic. Her assertion is that foreigners are represented in either a stereotypical or a non-stereotypical fashion.[5] She applies this framework to the entirety of Egyptian history and categorizes the chapters by people type: Asiatics, Syrians, Libyans, Nubians, Minoans and Indians. In this study she considers as 'non-stereotypical representations of foreigners' those that fall outside of the repertoire of what I categorize as 'king's captive' images in Chapter 5. The author focuses on images that do not fit into the royal context where the king is shown actively conquering the foreigner. This 'stereotypic' mode is the predominant way that foreigners are depicted throughout Egyptian history. Booth collects images that do not fall into this category. She includes the Ebony Statuette from the Petrie

Museum (discussed in Chapter 6). It is surprising that she does not include all of the tribute-bearer images as they are not obviously constrained or bound by the king.

In my dissertation I discussed images from early eighteenth-dynasty Theban tombs that do not easily fall into either palatial decoration or tribute-bearer categories. The chapter shows foreigners in unusual scenes and does shed light on the roles of foreigners in society in early eighteenth-dynasty Thebes.[6] This group of tomb paintings was not usually on the focal wall and from a study of these few images it was clear that the Egyptians had 'a multifaceted perception of foreigners that varied from context to context.'[7] I think it is this type of imagery she is trying to make sense of, yet placement, use and function of all of the different images from the span of the entirety of Egyptian civilization is probably a very difficult project to undertake.

Another way to approach the different ways that the Egyptians represented foreigners is to put them on an ideological spectrum. Antonio Loprieno proposed that descriptions of non-Egyptians in Middle Kingdom Egyptian literature fit on a range between two conceptual poles of *topos* and mimesis, an idea that is more complex than the other theoretical paradigms employed by scholars researching foreigners in ancient Egypt.[8] *Topos* represents the Egyptian concept of the cosmos, where foreigners can *only* be represented as chaotic forces under the control of the king. In Loprieno's study, the *topos* represents the Egyptian rhetorical and idealized stereotype of their enemies. In literature the *topos* relates foreigners to animals, which is an attribute of foreigners we also see in imagery such as the chest from King Tutankhamun's tomb (Pl. 1). On the side panels the king is killing either Levantines or Nubians and on the top he kills wild animals. All the images are represented in much the same way, with hunting dogs taking down both foreigners and animals. Mimesis, on the other hand, reflects the Egyptians' daily interaction with the foreigners that they encounter. Loprieno focuses on Middle Kingdom literature where any foreigner who has positive qualities, especially those who can speak Egyptian, contrast with those who form the foreigner *topos*.

In building his argument, Stuart Tyson Smith relies on Loprieno's ideas about *topos* in Middle Kingdom literature and applies it to New Kingdom texts.[9] Smith discusses foreigners in a post-colonial context and establishes that foreigners act as symbols for a dominating power. As an archaeologist he

approaches the material from an anthropological perspective and focuses his discussion around ethnicity, antiquity and 'otherness'. His study on a cemetery on Tombos is embedded in a discussion of Egypt and Nubia in terms of royal ideology versus actual physical reality.

Conceived at the same time and aligned with the way that I discuss foreigners within this work is Ann Macy Roth's essay 'Representing the Other: Non-Egyptians in Pharaonic Iconography'.[10] This essay was published in 2015 and she devised a number of categories that I also identified independently, which were published in my dissertation, published in 2014. The fact that these categories and their meanings were discovered independently means that they are recognizable to those familiar with ancient Egyptian ideas and iconography. We both identify the numerical grouping of foreigners and ascribe meaning to those numbers. I call these numerical groupings the 'king's captives'. They are palatial decorations or kingly accoutrements, discussed in this text in Chapter 5.

Both Roth and I worked with an interest in the notion of 'the other', an interest in historicity and an awareness of the ideological role of foreigner imagery. However, she links women, children and non-elites in the category of 'other'. While I believe that she is correct that the elite males would have considered themselves different from the rest of the population, I think that grouping them with foreigners is perhaps more a habit of our understanding of the origin of the academic study of 'the other' than a natural categorization that the Egyptians would have made. The ancient Egyptians would have considered the chaotic, captive foreigner as more of an animal and would not have linked women, children and non-elites with them conceptually. As she quotes from Hornung, foreigners 'were seen as the metaphorical embodiment of the undifferentiated chaos of non-existence'.[11] Women and children, though less than elite men in the social hierarchy, did not have this symbolic association in either iconography or text.

Roth also notes the similarity between the Egyptian offering-bearer motif and scenes where foreigners walk freely in New Kingdom non-royal contexts, the Theban tombs. Additionally she states that there seems to be a prohibition on representing foreigners on non-royal funerary monuments in the Old and Middle Kingdom. I propose here that the 'prohibition' she cites is surely the desire to not represent unrestricted chaos within a tomb context.

Extending past the time period of this work, Roth notes that the royal accoutrements which depicted foreigners seem to be off limits to non-royals until Graeco-Roman times, when they are depicted on the bottom of the deceased's sandals, arguably because the mummy is now syncretized with Osiris.[12] Her article covers the entirety of Egyptian history, citing the major monuments from each period that depict foreigners, and is thus a useful article in researching foreigner iconography in ancient Egypt.

Mu-chou Poo's work is also aligned with my own interests and objectives as he examines the idea of foreigner representation in tribute scenes.[13] He looks at attitudes towards foreigners in China, Mesopotamia and Egypt. The comparative study of visual, textual and archaeological evidence shows that the construction of the other is important to create a national identity. He proposes that judgements and dislikes about the other tend to be rooted in the cultural instead of the biophysical. Additionally, he recognizes the use of 'the other' to advance political agendas.

As mentioned earlier, Alaa El-Din M. Shaheen also looked at the tribute scenes in eighteenth-dynasty Theban tombs. His focus is on the historical accuracy of the scenes containing Nubians and Syrians.[14] His work does not lend much to this study, in part because it is already quite dated in relation to new research on archaeological comparanda. However, his work is unique in that he is interested in what the Nubians bring to Egypt, a topic that has received surprisingly little attention in the literature, perhaps in part because the Nubians bring mostly unworked materials and natural resources in contrast to the more ornate vessels and worked objects brought by the Levantines and Aegeans.

In his book *Aegeans in the Theban Tombs*, Shelley Wachsmann takes an in-depth look at just one geographical group represented in the tribute scenes.[15] Since there has been intense interest in both the attire and objects that the tribute bearers bring, he is able to expand on a fair amount of previous literature and draw new conclusions, some of which are countered in this text in Chapter 8. I believe that I would have inferred the same results as Wachsmann had I not been able to contrast the Aegeans to other cultural groups represented in the Theban tombs during the same period of time. His work is a good resource for those seeking historical comparanda for objects presented in Aegean tribute scenes as he discusses each offering type, which tomb it is presented in, and what historical comparanda exist for the object type.

The single instance in which all foreigners are considered in detail is by Diamantis Panagiotopoulos, though he is mainly interested in the veracity of the foreigner images from the reigns of Hatshepsut and Thutmose III (1479–1458 BC).[16] I find such a hypothesis – that the scenes represented in Theban tombs are completely historically accurate – to be implausible based on the fact that there is so much symbolism represented in the tribute scenes. I do not, however, contend that the scenes are completely inaccurate, as surely they reflect a version of reality.

Panagiotopoulos published another article, similar in scope and premise though different in content called 'Keftiu in Context: Theban Tomb Paintings as a Historical Source'.[17] Published in 2001, this work attempts to understand the material, the same sources that are the focus of this study, as historically accurate representations *within Egyptian iconographical conventions*. The author is heading in a direction that seems more plausible given the inherent symbolic nature of Egyptian art. However, Panagiotopoulos has not taken this or the function of tomb imagery into account. The ideas of symbolism and historical accuracy are not mutually exclusive, as discussed in Chapter 8 of this text. With a better understanding of what the Egyptians are bringing to these images in terms of ideology through iconography we can understand the intended function and purpose of these images.

Discussion of problematic terms

The tombs analysed in this study were recorded and discussed in the 1940s and earlier, almost exclusively by European and American men. Interestingly, I have noticed that the discussion of these scenes is often predominantly concerned with the pale-skinned male foreigners from the Aegean and the Levant. Figures of black Africans and foreign women and children were almost completely ignored. To rectify this, my intention in this work has been to look at all foreigners, male and female, and investigate the ways in which they were depicted. However, I realize that the material from the north of Egypt gives historians more material to consider and discuss.

In addition to focusing on one people type over another, scholars also used wording that was acceptable in their times to describe these various groups.

Some of these terms are outdated and others are now considered offensive. In this research I will actively avoid using the terms 'Asiatic' and 'Syrio-Palestinian' because of connotations that these terms evoke. Instead of these words I employ the term 'Levantine', though I am fully aware that this term is not perfect either. I will also not use the words 'Negress' or 'Negro', and will instead use the more neutral term 'Nubian'. Further, the terms 'Hamite' and 'Semite', which are often employed in describing people, will be avoided in this work, as I have no intention of linking any of these depictions to characters in the Bible. Additionally, in this study I use the term 'Aegean' to apply to people from that area who were usually called 'Keftiu' or *jw ḥrj-jb* nw *wȝd-wr* (the Isles in the Middle of the Great Green). It has been generally agreed that *Keftiu* refers to Crete and that the latter term refers to the Aegean islands, including the Peloponnese. To conclude, I chose to use the words Levantine, Nubian and Aegean to refer to the vast majority of foreigner types in an attempt to avoid connotations, though I sometimes quote authors and will use their original wording so as not to change the quotation.

The tomb owners and their titles

The men buried in the Theban necropolis consisted of the temple and state bureaucracy and the military; these individuals were the upper echelon of the elite society. They were below only the king in the social rank. When alive, the tomb owners and their families intermingled with one another and created the extreme elite of the population. Of the few hundred tombs that can be dated to this time and locale, only twenty of the Theban tombs from this period have a foreign tribute scene, making this motif rare. The ability to commission such a large project as a tomb required wealth and favour from the king, and such a relationship with the king was extremely important in both life and death. In fact, the standard offering formula for the deceased's eternal sustenance begins with 'an offering which the king gives'. Further, in many of these tomb scenes, the tomb owner acts as an intermediary between the king and foreign tribute bearers. Clearly the tomb scenes of presenting offerings to the king would have evoked the idea of the king's reciprocity in gift giving to the tomb owner, ensuring the high elites eternal life and wealth.

Some of the tomb owners with tribute scenes on their focal wall have titles indicating that they acted as a foreign emissary for the king. One such title, that of Amenmose (TT 42), was the 'Eyes of the King in the Two Lands of the Retenu'. His title alone gives us clear insight that he is working on behalf of the king in foreign lands. Another high official, Penhet (TT 239), held a similar administrative post as 'Governor of All Northern Lands'. Amunedjeh (TT 84) was the 'First Royal Herald and Overseer of the Gate'. In this capacity he probably allowed foreign gifts to arrive at the palace and thus had a real-life connection to foreign gifts. Viziers like Rekhmire (TT 100) and Useramun (TT 131) were only second to the king in the royal bureaucracy. These two officials also held the title of 'Governor of the Town', referring to Thebes, the cult centre for the god Amun. Many officials who chose tribute scenes for their tombs were likely involved in the collected of tribute for the cult of Amun, the King of Gods. For instance, Senenmut (TT 71) was the 'Steward of Amun', Menkheperrasonb (TT 86) was the 'First Prophet of Amun' and Puyemre (TT 39) was the 'Second Prophet of Amun'. These elite officials formed a very small and powerful group who wanted to display their status on their eternal monument. The choice of the tribute scenes as wall decoration is one that is based on the tomb owner's celebration of status in this life and the next. It was likely a restricted motif, reserved for the extremely elite officials who had some involvement with the collection of foreign goods on behalf of the Egyptian state. It was surely hoped that the tomb owner's worldly status would thus be projected into the afterworld.

The Cosmic Significance of the Tomb

To be able to better understand why images of foreigners were depicted on Theban tomb walls, it is first necessary to understand the function of the tomb. As an entity, these decorated monuments functioned to aid the deceased in achieving a successful afterlife. The ultimate goal of the tomb owner was to build a structure that would iconographically and architecturally assist the deceased in regenerating and finding life anew in the hereafter. The ideas surrounding the afterlife and the attainment of revivification in the next world are encoded within the tomb structure, layout and decoration. The functions of the various different tomb elements can be understood when the individual attributes of the Theban tomb are described and then understood in terms of concepts relevant to the ancient Egyptians.

Eighteenth-dynasty Theban tombs were physically separated into three vertical levels: the burial chamber, the chapel and the superstructure. These physical divisions are aligned with particular ritual meanings for the tomb owner. The burial chamber, which held the body of the tomb owner and his sarcophagus, was located underground, beneath the tomb chapel. Above the burial chamber a middle level consists of a tomb facade, exterior courtyard, interior rooms and a shrine. It was these inner rooms of the Theban tombs that were decorated with wall paintings. Above this middle level, on top of the tomb chapel, were architectural superstructures, either a stelaphorous statue with an inscribed solar hymn or a pyramidion (Fig. 4).

These three levels of the tomb corresponded with different but intertwined ancient Egyptian concepts about death.[1] The underground burial chamber was associated with the mummiform god of the underworld, Osiris. The above-ground superstructure connected the dead with the solar cycle. The deceased travelled through the afterlife with the sun, which was born again each

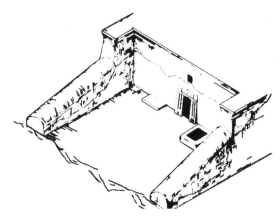

Figure 4 Exterior of an eighteenth-dynasty Theban tomb (reconstruction). Illustration compliments of Nigel Strudwick after Friederike Kampp. Kampp, Friederike. *Die Thebanische Nekropole: zum Wandel des Grabgedankens von der XVIII. bis zur XX. Dynastie.* Fig. 67.

morning. The middle level, the tomb chapel, was also concerned with regeneration and rebirth in the afterlife.[2] This liminal space was related to the world of the living and was 'the social monument to the tomb occupant'.[3] The visitors to these tomb chapels would see the tomb images and perform rites providing sustenance for the deceased. Visitors, such as the tomb owner's family, priests and others, would perform the rituals necessary for the survival of the dead in the afterlife. One such rite that the living could perform for the dead was the spoken pronouncement of the deceased's name. Another was to leave food offerings for the *ka*, or life force, of the tomb owner.[4]

Many scenes in the transverse hall, located on the middle level of the tomb, depict images that are often referred to as 'daily life scenes', because they appear to depict activities occurring in this world. Recent scholarship, however, has shown that they are symbolically charged, and that the images can include puns and other secondary meanings associated with fertility and rebirth.[5] For instance, larger-than-life butterflies emphasize the transformative nature of this insect's life cycle as a metaphor for the Egyptian concept of rebirth in the afterlife.[6] The iconography on these painted tomb walls conveyed multiple levels of meaning to the ancient Egyptian viewer.

The prototypical eighteenth-dynasty T-shaped tomb chapel (the middle level discussed above) has four main components. First, in the entrance area,

depictions of the tomb owner and his wife or other family members are shown either entering or leaving the tomb. The image of him leaving the tomb is accompanied by text praising the rising sun. If there is an image of him entering the tomb, the accompanying text praises either the setting sun or Osiris, god of the afterlife. Once the tomb is entered, the visitor can see the second area, the transverse walls, discussed below. By looking to the end of each wall one can see the narrow ends of the transverse halls, where stelae or false doors are often located. These decorated features act as a location to list titles and autobiographical information about the tomb owner. The false door acts as a liminal space between this world and the afterworld, where the deceased can come to the world of the living to collect offerings.[7]

The third area of the Theban chapel is the decorated longitudinal hall. The wall paintings that adorn this hall differ in theme and topic from the scene types found on the transverse hall. Scenes on the longitudinal wall often show the journey to Abydos, various mortuary rituals, and the funeral. The imagery is sombre and formal, showing the necessary rites needed to transition to the next world.[8] At the end of the longitudinal hall is usually a statue of the deceased and wife, which could embody the life force, *ka*, of the deceased. These statues are the fourth component of the Theban tomb chapel's decoration.[9]

Scholars have noted that the images on the back walls of the transverse hall, which has been termed the *Blickpunktsbild* ('focal point representation'),[10] were a sensitive indicator of the deceased's status, identity, relationships and social environment.[11] Scenes on this wall often show banqueting, fishing and fowling, and agricultural scenes. According to Hartwig, 'symbolically, the back walls of T-shaped chapels generally occurred at the intersection between representations concerned with the life of the tomb owner in the transverse hall and images of his transition into or life in the hereafter in the interior hall of the chapel or shrine.'[12] Indeed, these walls were the first image that a visitor would see on entering the tomb, since they receive direct light from the entrance.[13] Tribute scenes are located on this symbolically charged locale within the early eighteenth-dynasty Theban tombs.

With all of the various aspects of the tomb structure and iconography mentioned above, the tomb owner, in death, can follow the sun during the day, then enter the tomb at night to be in the underworld with Osiris. He can

receive offerings and be remembered by his family and friends. His wealth and status can be projected and maintained in the afterworld. Even the world, directionally, is maintained within the tomb context. The body of the elite is buried either in actuality or conceptually in the 'beautiful west'.

The rest of the tomb would be oriented accordingly, where the east, the world of the living, was the courtyard where the visitors would enter. In the earliest eighteenth-dynasty Theban tombs with foreigners in tribute scenes, the people are divided by types and placed on separate registers. Most frequently, the people types depicted are Levantines (from the north) and Nubians (from the south), although Egypt's other northern neighbours, the Aegeans, sometimes make an appearance on these tomb walls as well. Less common are registers of Puntites, Oasis dwellers, and the people from Wathor. When separated onto two walls, the people from the south appear on the left focal wall, and those from the north on the right. This way the tomb is aligned with the cardinal directions, creating a microcosm of the known world.

The tomb then has multivalent levels of meaning that coded this architectural space into a ritual and cosmic space that acted as a place of re-creation for perpetuity. Theban tombs were far more than a simple house for eternity; as described above, their every feature held meaning for the tomb owner. Each scene type included and the way it was realized represented a choice made by the tomb owner as a form of self-preservation for current and future viewers. Tombs in the Theban necropolis functioned to mark the tomb owner's life and their impact on society long after their death. What did such tombs mean to the ancient viewer, and what did these paintings of foreigners mean within this highly important, sophisticated, architectural vehicle for regeneration in the afterlife?

4

Foreigner Types

Before discussing the symbolism and iconography of foreigners depicted on tomb walls it is first necessary to discuss the ways that the Egyptians represented the different types of foreigners. One way that they identified the 'other' was through skin colour. Egyptians were painted red, Nubians black, Libyans and Aegeans with yellow or white skin. Egyptians also painted other distinctive coiffure, clothing and accoutrements that vary according to people type. Below are the traits associated with the different non-Egyptian peoples found in early eighteenth-dynasty Theban tomb paintings, when they are represented as both palatial decorations and tribute bearers.

Images of foreigners have generally been understood as symbols of chaos. In this study I propose that the palatial decorations do indeed embody chaos, and it is the king's role to destroy them. I also argue that they are represented in a different fashion than the tribute bearers (see Chapters 5 and 6). The tribute bearers are not bound and/or trampled, and they are not decorations in a palace. Instead these images are represented in exactly the same fashion as Egyptian offering bearers in offering scenes. The only difference between offering bearer and tribute scenes is the foreignness of the goods, iconography and accoutrements of the foreigners. In this chapter I discuss how each foreigner type is depicted in terms of non-Egyptian hair, clothing, body type and accessories in both palatial decorations and tribute-bearer images. While the two motifs had different meanings to the Egyptians, the foreigners do remain recognizable to the Egyptian viewer and thus retained the same physiological traits in most instances. Where this is not the case, the difference is indicated.

Nubians

Nubian men are depicted with short and sometimes rounded hair, which may start in the middle of the head. Their hair is usually black, though it can be black and yellow, a combination that likely indicated texture to the ancient Egyptians.[1] Nubian men wear white kilts with a slit in the middle, which is sometimes accentuated with a red band that goes around the waist and down the front of the kilt (Pl. 3).[2] In palatial decorations (see Chapter 5) Nubian men are represented with a red band that goes across their torso, which is sometimes decorated with round or rosette embellishments.[3]

White jewellery, indicating bone or ivory, often adorns these figures. The jewellery pieces include round, white earrings, white bangles and white beaded necklaces, which are often chokers consisting of two strands of white beads. Straight feathers also seem to be a common indicator of Nubian men.[4] The least common accoutrement on Nubian captives is that of foxtails, an accessory seen more often on Nubian men and women in tribute scenes.[5] When facial features are depicted, the Egyptian artist adds lines or shading that indicate high cheekbones and nasal-labial lines on the faces of the Nubian captives. Female figures on palatial decorations are represented with pendulous breasts and slightly protruding bellies (Fig. 5).[6] While the protruding stomachs are seen in both men and women from this time period, the pendulous breasts of the Nubian women are not seen on any other female types represented in Egyptian art, but are evident on the deities Hapy and Tawaret, who represent fecundity.[7] It is thus possible the pendulous breast represented fertility in ancient Egyptian art.

In the tribute scenes, Nubian men can be shown wearing white kilts with a straight bottom hem, similar to those worn by the Egyptians, though more commonly they are shown wearing loincloths that tie in the front (see Fig. 6). These garments, and kilts, seem to be made of different types of materials, including cow and cheetah skins. One, from TT 84, has a tail attached at the back.[8] Like in the palatial decorations, male Nubian tribute bearers have black hair and the most popular hairstyle seems to be one that is rounded. Sometimes it is shaved in the front so that the hair begins in the middle of the head. Nubian hair can also be depicted with circles, perhaps an allusion to short curls.[9] Some tomb scenes show two lines on the lower back portion of the head

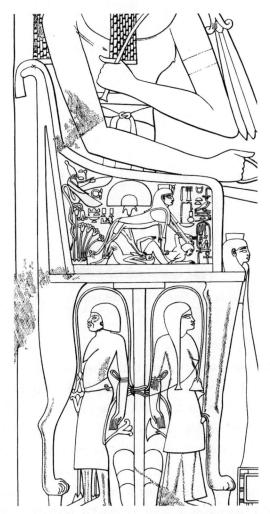

Figure 5 Nubian female captive from TT 192 Kheruef (left). Oriental Institute, *The Tomb of Kheruef [2] Key Plans and Plates*, pl. 47. Courtesy of the Oriental Institute of the University of Chicago.

that may have represented a ribbon worn as an adornment.[10] Additionally, Nubian males can be drawn with elongated head shapes such as can be seen in tombs 63 and 89.[11]

In addition to the small round earrings made out of a white material, either bone or ivory,[12] Nubian men can also wear short necklaces that can have disks or a single decoration at their apex. A few of these necklaces, specifically in

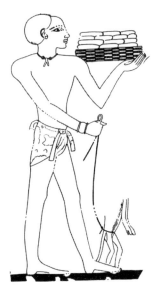

Figure 6 Nubian tribute bearer from TT 100 Rekhmire. Davies, Nina M. and Norman de Garis Davies. *The Tombs of Rekhmire*, pl. XIX.

tombs 100 and 63, look as if they are in the shape of a fly of valour.[13] This fly amulet was a royal award, given by the king for bravery in battle. Susanne Binder, in searching for fly amulets in the New Kingdom, found that both gold and ivory fly pendants were found in Kerma in burials. Some were still around the necks of the deceased. Whether the flies retained the same meaning in the Kerman culture as they did in Egyptian culture is unknown.[14] As for other accoutrements, two male figures, one from the tomb of Rekhmire and one from the tomb of Haremheb, wear an armband or perhaps a tattoo.[15]

The Nubian women in the tribute scenes show interesting variations in the ways that they are represented. In TT 81 the women have long, pink pleated or scalloped skirts and are topless (Pl. 4).[16] Two are hunched over with panniers on their backs. They have slim figures and pendulous breasts, and one of these women leads a child by the hand and has beads that hang down from one shoulder to her waist. In TT 100 another woman with a pannier strapped to her head wears a pleated ankle-length skirt like those seen in TT 81.[17] All of the Nubian women from these scenes have rounded or shoulder-length hair. The woman who holds children in a pannier in TT 63 is sturdily built (Pl. 5), with pendulous breasts and a large stomach, perhaps indicating

pregnancy.[18] She wears a knee-length cowhide skirt, seen also on the women in TT 78.[19]

Adolescent female Nubians are also depicted, though some of these images have not survived as well. The younger women do not have pendulous breasts and they also wear different attire. In TT 81 an adolescent girl wears a beaded dress with anklets[20] while the young women from TT 100 wear a beaded necklace and perhaps a hip girdle, but are otherwise nude.[21] In TT 78, there are nine young women shown wearing loincloths and dancing (Pl. 6).[22] These young women have three tufts of hair and wear streamers on their elbows to accentuate movement. They also wear necklaces, bracelets and earrings. The panniers that Nubian women wear are either woven or made of cowhide and carry small children. In these images the women strap the panniers around their foreheads or push the strap up around their shoulders with their hands.[23] Nubian women also sometimes carry small baskets.

Children are the most active figures in the tribute scenes. When carried in panniers, they wave their arms around. Some Nubian children, as seen in TT 78 and 89, have their hair in separate small tufts atop their head; others are depicted without hair.[24] Nubians carry more children in their panniers than do the Levantine women. For instance, in tomb 63 there are four small children carried on the back of one Nubian mother.[25]

Levantines

Most of the Levantine men represented in palatial decorations have shoulder-length hair with a white fillet, though this is not the case in tribute scenes. The predominant type of attire worn by these long-haired individuals is a white galabeya (a long, sleeved gown), with blue and red seams. The other type of Levantine man shown is bald with a cape over his galabeya. Both Levantine male types have a beard and when the image is detailed, one can see that a moustache attaches to the beard (see Pl. 3).[26]

There is some variation in the long-haired figures represented in the images from TT 120 (Pl. 7). The hair can either be shown coming down in separate strands ending in curls below the shoulder, or the hair can be more rounded at the bottom, near the nape of the neck. In TT 63, the white galabeya is shown with a swathe of white fabric with red or blue seams wrapped around the

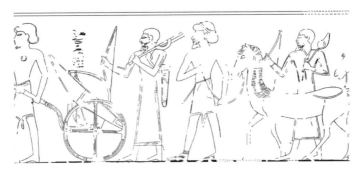

Figure 7 Levantine hairstyles from TT 84 Amunedjeh. Davies, Nina M. 'Syrians in the Tomb of Amunedjeh', pl. XIII.

skirt.[27] The Levantines from TT 120 and TT 58 are highly detailed and show the elaborate decoration and brilliantly coloured swathes of material, which are usually layered over a white galabeya with coloured seams (either blue and red or green and red).[28] This type of attire is more ornate than that seen in the tribute-bearer images.

Just like in the palatial decorations, the tribute-bearing Levantine men can be rendered with two hair types, long (chin or shoulder length) or shaved. In rows of figures, these two types usually alternate (see Fig. 7).[29] Those who wear their hair long usually adorn it with a fillet. Most Levantines are also bearded. Sometimes Levantines are depicted with red hair, which is shown as unkempt, with hair out of place.[30]

The clothes on northerners similarly alternate between two types. The standard Levantine kilt in these scenes extends to just above the knees. These kilts narrow to a point between the legs and have red and blue decorated borders.[31] Figures wearing this attire are usually shown with ear- or shoulder-length hair and a fillet.[32] On rare occasions an Aegean (*Keftiu*) skirt can be found in a Levantine register,[33] perhaps due to a conflation of these two areas located north of Egypt (see Chapter 6 on 'hybridization').

The other type of clothing depicted on Levantines is a galabeya.[34] Like the kilts, Levantine galabeyas consist of white fabric with blue and red edging. Often the galabeya has a broad seam that runs down the centre and it also has long sleeves that extend to the calves or ankles. Pritchard calculated that in 45 out of 63 examples, the galabeya is worn with shaved hair.[35]

Long swathes of fabric are sometimes wrapped a number of times around the galabeya, which can also be embellished with decoration (Fig. 8). This type of attire replaces that of the galabeya without the cloth wrap around the skirt in tombs from the reign of Thutmose IV until that of Amenhotep III (*c.* 1401–1391 BC).[36] Sometimes a cape is worn over the shoulders in addition to the galabeya and wrap, suggesting conspicuous consumption of fabric.[37] The most common jewellery that the Levantine men wear is a circular medallion around the neck.[38] It seems likely that these medallions correspond with those common in the Levant and the Near East representing the sun god Shamash.[39] The hairstyles, attire and physical appearances of the Levantines cannot be correlated to specific locales or ancient cultural groups.[40]

Levantine women are not depicted nearly as often as men in tribute scenes. They are shown with a short-sleeved long dress that have three tiers in the skirt (Fig. 9). Like the men's galabeyas and kilts, the dresses are white with blue and red decoration adorning the edges. Though there are not enough examples to conclude that there is a trend seen in the images, it is interesting to note that here too the cape shawl makes an appearance in the later tomb images.

Levantine women are typically represented with long hair that falls behind their back. In images where the hair falls in front of the shoulder, it is shown gathered together, as if tied near the bottom. When carrying a pannier of

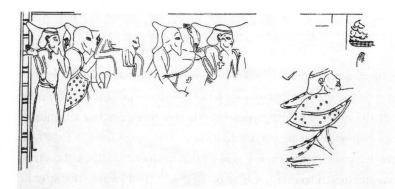

Figure 8 Examples of Levantine attire from TT 239 Penhet. Hartwig, Melinda K. *Tomb Painting and Identity in Ancient Thebes*, fig. 44. Reprinted with permission from author.

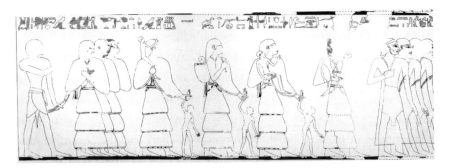

Figure 9 Examples of Levantine women's dress from TT 100 Rekhmire. Davies, Norman de Garis. *The Tombs of Rekhmire*, pl. XXIII.

children on their back, the women hold the rope at their shoulders to relieve the weight, unlike the Nubian women who wear the pannier strap on their forehead. Occasionally female Levantines also wear earrings or are depicted with red hair.[41] Levantine women are depicted with slender physiques, and their breasts are not indicated in the tribute-scene images. Interestingly, in the one image where two representations of women are depicted as palatial decorations, adorning the throne of Queen Tiye, the women have pendulous breasts (Fig. 5).

Children are usually shown with women, and are either held by the wrist as they are walking or in panniers on women's backs.[42] The children are typically depicted naked or wearing a galabeya and shaved hair, sometimes with a side-lock. Occasionally Levantine children are shown with their hand to their mouth, a convention used to depict Egyptian children.

Libyans

The Egyptians rarely depicted images of Libyans in early eighteenth-dynasty Theban tombs and the way that they look in TT 120 is quite different from the features of the other foreigner types (Pl. 8). This foreigner has an unusual hairstyle, a bob with a fringe and side-lock. In the image from TT 120 the Libyan has two feathers in his hair. It is likely that the ostrich feather, in contrast to the straight Nubian feather,[43] was associated with the Libyans. This specific feather type is also associated with the symbol for the west, which is where the Libyans are in relation to Egypt. Libyans are also depicted with tattoos or henna, decoration which is only associated with Egyptian women in this

period,[44] which could be part of why in ancient Egyptian texts Libyan men are thought to be effeminate.[45] One noteworthy observation is that Libyans are never shown in any extant tribute bearing images. The only image of Libyans from early eighteenth-dynasty Theban tombs shows them bound and trampled as palatial decorations. They are not shown bringing goods to the king. So we are missing visual information about this group of peoples.

Aegeans

The only known image of an Aegean (*Keftiu*) as a palatial decoration is from tomb 120, and this image is unlike the *Keftiu* seen in the tribute scenes (see Pl. 8). The cap and attire on this figure are not seen in other images either. The *Keftiu* are the only people represented with shoes, and their sandals always have straps that wrap around the ankle. In this image the figure has long, curly hair that falls down his back, a trait also seen in images of the *Keftiu* from tribute-bearing scenes.[46] The other features, such as the ornate open galabeya, are unique to this figure, perhaps because this image is from the reign of Amenhotep III.

The tribute-bearing Aegeans date to the reigns of Hatshepsut and Amenhotep II (*c.* 1473–1401 BC). 'The earlier paintings, from the tombs of Senenmut, Antef, and Useramun, show individuals dressed in a stylized version of the Minoan breechcloth with codpiece and backflap.'[47] In the tombs of Rekhmire and and Menkhepperrasonb, which are of a later date, the figures originally wore breechcloths which were painted over and depicted with kilts. In one tomb (TT 100) the figures originally wore breechcloths and then were painted over and depicted with kilts (Fig. 10).[48]

In tombs 131 and 71, the figures wear long hair falling behind their shoulders.[49] In later images in TT 100 and 86, the hair falls over the shoulder in strands, perhaps indicating curls.[50] The 'Aegean curl', seen on the top of the heads of many *Keftiu* in these scenes, may also indicate curly hair.[51] This curl is also common on the Levantine men, which is either a conflation of hair types or the symbol is not related to people from a specific geographical area. What is not debated is that in these tribute scenes the only foreigners to wear shoes are the Aegeans.[52] These shoes sometimes curl at the toe and they can also have straps that wrap around the calf. Such elaborate shoe types are not seen on Egyptian figures from the same time period.

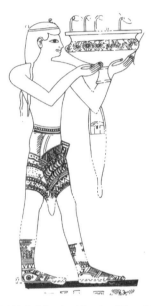

Figure 10 Aegean from TT 100 Rekhmire. Davies, Nina M. and Norman de Garis Davies. *The Tombs of Rekhmire*, pl. XIX.

Oases dwellers

People from the oases, Wat-hor and Punt are not represented on royal decorations; they are only (and relatively rarely) depicted in tribute scenes. In these images, the men leading the oases tribute bearers are represented with kilts and wigs that are similar to those shown on the Egyptians who record the tribute in the scene (Fig. 11). It is likely that these individuals could afford the

Figure 11 Oases tribute bearers from TT 39 Puyemre. Davies, Norman de Garis. *The Tomb of Puyemrê at Thebes*, pl. XXXI.

Figure 12 Female from the oases from TT 155 Antef. Säve-Söderbergh, Torgny, Norman de Garis Davies and Nina M. Davies. *Four Eighteenth Dynasty Tombs*, pl. XIII.

Egyptian accoutrements, or perhaps the scene is depicting Egyptian colonists leading indigenous peoples. More natural locks, which are shoulder length and do not have the patterning seen on Egyptian hair in these tombs, are seen on the figures that follow the procession leaders. In the tomb of Ineni some men from the oases have medium-length hair, and one wears a fillet. In the tomb of Antef two women are shown at the rear of the procession, and the women wear their hair in a long, tripartite style that reaches the waist (Fig. 12). This length is longer than we see on Egyptian women from this time period.[53]

People from Wat-hor

Wat-hor,[54] which translates to 'the road of Horus', was a strategic economic and military corridor connecting Egypt and the Levant, to the east of the Nile valley.[55] By the eighteenth dynasty Wat-hor was under Egypt's control. The men from Wat-hor look Egyptian because they wear a short, patterned wig and kilt, just as the Egyptian administrators wear (Fig. 13).[56] In the extant tribute-bearing scene from this region, pomegranates are brought forth to the administrator. In the register there are also piles of raw materials, which are not labelled, and six large jars are part of the tribute as well. The text accompanying the depiction reads 'wine of the vineyards of the Road of Horus'. No women or children are depicted in the sole tomb scene representing the people from Wat-hor.

Figure 13 Tribute bearers from Wat-hor from TT 39 Puyemre. Davies, Norman de Garis. *The Tomb of Puyemrê at Thebes*, pl. XXXI.

Puntites

Interestingly, men who are identified by text as being from Punt can be depicted with Egyptian, Levantine and Nubian traits. The kilts that they are shown wearing reflect these different types of dress. Sometimes Puntites wear kilts that are Levantine in style, with a flap of fabric that hangs down between the legs.[57] They can also wear kilts with a straight bottom hem, made out of cowhide, or undecorated.[58] There is one type of kilt not associated with other people types, seen in the Puntite tribute scenes from TT 39,[59] with a triple red stripe on white material, and extra material bunched in the back (Fig. 14).

Other unusual garb is portrayed on a Puntite chief from tomb 143,[60] where the front figure wears a red robe with inverted blue triangles decorated with spots on the top hem (Fig. 15).[61] In TT 39, the leader of the procession wears a red tie on his shoulder, but little else is preserved from this image.[62] Because the available records of the tomb are mainly black and white, little information can be gleaned about skin tone. Nevertheless, Davies states that in TT 143 the figures are painted a dark-purplish red colour.[63]

Male Puntites are also shown with a variety of hairstyles. Some wear short, cropped hair, with or without a beard.[64] Others are depicted with Levantine-style hair, long and curled at the end with a fillet around the forehead and a beard,[65] or with rounded hair and a beard, similar to how Nubian men appear in tribute scenes.[66] As for accessories, the Puntite figures wear very few. In one instance, from TT 100, a male Puntite wears a necklace[67] and in TT 39 another male figure has an anklet.[68]

Iconographically, the figures do not conform to any single set of foreigner traits. Their hair, beards, clothing and accoutrements draw on traits identified

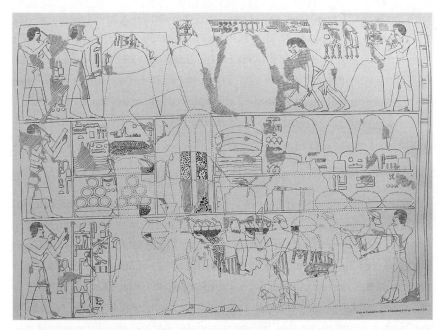

Figure 14 The tribute from Punt, TT 39 Puyemre. Davies, Norman de Garis. *The Tomb of Puyemrê at Thebes*, pl. XLII.

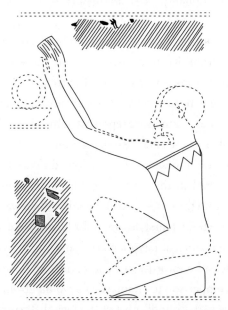

Figure 15 Puntite chief from TT 143 (name lost). Davies, Norman de Garis. The Work of the Graphic Branch of the Expedition. *MMAEE* 2 (1935), Fig. 1.

with Nubians, Levantines and Egyptians. Nevertheless, the leaders of the Puntite tribute scenes can also be shown wearing unique attire, either a strapless red robe or a kilt with vertical red lines. Scholars find the placement of Punt problematic.[69] It seems as if the Egyptian artists might have been equally confused about the physical attributes of foreigners from Punt.

Contrasting foreigner types

This chapter has described the ways that the Egyptians rendered the different foreigner people types on Theban tomb walls from the early eighteenth dynasty.[70] As mentioned in the text above, there are two very different categories of image types analysed in this discussion. One is foreigners represented as part of palatial decorations, a practice that likely dates back to the dawn of Egyptian history.[71] The other is foreigners bringing tribute to the king, a visual motif that becomes popular only in this time period and only on the funerary monuments under discussion. These two scene types will be explored and analysed in the following chapters in order to better understand the functionality of these images within an ancient Egyptian funerary context.[72]

In this chapter I make separate iconographical conclusions about each people category within its respective section; however, I think further discussion on comparisons is warranted. Of particular interest to me, in part because they have not been discussed before, are the women and children depicted in these scenes. Women are represented in delegations from the oases, the Levant and Nubia. These latter two delegations also bring children. Of the women from the oases in these images, only one difference exists between the extant woman depicted in this scene and Egyptian women from the same tomb. The woman from the oases wears longer hair than was fashionable at the time. As mentioned above, hairstyles and hair length were status and identity markers on women in ancient Egyptian art,[73] so while this is not a remarkable difference, it is at least noteworthy in a comparison of images of women from the Nile valley in comparison to an image of a woman from Egypt's periphery. Such a difference is perhaps indicative of the idea that women from the oases did not keep up with Egyptian hairstyles popular at the time.

More conceptually perplexing are the images of the Levantine and Nubian women from these tombs, and how these images compare to one another. As described above, Levantine women in tribute scenes are represented in long dresses, long hair, and with breasts that are barely indicated, if indicated at all. They carry children in panniers on their back. The Nubian women are depicted in a number of ways (discussed above). They also carry children in panniers on their back, though the number of children they carry is more than the Levantine children carry. The Nubian women are depicted with pendulous breasts and can have round bellies, both of which are exposed because they usually only wear skirts. Clearly, thin women with no breasts and larger women with pendulous breasts are both contrasts to the ideal female image of a woman in the prime of her youth, which is how Egyptian women are shown within early eighteenth-dynasty Theban tomb paintings.

However, it is interesting to note that the Egyptian dancing girls (like those in the tomb of Nebamun), who so often are referenced to as alluding to sexuality,[74] have small breasts, indicating adolescence, as do the Nubian dancing girls, such as those in the tomb of Haremheb. This must represent an early age of acceptable sexuality in the ancient Egyptian worldview.

Further, as stated above, I believe that pendulous breasts, in Egyptian iconography, are related to ideas of fertility and fecundity. This notion is further supported by the large number of small children, up to four, in each individual pannier. Although it could be argued that these children could be born from other women, if one is taking a more historical approach to the material. If the viewer were an ancient Egyptian looking at these two female types, the Levantine and the Nubian females in tribute scenes, the Levantine would be similar to the way the Egyptian elite was represented. Levantine women are fully clothed, with long hair, and the Nubian women wear only a skirt, which may remind the Egyptian elite of the working class who have very little to wear. Also, while Egyptian men are red, Egyptian women are usually depicted as yellow, which is more similar to how Levantines are coloured.

However, in the one instance where women are shown as decorations on a throne being dominated by the queen, the Levantine woman's figure is depicted differently than the Levantine women in the tribute scene. She has long, pendulous breasts and a round belly, like the Nubian woman depicted with her. While these are the only two instances of women who represent chaos, both on

Tiye's throne (as palatial decorations of foreigners are symbols of chaos; see Chapter 5), it does fit nicely into the hypothesis that the tribute scenes and the represented palatial decorations are indeed representing different concepts and the tribute scene images do not represent chaos. The foreigner women are represented as physically different from the Egyptian ideal, represented by the queen who is seated on the throne where they are depicted. In the one scene where foreign women are shown as palatial decorations, and thus symbols of chaos, the Levantine women even have pendulous breasts, showing that they are not conforming to Egyptian norms, even though in tribute scenes their bodies are rendered differently. The slim and perky-breasted monarch shows order conquering chaos, which here has an interpretation in the physical bodies of the women representing order and chaos.

Another interesting comparison between Levantine and Nubian representations is that of the chiefs of foreign groups. Nubian chiefs show status through assimilation. The status indicator for the Levantines is again different: they wear billowing fabric and show conspicuous consumption, which is how the Egyptians in the early eighteenth dynasty displayed their wealth and status on these same tomb walls.

What can we tell about the other groups when compared to one another? Of the tribute scenes that represent the oases and Wat-hor, the goods and peoples from these places are only represented in the tomb of Puyemre, one of the earliest tombs in this study, from the reign of Hatshepsut/Thutmose III. It seems as if this experiment in representation was not continued, likely because it was not visually interesting. It does not present the main appeal of these images to the ancient Egyptians, mainly opulence, luxury or exoticism. These two registers are represented in much the same fashion. They bring different products (discussed in Chapter 7). In both registers, the leaders are bowing before the Egyptian administrators and they wear Egyptian kilts and wigs like the Egyptians. The tribute bearers that follow from Wat-hor look Egyptian as well, with the same attire and hair as the chiefs and Egyptians. This indicates that this area has been colonized. The men from the oases have medium-length shaggy hair and wear kilts with a flap in the front. It is unclear whether they do or do not conform to standard Egyptian norms. It is unclear if they are being shown as non-elite Egyptians or as exhibiting traits from a slightly different culture.

The iconographical issues regarding the Levant and the Aegean are discussed in the 'hybridism' section in Chapter 6. Other iconographical challenges obviously presented in this chapter are those of the Puntites, who seemingly have no definite set traits, but incorporate all hair and dress types, including some that are unique to Punt. It seems here that the display of goods is more important than the way that the tribute bearers are rendered. It also may reflect the fact that the Egyptian artist was likely unfamiliar with Puntites, though they had probably engaged with other foreigner types in life before.

Such a study of sometimes tediously descriptive information on representation of foreigners is helpful for identification of various people types in ancient Egyptian art. It is necessary for any further discussion of the meaning of images incorporating the various foreigner types. These images have been a subject of interest to scholars since these scenes were first discovered, and yet the context and function of these paintings has never been discussed.[73]

Palatial Decorations

In the ancient Egyptian worldview, the king ruled over all people. One of his principal kingly duties was to destroy chaos and maintain order. Perhaps the most effective visual motif that conveys this message is the image of bound captives who are struck or trampled by the king.[1] These images are first found at the beginning of Egyptian history and continue in use until the end of the Pharaonic era. Captive foreigners were a decorative motif within the audience hall of the palace, a place that is pictured on the focal wall of many of the Theban tombs. By destroying foreign captives the king fulfils his role of preserving order (*maat*) by destroying chaos (*isfet*).[2]

In the eighteenth dynasty, foreigners are represented on royal furniture and architectural elements in a number of fashions within the kiosk scenes located on the focal wall of the tomb chapel.[3] These images depict the audience hall of the king in the palace, where the foreigner images would have enhanced the impression of his power and strength.

The nine bows

In a number of scenes depicting royal kiosks from eighteenth-dynasty Theban tombs, dated 1550–1372 BC, sets of nine anthropomorphic crenellated ovals are depicted. This number was significant to the ancient Egyptians. Nine is three times three – a plurality of a plurality,[4] which represented the concept of 'many' to the ancient Egyptians[5] who used the term 'the nine bows' to describe the enemies of Egypt.[6] When the nine bows are shown in Theban tomb images they are found on the throne dais, under the figure of the seated king so that he is actively dominating these symbols of potential rebellion and chaos.

The use of the bow image to represent groups of people can be traced as far back as the scorpion mace head from Hierakonpolis.[7] One of the earliest surviving examples of the king crushing nine bows under his feet is on a statue of Djoser from Saqqara (Fig. 16). Images of bows were depicted because they are weapons that could be used against the king.[8] Once the king has his enemies' weapons, he renders them impotent and assumes their power. In the examples from the tomb paintings under study, actual bows are not shown. Instead, the 'nine bows' are most commonly rendered using anthropomorphic crenellated ovals, which I will call the 'conventional nine bow motif' (Fig. 17).

The concept of the conventional nine bows motif expressed the king's control over the world and all of the people within it. In these images captive figures have their arms bound behind their backs. An oval crenellated wall that encloses a place name replaces the lower part of their body.

The crenellated ovals that form the lower part of these figures evoke the idea of a fortified city.[9] In the New Kingdom, there are many examples of the conventional nine bows motif, which consists of a specific order of peoples. The first preserved example of the classic list of the nine bows appears during the reign of Thutmose III on the left focal wall in the tomb of Amenmose,

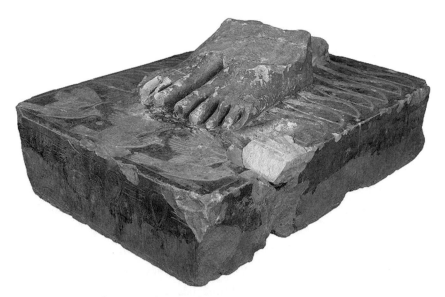

Figure 16 Base of a statue of Djoser from Saqqara (JE 49889 A, B). Courtesy of the Global Egyptian Museum. http://www.globalegyptianmuseum.org/record. aspx?id=15183.

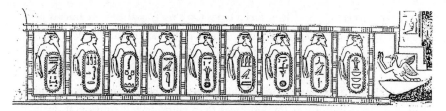

Figure 17 Classical nine bow image from TT 57 Khaemhet, called Mahu. Wreszinski, Walter. *Atlas Zur Altaegyptischen Kulturgeschichte*, pl. 203.

captain of troops, eyes of the king in the two lands of the Retenu (TT 42).[10] The conventional nine bows consisted of the following groups of peoples, in this specific order; *Hau-nbw* (*ḥꜣw-nbw*), *Shat* (*šꜣt*), *Ta-Shema* (*tꜣ-šmꜥw*), *Sekhet-Iam* (*sḫt-jꜣm*), *Ta-Mehu* (*tꜣ-mḥw*), *Pedjtiu-Shu* (*pḏtjw-šw*), *Tjehenu* (*ṯḥnw*), *Jwntjw-Stj* (*jwntyw-stj*) and *Mentiu Setjt* (*mntyw-stt*).[11]

In this study, the geographical locations of these place names are less important than the way that these images were used within the Theban tombs. Also, although *Ta-Shema* and *Ta-Mehu* are the Egyptian names for Upper and Lower Egypt, they are included in this grouping of foreigners.[12] This is because in the Egyptian worldview the king created Egypt by uniting the south and the north. Thus the king was in charge of controlling chaos and thwarting rebellion within Egypt's boundaries. Further, the list of the nine bows mainly represents foreign groups that existed at an earlier time than the New Kingdom, incorporating names that date back to the Middle Kingdom and earlier.[13] This use of historical terms perhaps evoked the power of past kings, linking Egypt's current ruler to his ancient predecessors and the greatness of Egypt's past.

Since the king was also ruler of the world, and in Egyptian history the Egyptian state was the centre of the world, it was natural to see the conceptual boundaries as involving foreign lands. Thus the Egyptians believed that the nine bows motif represents the concept that the king is the lord of all peoples in the world.

People types occurring with the nine bows

Eric Uphill states that:

The faces of the figures portrayed on the escutcheons are differentiated into two main types: viz Asiatic and African. Vercoutter has pointed out 1) that

it is dangerous to follow these facial types too closely as they were not always used consistently … less surprising perhaps is the fact that *Sekhet-Iam* is also given Asiatic features, because lists like that found in the tomb of Khaemhet tend to show no essential difference between the Libyans and the Asiatics. The artists of this time appear to have been less concerned with showing exact representations of foreign races than with general considerations of political geography.[14]

All of the images with nine bows on the dais are labelled and they are always in the same order. However, the physical traits of these people types are not consistent, and vary from tomb to tomb. Why did the Egyptians not follow a pattern of foreigner depiction when they clearly followed a pattern in the labelling of these figures? After analysing each of the nine bows motifs in the Theban tombs from the early eighteenth dynasty, I found a pattern that was not expected. With many of these images I am working solely with line drawings, and valuable information such as skin colour is not available. However, even with this limitation the iconographical categories of the nine bows seem to be easily distinguishable. Nubians are shown with rounded hair, a fillet, a short beard and sometimes a necklace with a fly pendant. They are also occasionally depicted with lines on their face to indicate high cheekbones or nasal labial lines. Levantines are drawn with long hair that falls behind their shoulders, a long, pointed beard, and a fillet. When drawn to accentuate their facial features, these figures have bulbous noses and nasal labial lines. Libyans, when differentiated from Levantines, have an unusual haircut, with a fringe in front, a side-lock, and short, cropped hair in the back. They are sometimes drawn with cross bands on their upper torsos.

The hieroglyphs identifying the names of the figures serve as a visual substitute for the lower half of each figure's body, and the name is in an oval surrounded by an aerial view of a city with a fortified wall.[15] Thus each of the nine bows represents a personified place. As such, it would make sense if Nubians were drawn with Nubian features and Levantines were depicted as Levantines.

It seems that when an artist does not represent the figure with the physical features that would match the name, a Levantine figure is depicted in its stead. I propose that this is due to the fact that in hieroglyphs the determinative for enemy is a Levantine.[16] It is therefore likely that in the Egyptian worldview a

Levantine figure can serve as a symbol for the idea of 'foreigner'. Thus, the long-haired Levantine can be used as a symbol for 'foreigner' even if the foreigner name is Nubian. This explains the strange images from TT 57, where all foreigners, save one, are represented as Levantines (see Fig. 17). Also interesting are the images of Upper and Lower Egypt, which are depicted as Nubians and Levantines, respectively. This is probably due to the likelihood that the nine bows were conceptually equated with foreigners. Interestingly, the bald Levantine, a frequent figure in tribute bearing scenes, is not depicted in the conventional nine bow motif from the same time.

Fully human captives

I use the term 'fully human' to contrast these images to those of the anthropomorphic crenellated ovals, discussed above. The foreigner types in these images include Nubians, Levantines and Libyans. In Theban tomb paintings, foreigners are depicted on royal palatial objects in a number of different, fully human, forms. These images show the foreigners kneeling, hunched over and lying down. The figures that are lying down appear as if they are standing because they are drawn from an aerial view.

Analysis of these individual motifs within the kiosk scenes shows that they are never represented in exactly the same way, even within the same tomb. For instance, in the tomb of Sobekhotep (TT 63), the bound foreigners on the left wall on the throne dais are lying down while those from the dais on the right wall are represented in the conventional nine bows motif.[17] The manner in which the foreigners are represented is often a matter of choice and creativity either by the artists working on the tomb or the tomb owner. This observation is applicable to other royal (non-foreigner) motifs represented in the kiosk scenes as well. The artist is not recording what is physically present in the audience hall of the king, but is instead creating new combinations of appropriate royal motifs, expressing creativity within a limited range of canonical image types.

One of the best known of these image types is on the kiosk from the tomb of Anen (TT 120) (Pl. 7). This is the only extant example where the foreigners include the Aegeans and Libyans. It is also the only fully

human captives example that labels the foreigners. They are: *Senger (sngr)*, *Kush (kꜣš)*, *Naharin (nhrn)*, *Irm (irm)*, *Keftiu (kftyw)*, *Iwntiw-Sti (iwntyw-sti)*, *Tjehenu (t̲ḥnw)*, *Shasu (šꜣsw)* and *Mentiu Setet (mntyw-stt)*. The place names from the tomb of Anen incorporate earlier nine bow names, but do not include Upper and Lower Egypt. This scene brings the names of the nine bows motif up to date and it also depicts foreigners in completely human form, in contrast to the conventional nine bows motif. It should be noted that this innovation is only found in the one tomb and that the conventional nine bows motif was far more common, perhaps because of its implied link to the past.

In addition to motifs that decorate the dais, foreigners are also represented on royal furniture as captives that are bound and trampled by the king. Actual extant examples of palace-related artefacts with captive foreigners are discussed later in this chapter.

A motif consisting of a paired Nubian and Levantine was used in a royal context to imply Egyptian authority south and north of Egypt proper. One way the Egyptians viewed their world was through dualities. In fact, nouns in the Egyptian language included a dual form, in addition to the singular and plural. Concepts of duality also naturally embodied the concept of balance (or *maat*) in the ancient Egyptian worldview.

One way these dual, contrasting foreigners were incorporated into royal iconography is in an extended *sema tawy* motif (Fig. 18).[18] Here the conventional image of the uniting of south and north Egypt is merged with the figures of southern and northern foreigners, a Levantine and Nubian. The *sema tawy* symbol is composed of the Upper Egyptian sedge flower and the Lower Egyptian papyrus tied around the lung and windpipe hieroglyph writing 'union'.[19] This motif indicated the political entity of the Two Lands made up of Upper and Lower Egypt.[20] Like the anthropomorphic crenellated ovals discussed above, when this image incorporates foreigners it expands upon the concept of the king's rule over northern and southern Egypt. The sedge and papyrus, symbols for Upper and Lower Egypt, are also often used to bind the foreigners, and they are also found in other images of bound foreigners, such as in the tombs of Sobekhotep (63), Anen (120) and 58 (name unknown). In the images analysed for this study, the extended *sema tawy* motif is found in between the legs of the throne.

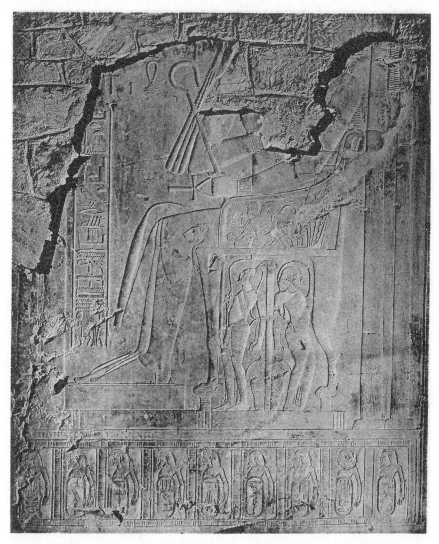

Figure 18 Extended *sema tawy* motif from TT 57 Khaemhet. Wreszinski, Walter. *Atlas Zur Altaegyptischen Kulturgeschichte*, 88b.

In TT 192, the *sema tawy*, conventionally a kingly motif, is appropriated by Queen Tiye (Fig. 5). Between her chair legs a Nubian woman and a Levantine woman are bound to the lung and windpipe sign by sedge and papyrus plants.[21] Another anomalous extended *sema tawy* motif is from TT 155, where the image appears next to the striding tomb owner on the inner entrance in the

tomb (not the focal wall). The extended *sema tawy* on the south depicts the Nubians. The one on the north has two Levantines.[22]

An additional royal motif involving foreigners found since Egyptian prehistory is that of the smiting motif, as seen in the iconic, predynastic, Narmer Palette (Fig. 1).[23] On the reverse of this object, the king strides forward and grabs the hair of the captive, while holding his arm above him to swing the mace and smash the head of the foreigners. Here too, the king physically destroys and dominates the foreigner, reinforcing the notion of order over chaos and of the king's dominion over the world and its people. The smiting image, popular on temple pylons, occurs on the throne dais only in tomb 48.[24]

The numerical importance of two and nine have been explained, but occasionally there are groups of three foreigners, as seen on the throne arms in tombs 48 and 120. In tomb 120, the three foreigners consist of the standard dual, the Nubian and Levantine with the addition of a Libyan.[25] This is one of the few instances in which Libyans are shown in early eighteenth-dynasty Theban tomb paintings. In TT 48 there is a Levantine with a pair of Nubians under the paws of the sphinx.[26] For ancient Egyptians, the number three represented a plurality, as three is the smallest number that can grammatically represent a plurality in Middle Egyptian. Further, three sides of Egypt were bordered by foreigners – the south (Nubians), north (Levantines) and west (Libyans) – and these foreigners could be depicted as iconographically distinct. In images of the king as a sphinx who is trampling foreigners, they are shown in various contorted positions indicating the absolute dominion of order over chaos (Fig. 19).[27]

In the tomb paintings under study, there is only one instance where the queen has appropriated this motif. In TT 192, on Queen Tiye's throne arm there is a sphinx with the head of Queen Tiye who is trampling a female Nubian and Levantine. This is the only image of a sphinx trampling two foreigners in this study (Fig. 5).[28]

Associated motifs

I have already discussed the relation between the *sema tawy* motif and the extended *sema tawy* motif, but there are other relatively common royal

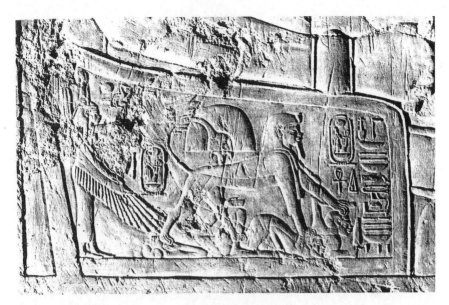

Figure 19 Trampling sphinx from TT 48 Surero. Säve-Söderbergh, Torgny. *Four Eighteenth Dynasty Tombs* (Private Tombs at Thebes, 1), pl. XXXV

decorative patterns that are easily exchangeable with foreigner figures. Since this is not a study and catalogue of palatial decoration, I will point out only a few examples.[29]

Instead of the various manners in which foreigners can be represented in this space, discussed above, it can also be filled with other conceptually similar motifs. Two particularly striking examples of this are on the throne dais and/ or royal footstools. One of these is the praising *rekhyt* bird (Fig. 20).[30] The *rekhyt*, or lapwing, is a symbol representing 'mankind'.[31] In TT 78, the tomb of Haremheb, the *rekhyt* are shown with arms before them in a sign of praise as they face a hieroglyphic epithet for the king.[32] This imagery would have evoked the idea of adoration by all *rekhyt*. In tomb 192 the *rekhyt* are shown adorning the kiosk within the symbol for *maat* (order), though accompanying text states that the chiefs of foreign lands are praising the king.[33]

Another example that is interchangeable with that of captive foreigners is a row of specific hieroglyphs. One example of this motif is on the royal dais in tomb 78 where there is a repeating pattern of two *was* sceptres, and an *ankh* over a *neb* basket (see Fig. 20). In Egyptian this reads 'all dominion, life and dominion'. These concepts of life (vitality) and dominion are necessary aspects

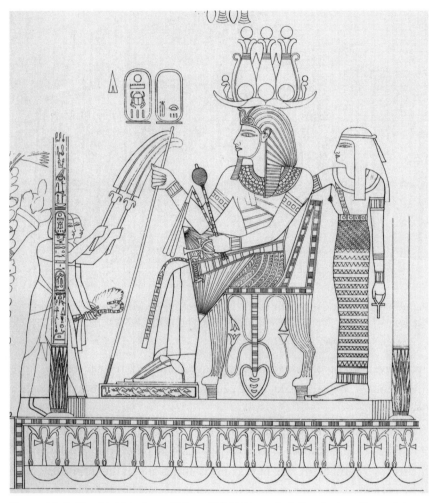

Figure 20 *Rekhyt* bird kiosk motif from TT 78 Haremheb. Brack, Annelies and Artur. *Das Grab des Haremheb Theban Nr. 78*, pl. 86. Image courtesy of Deutsches Archäologisches Institut, Cairo.

that a king must have to rule Egypt. Like the images of foreigners, these hieroglyphs reinforce the king's role in the Egyptian worldview.

Surviving palatial objects

A number of examples of actual palaces and royal items have survived. In New Kingdom palaces, at Malkata and elsewhere, images of bows alternate with

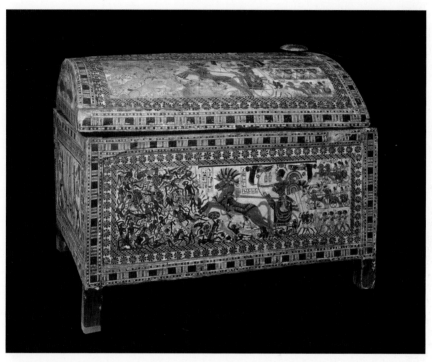

1 Decorated chest from King Tutankhamun's tomb. Image 436918 Purchased from Art Resource, New York.

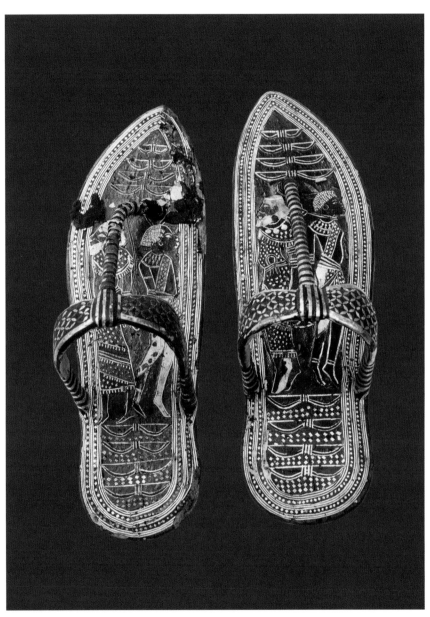

2 Sandals of King Tutankhamun. Image 125785 Purchased from Art Resource, New York.

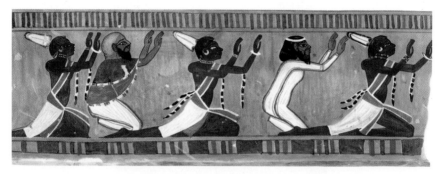

3 Nubian and Levantine people types from TT 226 (name unknown), Davies, Nina M. and Alan H. Gardiner. *Ancient Egyptian Paintings*, Vol. 2 pl. LVIII. Image courtesy of the University of Chicago Press.

4 Nubian woman with child from TT 81. Ineni. Dziobek, Eberhard. *Das Grab des Ineni: Theben Nr. 81*, pl. 1A. Courtesy of Deutsches Archäologisches Institut, Kairo.

5 Nubian woman and children from TT 63 Sobekhotep. Chic Photo 10342 B_S10513. Courtesy of the Oriental Institute of the University of Chicago.

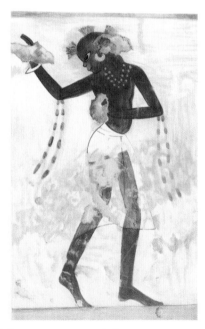

6 Nubian dancing girl from TT 78 Haremheb. Davies, Nina M. and Alan H. Gardiner. *Ancient Egyptian Paintings*, Vol. 1 pl. XL. Image courtesy of the University of Chicago Press.

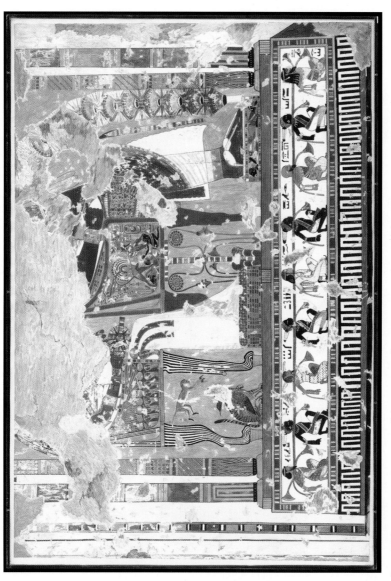

7 Kiosk scene from TT120 Anen. Courtesy of the Metropolitan Museum of Art, Open Access for Scholarly Content. www.metmuseum.org.

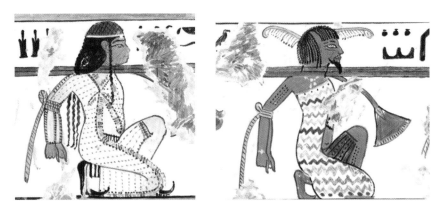

8 Libyan and *Keftiu* people types from TT 120 Anen. Courtesy of the Metropolitan Museum of Art, Open Access for Scholarly Content. www.metmuseum.org.

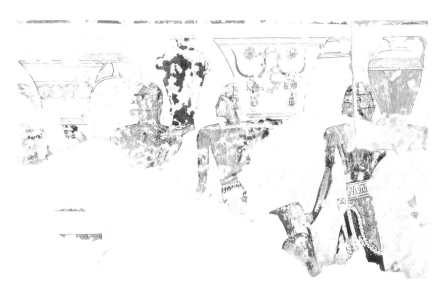

9 Aegeans from TT 71 Senenmut. Davies, Nina M. and Alan H. Gardiner. *Ancient Egyptian Paintings*, Vol. 1 pl. XIV. Image courtesy of the University of Chicago Press.

10 Restoration drawing of the coloured stairway at Malkata. Watanabe, Yasutada and Kazuaki Seki, *The Architecture of 'Kom el Samak' at Malkata-South: A Study of Architectural Restoration*, Studies in Egyptian Culture, pl. 3. Copyright the Institute of Egyptology, Waseda University, used with permission.

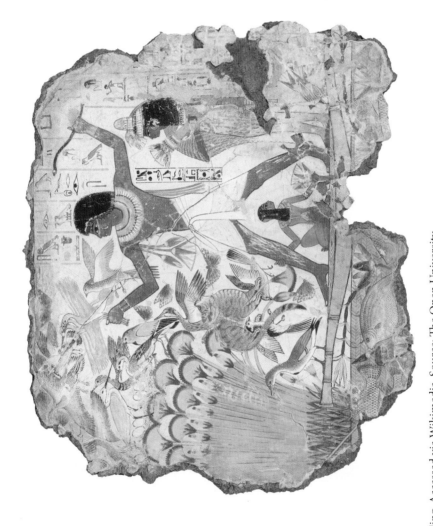

11 Nebamun fowling. Accessed via Wikimedia. Source: The Open University.

those of foreigners in the decoration (Pl. 10),[34] showing how interchangeable these two images were conceptually. In the example from Malkata, two bows are depicted on one step and the foreigners on the alternating steps. Both image types, the bows and the foreigners, are red and white with a light orange background. They are approximately the same size, and they are clearly meant to complement one another.

Other examples include Thutmose IV, in sphinx form, trampling foreigners on a once gilded throne arm (Fig. 2). There are also sandals (Pl. 2), footstools (Fig. 21), canes and chariots[35] with images of captive foreigners from the tomb of King Tutankhamun.[36] Such objects invoke the Egyptian idea that 'Every foreign land is under your (the king's) sandals.'[37] Though palace decoration does not often survive, there are intricate polychrome inlaid tiles depicting various foreigners from the royal palace of Ramesses III at Qantir and Medinet Habu.[38]

Not much palatial decoration and kingly regalia survives from ancient Egypt. However, it becomes obvious from these Theban tomb paintings and surviving palatial artefacts that the various foreigner motifs would have been a prevailing theme in royal iconography. Further, because of the exoticism of these foreigners, and the violent and creative ways that they were rendered, they would have drawn the attention of the ancient viewer. These captive images, in both the tomb and palatial contexts, would have captured the imagination of the elite Egyptian viewers.

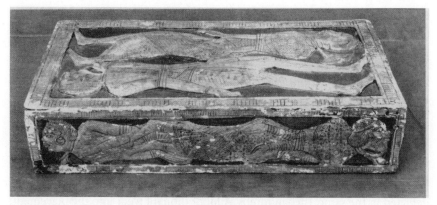

Figure 21 Footstool from King Tutankhamun's tomb. Eaton-Krauss, Marianne, Walter Segal and Institute Griffith, *The Thrones, Chairs, Stools, and Footstools from the Tomb of Tutankhamun*, pl. LXX. Image courtesy of the Griffith Institute.

The purpose of audience halls

One aspect of kingship, at least in the eighteenth dynasty, was the spectacle of the king in his palace, seated upon his dais in his throne room, which was decorated with captive foreigners. Depicted in the Theban tombs, these 'places of audience' were where the king would have received delegations of foreigners, and presumably Egyptian officials as well. The king would have been lifted up on his dais and would be destroying foreigners simply by virtue of where he was seated. This placement of the king was an intentional display of wealth and power.

However, no two throne rooms are depicted in the exact same fashion in the tomb scenes, which leads me to conclude that the artist could be creative within certain bounds. It is also possible that the artist had never actually seen the throne room, but had heard of the motifs used to adorn the royal palace. As is often the case in ancient Egyptian art, value is placed on the conceptual and not the perceptual when illustrating actual events, people and places. Emphasis on the concepts and not the way that objects and people were visually perceived is further explored in the next chapter on foreign tribute scenes.

The throne room in the palace was created to display the king. Captive foreigner images on the dais, throne and royal accoutrements served this purpose. For both foreigners and Egyptians the images reinforced the king's divine aspect and dominion over all peoples, and, for foreigners who viewed the royal captive foreigner motifs in the palace, the imagery was also a royal threat. The imagery conveys the idea that if anyone does not obey the king, then they will be destroyed. Indeed, such palatial iconography might have played a role in the atmosphere of the king's dealings with foreign delegations. For Egyptians, the spectacle of the king overcoming chaos and providing order was reassuring; it showed that the king was fulfilling his role in the universe. Such images were interesting to the viewer because of the exoticism of the foreigners themselves. The captive foreigner images displayed different hairstyles, skin colour, attire and accessories than were worn by Egyptians depicted in the same Theban tombs. A lot of thought went into the placement, meaning and impact of these captive foreigner images that adorned the king when he needed to be the most powerful – when he gave audience.

Conclusions

The individual features of the figures on the conventional nine bows motif do not always correspond with the names that identify them.[39] For instance, the *Sekhetiu-im* peoples, from the oases, are often represented with a beard, long hair and a fillet, traits that are used to represent Levantines. In fact, this Levantine type was also used to represent the *Tjehenu* (Libyans) in TT 93, TT 57 and TT 55. The Libyans are represented with a side-lock in TT 192 and with both a side-lock and straps that cross over the chest in TT 48. Another group that should not be represented as Levantine, the *Iuntiu-Setet*, who lived south of Egypt, show a similar discrepancy, with two of the six extant images of these people represented as Levantine, though we know they were Nubian.[40] The most likely conclusion is that the visage of a Levantine was a symbol for 'foreigner' in the ancient Egyptian schema. Levantines were more exotic as they were from a more geographically distant locale than the Nubians. This explains the often inaccurate attribution of traits to the foreigner types in images of the conventional nine bows.

The Egyptian artists and draughtsmen worked within a set of conventions, though the people who planned the tomb's imagery could choose from an array of motifs that were interchangeable with one another. On a larger scale, foreigner motifs on the throne dais could be substituted for lapwings on *neb* baskets or the *ankh*, *was* and *djed* frieze or two *was* sceptres and an *ankh* over a *neb* basket. Each visually different motif had a similar meaning: that the king was the ultimate ruler of everyone, his reign was stable, and that he maintained *maat* in the universe.

Looking at this set of tombs and the images that decorate them, it can be concluded that the captive foreigners motif was used in royal contexts. This decorative subject illustrates a concept of kingship and thus would have adorned the audience hall, the dais, shoes, walking sticks and other royal accoutrements. Through the act of sitting down on his dais, or even walking, the king is participating in symbolically crushing his enemies, is ruling all of the peoples in the world, and is maintaining order in the cosmos.

The concept of the conventional nine bows, which represented all of Egypt's enemies (including Upper and Lower Egyptians), is a motif that dates back to the beginning of pharaonic Egypt. The conventional nine bows image used in

early eighteenth-dynasty Theban tombs incorporates old groups of peoples, perhaps connecting the reigning king to his forefathers.

As for the other foreigner groupings of fully human captives, they were almost exclusively Nubian and Levantine. Of the extant anthropomorphic crenellated ovals, approximately ten of them have Nubian attributes, forty-two have Levantine attributes and three are identifiable as Libyans. Of fully human captives, approximately twenty-eight are Nubian, twenty-nine are Levantine and only two are Libyan. The Egyptians rarely represented the Libyans in the context under study, as the focus seems to be on expanding the boundaries north and south. They seem to be endlessly interested in coming up with different ways to bind and trample the foreigners. In the examples above, defeated foreigners are represented as controlled chaos (*isfet*) bounded within the constraints of *maat*, a concept that was sometimes made so explicit that the foreigners on the dais were represented within the actual hieroglyphic symbol for *maat*.

Within the time period under study, in these scene types, Nubians are represented in an almost uniform fashion, whereas there are more variations among the northerners. Of the Levantines, there seem to be two dominating types, one bald and bearded and one with long hair and a beard. These two also wear different attire. The bald figure usually has a shawl wrapped over his shoulder and the figure with the long hair is usually wearing a long sleeved galabeya without the shawl. I would argue that these two types show a range of how Levantines could look in real life. The differences are not associated with specific locales.

Images of the conventional nine bows and the bound or trampled foreigners on the throne dais seem to be completely interchangeable. At the outset of this study I was hoping to identify the decorative scheme of the audience palace of different kings, or perhaps to recognize a few royal kiosks that were used within specific reigns. However, the artists created something more complex than a simple reconstruction of a kiosk within an audience hall. No two kiosk, dais and throne combinations are represented in the exact same way. It seems as if the artist or the tomb owner commissioning the work could choose from a set of appropriate motifs.[41] For example, instead of the conventional nine bows, there could be thirteen figures, or pairs of bound standing Nubians and Syrians, or nine contemporary people types, or prostrate Nubians and Syrians.

These different motifs relay the same message but show the creativity and innovation of the person who designed the royal kiosk scene. As long as the message that the king has dominion over everything is expressed, it can be constructed in myriad different fashions.

Underlying Egyptian Concepts in Tribute Scenes

A note on the term 'tribute'

The purpose of this chapter is to examine the 'tribute' scenes with specific attention towards their context and function. It is important to note that the word 'tribute' is only a rough English translation of the Egyptian word *inw*, which is better described as 'free gifts irregularly delivered and repaid by a counter gift'.[1] In this study I employ ancient Egyptian ideology and iconography to interpret these images. To understand tomb paintings of foreigners it is important to note their physical location, why these tomb scenes were created, and relevant ancient Egyptian concepts.[2]

Exchange in the tribute scenes

The early eighteenth dynasty was a time of imperialism and expansion for ancient Egypt, as documented in an official Egyptian perspective in the annals of Thutmose III.[3] During this time foreign delegations were represented on tomb walls before the king or the tomb owner, his proxy. The members of the foreign delegations are depicted in the same poses as ancient Egyptian 'offering bearers'. In both instances the figure strides forward, with his legs apart, while holding an offering, often a jar. This would have likely reminded the Egyptian viewer of the term *inw* written with a jar surmounting a pair of striding legs underneath �. The *inw* brought to the king in these scenes likely implied the notion of *do ut des*. The tomb owner is shown facilitating gift giving to the king in order to obtain provisions and protection from the king

in the afterlife. In the standard funerary offering formula, it is the king who gives the provisions for the deceased.[4] Though the foreigners are giving gifts to the king, it is the tomb owner who expects to receive the king's favour back in return.

Another, less visual commodity that plays a role in these scenes is 'the breath of life'. In a number of tombs, the textual caption explains that the tribute is given to the king in exchange for the 'breath of life'.[5] Hartwig states that the breath of life is 'related to the life given by the king who sanctioned foreign rule, economic health, and, if the subject nations shared the Egyptian world view, their well-being in the hereafter through the role of the king'.[6] This same breath of life is given to the king by the gods and is distributed to the orderly Egyptians as well as foreigners.[7] Of course, this was an Egyptian concept and foreigners would hardly have subscribed to this belief. The foreigners in the tribute scenes are depicted acting in accordance with the Egyptian view of an orderly world, where the king rules all people.[8]

Symbolism in fishing and fowling scenes

One example of scenes that occur on focal walls shows the tomb owner hunting fish with a spear and birds with a throw stick (for a fowling image see Pl. 11). These images have many underlying conceptual similarities to the tribute scenes. Although such images may represent the procurement of provisions for the afterlife and the family's status as members of the ancient Egyptian elite,[9] the scenes are also heavily laden with symbolism connected to the afterlife.[10] The scenes are set in the marsh, a place associated in myths with Hathor, the goddess of sexuality, birth and regeneration.[11] To the Egyptians the marsh evoked the primordial mound, the mythical place where life began.[12] The killing of birds with a throw stick represented the ancient Egyptian belief of order triumphing over chaos. The birds represent chaos and are being destroyed to maintain order in the universe.[13] This maintenance of order was important within the tomb context, as the tomb owner desired a smooth transition into the afterlife. The Egyptians believed that after death a person had to pass a number of tests to enter into an orderly underworld. Otherwise they would be eternally tormented by demons.[14]

The fish being speared in the fishing and fowling scenes are tilapia and Nile perch. The perch was mythically associated with the goddess Neith, who transforms into one of these fish in the story of the primordial mound.[15] The tilapia was also associated with rebirth and fertility, likely because it broods in its mouth.[16] Through various ancient Egyptian myths, tilapia were also associated with the creator god, Atum, the goddess Hathor, and, through their red colouring, the sun. Further, tilapia were mentioned in the *Book of Going Forth By Day*, as a fish that the deceased would see while sailing through the afterlife with the sun god.[17] Male figures in the fishing and fowling scenes hold a throw stick while the females hold either a small chick or a water lily. Such objects refer to the fertility and regeneration of males and females, which guaranteed the regeneration of the deceased within his tomb.[18]

Visual word play is also an aspect of fishing and fowling scenes.[19] Hurling a throw stick is equated with the hieroglyph used in the Egyptian word for 'beget' or 'create', ḳmꜣ. The word for 'to spear' is similar to the Egyptian word sti, to impregnate.[20] This and the woman's transparent gown indicate the sexuality and fertility of the tomb owner's wife, concepts that would have been important in the death and rebirth of the deceased into the afterlife.[21] Other symbols of regeneration and rebirth include pintail ducks.[22] Such symbolism was regenerative in nature and promised rebirth and regeneration in the afterlife.

I propose that, like the fishing and fowling scenes, images of foreigners bringing tribute carried meaning for the deceased. First, they often show the tomb owner in the presence of the king, thus displaying his high status to the viewer; or if the king is not present, the tomb owner is in the space where the king would be depicted. The tomb owner's status is further enhanced by his proximity to expensive foreign goods that are brought to the palace, and his role as intermediary between the king and the foreign tribute bearers. Further, the triumph of order over chaos represented by the subjugated and submissive foreigners reflects the desired restoration of order following the chaos brought by death. Cosmic order must be re-established so that the tomb owner can pass through death into a new life. Though many scholars have deciphered the symbolism of birth and rebirth in the 'daily life' scenes, the tribute scenes were also rich in abundant visual symbolism for the ancient Egyptian viewer. However, these scenes have never been looked at as symbolic,

and their placement and function within the Theban tombs has not been thoroughly discussed.

Visual organization of tribute scenes

In most early eighteenth-dynasty Theban tombs the foreigners are divided by people types and placed in different registers. The most frequent foreigners shown in these scenes are Levantines and Nubians, though the Aegeans are often pictured as well.[23] Less common are registers of Puntites, oasis dwellers, and the people from Wat-hor. When separated onto two walls, the southern people appear on the left focal wall, the northerners on the right. In this way the tomb is aligned with the cardinal directions, with the southerners on the south and the northerners on the north wall. As the tomb visitor walks into the tomb they are heading west, the direction associated with death in ancient Egyptian ideology. In her master's thesis, Victoria Russell states that 'people who are farthest away from Egypt are depicted in registers above those people who are closer to Egypt'.[24] She adds: 'in cases where peoples from both the north and south appear on the wall, the people who normally would be assigned to the wall are depicted in registers above those people who typically appear on the opposite wall'.[25] After the reign of Amenhotep II, only Nubians and Levantines are shown in tribute scenes because they form a perfect conceptual duality representing south and north and extending the duality of Upper and Lower Egypt.

Within each register there is generally a hierarchical ordering of people and objects according to the Egyptian ideological worldview (for an example see Fig. 22). The first component of a tribute scene is usually a pile of offerings. At the front of the delegation is the most important figure, usually the *wr* or chief. Following him are other men in varying attire. Behind the men are the women and children, who follow the animals that the men in front of them carry or lead on a leash.[26]

Tribute scenes thus display Egyptian value judgements. The most important element in these scenes is the pile of offering goods, then the high-ranking men, lower ranking men, women and children. Additionally, such a visual layout would accentuate the most essential aspects of the composition to the

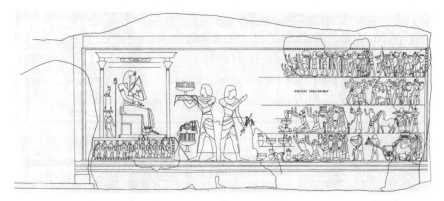

Figure 22 Tomb wall layout from TT 63 Sobekhotep. Dziobek, Eberhard and Mahmud Abdel Raziq, *Das Grab des Sobekhotep, Theben Nr. 63 (AV 71)*, pl. 34. Image courtesy of Deutsches Archäologisches Institut, Cairo.

Egyptian viewer. When light entered the tomb from the door it would illuminate the king or tomb owner, who was on a much larger scale than the foreigners and their goods. The viewer would then see the luxury goods and chiefs in the front of the register. The remaining part of the register was viewed in diminishing light as the eye moved from the centre to the periphery of the wall. The composition and natural lighting worked to enhance the aspects of the painting that were the most significant for the ancient Egyptian viewer.

Another interesting aspect of the arrangement of these scenes is the fact that all foreigners are shown in the same relationship with the king. This, of course, was not the case in reality. For example, the Aegeans had a very different political dynamic with the Egyptian state than the Nubians or the Levantines. However, the Egyptians rendered all foreign peoples equally in their relationship with the king. Foreigners are shown as always being subservient, in adherence to their worldview. The Egyptian king is the ruler of the whole world.

Foreigners as agents of chaos

The ancient Egyptian elite used images of foreigners to decorate household items and adorn their tomb walls. The household items represent foreigners as servants, bringing something for the elite Egyptian or the Egyptian

king. Foreigner images were symbols of luxury and exotic goods, and were physical manifestations of a fascination with the 'other'. O'Connor makes the argument that foreigners, who are inherently chaotic beings, according to Egyptian ideology, contain a kind of transformative power.[27] When the owner of the decorated cosmetic container applies the make-up, s/he is using the transformative nature of the chaotic foreigner to transform her- or himself into the physical Egyptian ideal, which conformed with *maat*, or order. Therefore the elite Egyptians are using the transformative nature of chaos, through cosmetic containers in the likeness of foreigners, to create *maat*.

Tribute scenes, found in the tombs of elite Egyptians, likely acted in the same fashion. These foreigners overcame their own inherently chaotic nature to function within the orderly confines of the Egyptian state. To the ancient Egyptian, tribute scenes acted as a metaphor for the Egyptian tomb owner who overcomes the chaos of death to enter the orderly afterlife.

If foreigners were symbols of chaos, then they must be contained within the liminal and transformative area of the tomb, to protect the tomb owner. This is the case with the captive foreigners on the focal walls (as explained in Chapter 5). As can be seen as early as the Pyramid Texts, potentially dangerous hieroglyphs were apotropaically rendered harmless to the deceased. At certain periods and in certain contexts hieroglyphs whose images could cause harm, such as snakes, were drawn so that they were cut with knives.[28] The purpose of such mutilations was to render the potentially dangerous visual element impotent within the space of the tomb.[29] It is therefore likely that the Egyptians would only paint images of foreigners in their tomb if they were acting within the constraints of order and were not chaotic and potentially harmful to the tomb owner.

Dancing girls

Though only small details in much larger scenes, it should be noted that nearly naked dancing adolescent girls, such as in those from the tomb of Haremheb (Pl. 6), served as symbols for sexuality in these tomb scenes. In the example from TT 78 Nubian girls are part of a scene that shows the opulence and

abundant resources of ancient Nubia. I single out one of the girls in the painting, the third female figure in this scene, because her face is preserved. This girl is rendered with three puffs of hair, a dark reddish brown skin colour, two necklaces, hoop earrings, a bangle bracelet and streamers that hang from her elbows, two on each side. She is topless and wears a loincloth overlaid with a transparent skirt.

Other nearly nude dancing adolescent girls from the banqueting scene on the focal wall of Nebamun's tomb have been interpreted as symbols of sexuality. Indeed, dancing itself was an action associated with Hathor, the goddess of sexuality, in ancient Egypt.[30] Additionally, topless or naked Egyptian girls are also shown on cosmetic accoutrements from this period.[31] These objects seem to be three-dimensional versions of the banqueting scene girls. Both tomb paintings and cosmetic accoutrements emphasize sexuality, an important theme in an Egyptian tomb because of the desired rebirth in the afterlife. Such naked female figurines can be shown with tilapia fish or ducks, both symbols associated with sexuality.[32]

Like the naked Egyptian adolescent girl motif, naked or nearly naked foreign girls can also be depicted on cosmetic accoutrements.[33] One such object shows a naked girl striding forward carrying an offering (Fig. 23). She wears her hair in three puffs and is shown with a monkey, another ancient Egyptian allusion to sexuality.[34] She is even made of ebony, an exotic material brought by Nubian tribute bearers in Egyptian tomb paintings.

Such cosmetic items should be considered in the genre that shows foreigners and/or women carrying luxury goods. These women and foreigners are also three-dimensional renderings of the subjects painted on the focal walls of the Theban tombs, either banquet or tribute-bearing scenes. Therefore, this statuette is a three-dimensional embodiment of the aspects seen in the painting of the tomb of Haremheb (Pl. 6).

The Nubian girl statuette illustrates that the Nubian adolescent image, though a minor detail in the larger context of TT 63, shows that sexuality, and thus revivification in the afterlife, are intended messages conveyed through the tribute-bearer scenes. Such iconography was probably also incorporated in other tomb paintings that did not survive.

The Nubian naked girl motif is part of the larger conceptual system found in both tomb paintings and cosmetic objects from the eighteenth dynasty. The

Figure 23 Nubian girl statuette (Object 14210). University College London Petrie Museum of Egyptian Archaeology. Copyright: Petrie Museum of Egyptian Archaeology, University College London.

tomb paintings display foreigners not as they appeared in reality, but rather as they should appear in order to enhance and conform to Egyptian ideological perceptions. The foreigners are forever in a state of service to Egypt, and if foreigners are not functioning as bringers of wealth then they must be destroyed. These images of foreigners act as spectacles to draw in the viewer through their un-Egyptian garb and physical attributes.

The 'international style' in Egypt, the Aegean and the Levant

During the Late Bronze Age, which overlaps with the earlier portion of the eighteenth dynasty, before the rule of Akhenaton,[35] there was an 'international' focus on prestige and foreignness, and an interest in obtaining precious materials from other locales. In a study of Late Bronze Age artistic motifs, Kantor discusses the 'international' style, which consisted of a frequent use of patterns from different cultures.[36] Such motifs include spirals, interlocked patterns, meanders and guilloches. Objects from the Levant, Aegean and Egypt also often incorporate figural representations such as lions, sphinxes, griffins and bulls. The bulls were symbolically important because they represented strength and fertility in Egypt, the Aegean and the Levant.[37]

The objects with these specific motifs were fashionable at the time internationally because they represented opulence and foreigners.[38] Indeed, the tribute scenes in the Theban tombs represent the international ideas of the importance of luxury and foreigness. These scenes also portray Egyptian ideology, like the importance of order overcoming chaos, and rebirth in the afterlife. Archaeologists debate how actual foreign goods related to these images. In this study, I suggest how these images functioned within the tomb context, and what these paintings meant to ancient Egyptian viewers, though it is important to recognize that they are part of an international system as well (as will be discussed in more depth in Chapter 8).

Another iconographical issue related to the international style is that of 'hybridism'. Feldman points out that hybridity of foreign motifs helps form the international koiné (a more nuanced form of the 'international style') in her chapter on 'the role of visual hybridity'.[39] It should therefore be noted that the hybridity in figures on the Theban tomb walls (discussed below) is within the toolkit and conventions of the artists familiar with the international artistic styles and practices that were common in the Late Bronze Age.

Hybridism

As mentioned above, one major issue in reading tribute scenes is 'hybridism', where foreigner attributes are mixed within a single figure.[40] For instance, in

the tomb of Menkheperrasonb, the Aegeans (*Keftiu*) and Levantines are difficult to differentiate because their traits are combined.[41] Additionally, the chiefs are labelled inaccurately at the front of the register, so that a man captioned as *Keftiu* is depicted with iconographically Levantine attributes (Fig. 24). Although it is tempting to think that the labels correctly identify the figures and that the figures represent the national garb and coiffure thus identified, this is clearly not the case. The primary function of these images is to portray foreigners giving offerings to the king. The offerings, themselves, are meant to be the focus of this register. As for the foreigners, since

Figure 24 Hybrid figures from TT 86 Menkheperrasonb. Davies, Nina M. and Norman de Garis Davies. *The Tombs of Menkheperrasonb, Amenmose, and Another*, pl. IV.

identification and accuracy are not the primary function of these images, the conflation of people types from the Aegean and the Levant does not seem to be problematic as the images were meant to display the idea of 'foreignness'.

As has been discussed in Chapter 4, Levantines can be used as the symbol for 'foreigner' in ancient Egyptian representations. Thus, it is not fruitful to look at these images through a historical lens, without consideration of their function. The purpose of these tomb walls was not to represent reality, but to show the king's dominion over all foreign lands in accordance with order (*maat*), a task that does not necessitate historical accuracy.

Captive and tribute-bearer motifs in the same tomb

On the right focal wall of Sobekhotep (see Fig. 22) and Haremheb's tombs (63 and 78 respectively) the tribute bearers are confronted with the images of bound and trampled Levantines.[42] These scenes show the contrast between foreigners as chaotic elements that have to be bound and trampled, and foreigners who are unrestrained and praising the king, who are ordered by being lined up in registers. Having been 'conquered' by the king, they are transformed into orderly suppliers to the state. This shows the contrast between the traditional image of a foreigner as a royal decorative motif and the newer, more cosmopolitan understanding of foreigners as contributors to the state.

In TT 90, the tribute scene is unusual as there are captive foreigners along with tribute bearers. Here the tomb owner is holding leashes for two rows of captives represented on the first and second register. These captives may be prisoners from battle, referents to Nebamun's military career. As in TT 63, the Nubians are placed in registers above the Levantines. Then following immediately the group of bound foreigners in the second register is a man who is prostrating. This compositional structure parallels numerous other tribute scenes, except that the captive Nubians and Levantines fill the space where the pile of offerings is usually located. It is interesting that even as captives the southern and northern foreigners are separated. There the captive foreigners are obviously chaotic elements that need to be harnessed. This innovative wall painting shows the control of the tomb owner but disregards the usual placement of captives towards the end of the register. Here the captives are the offerings.

Funerary Symbolism in Tribute Scenes

Having established in Chapter 4 the way that Egyptian artists depicted the different people types, it is now necessary to turn our attention to what objects and animals the foreigners present in these tomb paintings. In some instances it is additionally possible to decipher what meaning these images had for the Egyptian viewer. For comparative purposes this section is first divided by place names, and then the goods that these people bring are identified. Each subsection concludes with a discussion of the possible symbolism that the objects and tribute bearers depicted represented to the tomb painting's intended audience.

These images of tribute-bearing foreigners have fascinated scholars and have served as the main source of information about various people types from this period. The problem is that these images have been analysed as historical records, though, like most Egyptian paintings, they reflect ideas through symbolism. I am therefore focusing this study on the symbolism of the objects and not their archaeological parallels. Vercoutter, Rehak, Laffineur, Wachsmann, Cline and Montet have already done this research.[1]

Since the oases, Wat-hor, Nubia, and Punt present objects that occur as natural resources, parallels cannot be identified as their tribute objects do not survive in the archaeological record. Therefore I will not address whether, in reality, the actual objects were presented to the king or tomb owner, whether these goods were produced by Egyptians or foreigners, or who the market for these objects would have been. That said, these depictions do reveal a separate set of information that the corpus of material addresses. How did the Egyptians rank various natural resources in accordance to value? Why did these foreigner scenes exist? What purpose did they serve to the Egyptian tomb owner?

Nubia (tombs 39, 63, 78, 81, 84, 89, 91 and 100)

Tribute goods

Nubian tribute bearers bring a variety of animals to present to the king,[2] including numerous baboons and monkeys.[3] There are also giraffes, bulls and dogs, some of which stick out their tongues, likely indicating that they are barking.[4] Other animal products brought by Nubians include ivory, assorted animal tails, ostrich eggs, ostrich feathers, straight feathers, cheetah and other animal pelts, and animal-skin shields.[5]

Large amounts of inorganic materials are presented in these scenes, such as gold and gold dust, bags of *dam* (fine) gold, *sty* ointment, green minerals (perhaps malachite) and red pebbles (which might be carnelian). Additionally there are numerous piles of raw materials carried in baskets that are unidentifiable due to the lack of a label or recorded colouring. Nubian figures in these scenes carry many bundles of sticks and stools of wood. When the colouring is recorded, the black wood is identified as ebony.[6]

Symbolism

While much ink has been spilled on Levantine and Aegean tribute scenes, little has been written about the Nubian ones. One aspect of Nubian tribute-bearer scenes, which occurs also in other tribute scenes, is that the first few figures are differentiated from the rest by their attire. In the fully intact Nubian tribute scene in the tomb of Rekhmire, the first two Nubians wear Egyptian kilts and fly of valour necklaces that differentiate them from the following Nubians in the rest of the register.[7] In tomb 78 the first two figures in the register are drawn on a much larger scale than the following Nubian tribute bearers (Fig. 25).[8] Such visual cues, seen repeatedly in the different foreign tribute bearer scenes, indicate that assimilation was an indicator of prestige and high status.

Frequently in these scenes gold and precious metals are represented in the Nubian register before the feathers, wild animals and wood. In TT 89, following the pile of goods are the individual offerings, and then the women and children are represented at the end of the register.[9] This shows that the

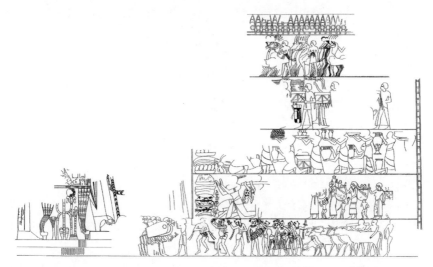

Figure 25 Register layout from TT 78 Haremheb. Brack, Annelies and Artur. *Das Grab des Haremheb Theban Nr. 78 (AV 35)*, pl. 87. Image courtesy of Deutsches Archäologisches Institut, Cairo.

Egyptians seem to place what they thought were the most valuable goods at the front of the procession, and the less valuable goods, or people, at the rear of it. Again, the prostrate Nubians at the front of the register are wearing the Egyptian kilt while the Nubians in the procession are wearing animal skin, or plain loincloths. This indicates that the Nubian leaders are depicted as Egyptianized, though the rest of the tribute bearers wear traditional Nubian loincloths. In this representation the children are quite active, waving their arms, a gesture that would cause the viewer to notice their active, if small, presence in the scene.

In Theban tomb 91 (Fig. 26) the foreigners are separated onto the right and left focal walls.[10] On the north wall, the soldiers surrounding the Levantines seem to be mostly Egyptians. On the south wall, the Nubian tribute bearers are similarly surrounded by the 'Egyptian' soldiers, but many of these seem also to be Nubian. It is well known that Nubians served in the military in ancient Egypt, and this shows the different roles that Nubians could play in making a contribution to the Egyptian state.[11]

In the Nubian tribute scene from TT 91 the Nubian men are divided into five registers. The men on the top level wear kilts, in contrast to the bottom

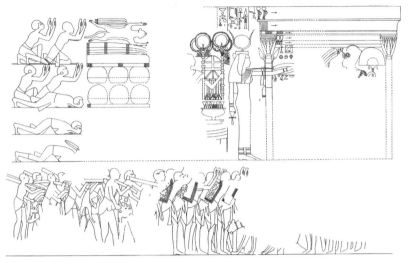

TOMB PAINTING AND IDENTITY IN ANCIENT THEBES, 1419-1372 BCE

Figure 26 Tomb wall from TT 91 (name lost). Hartwig, Melinda K. *Tomb Painting and Identity in Ancient Thebes*, fig. 31. Reprinted with permission from author.

register where the soldiers wear animal skins or plain loincloths. In the fourth register the Nubian figure is wearing a straight feather, a Nubian accoutrement, which is not seen on the Nubians in the top two registers. It is thus likely that these registers are relaying messages of status to the ancient Egyptian viewer. The first register shows Egyptian clothing on Nubian men, then leaders in Egyptian attire and Nubian (straight) feathers. The bottom row, where the army is depicted, shows Nubians in loincloths. This may show costume differentiation according to a hierarchy of status.

As discussed in the Levantine discussion section below, two physical types of Levantines seem to alternate. In Nubian scenes there is no such patterning, but in tomb 84 there is a wide variation in physical attributes in the Nubian tribute-bearing register, where there are white men, pink men and red men, having varying hairstyles with different hair colours.[12]

Women and children are most often depicted at the end of the register. Unlike the men in tribute scenes, the women are depicted in different attire based on their age and whether they have children. Adolescents in girdles likely indicate sexuality, as has been proposed in the interpretation of naked girls with girdles, depicted elsewhere, as in the tomb of Nebamun.[13]

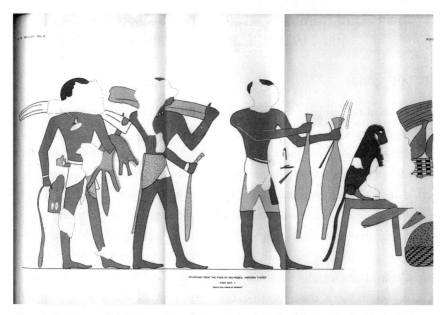

Figure 27 Front of Nubian register from TT 84 Amunedjeh. Müller, Wilhelm Max and Carnegie Institution (Washington DC). *Egyptological Researches 2: Results of a Journey in 1906*, 30.

An interesting detail from TT 84 (seen in Fig. 27) is that, immediately following the pile of offerings, in the place of a chief is a baboon sitting on a stool, which could allude to the myth of Thoth, who is a baboon in his animal form, and the story of his trip to Nubia.[14] It could also reference the way that the Egyptians thought of how the Nubian language(s) sounded. In a didactic ancient Egyptian text, a teacher admonished a student by saying, 'The ape understands words, yet is brought from Kush,' which Liverani interprets as 'the language of Nubians was unintelligible [to the Egyptians], like the jabbering of baboons.'[15] Another noteworthy aspect of these tribute scenes is that the tribute bearers hold leashes for wild animals, such as cheetahs, giraffes and baboons. Leashes are a means of controlling agents of chaos and these wild animals in a tomb setting are shown as being ordered and controlled. Similar imagery occurs on the obverse side of the Narmer Palette.[16] In TT 90 leashes are used to control the foreign captives who are being presented as tribute to the king.[17]

The Levant (tombs 39, 42, 63, 78, 81, 84, 85, 86, 89, 90, 91, 100, 119, 131, 155, 239, 256 and 276)[18]

Tribute goods

The Levantine animals brought to Egypt in tribute processions include elephants, bears, an ibex, horses and bulls. Also in tomb 42 there are two bulls that are expunged from the scene, both behind a man in a galabeya who holds a sheathed dagger. The elephants and bears in these scenes are on leashes. They are also shown in a very small scale, just reaching the men's knees (Fig. 28).

Only a few objects made from animals are depicted in Levantine scenes, including unworked tusks and worked horns, which are shaped to end in a hand or spoon. Other materials that the Levantines bring include silver, gold, lapis, *mfk3t* (turquoise), *men* stone, copper and wood. In addition to minerals and ointment horns, the Levantines bring many ornate metal vases.

These vessels are usually highly decorated and are often wide rimmed, with plants and plant stalks rising from the interior.[19] These plants can be identified as papyrus reeds, water lilies and poppies.[20] For example, one vase from tomb 100 (Rekhmire) in this category has a carinated base, a line of flower decorations around its neck, and flowers, stems and buds rising from the interior (Fig. 29).[21] Water-lily-shaped cups are also depicted in these tomb paintings.[22]

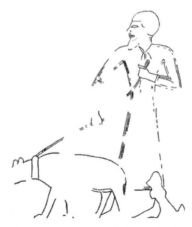

Figure 28 Bear on leash from TT 84 Amunedjeh. Davies, Nina M. 'Syrians in the Tomb of Amunedjeh', pl. XIII.

Symbolism

As discussed in Chapter 6, the most valuable objects are usually at the front of the register. Of all the vases that are depicted, one vase type is usually presented to the focal figure, either the king or the tomb owner, in the scene. On the vase from TT 84 (Amunedjeh) three poppy pods are clumped together on each side of the frog (Fig. 30).[23] On the ornately detailed vase from TT 86 (Menkheperrasonb), three sets of three stems attached to drooping buds adorn the rim and centre pedestal where the frog sits.[24] Hekat, the goddess of birth, was represented in frog form, and thus life, birth and creation were likely evoked through the image of a frog. This is an idea expressed by the image of a tadpole, the hieroglyph for the number 100,000. The frog and poppy vessel was an ideal offering in these tomb scenes that emphasize the death and resurrection of the deceased through other symbolic imagery.

The poppies portrayed on these marsh vessels are in three stages of life: the buds, which bend to the side, the flowers and the pods.[25] The Egyptian artist is showing the three life stages of one plant. Davies has identified the poppy pods as pomegranates. However, pomegranates grow from tree branches and the

Figure 29 Interior decorations on vase from TT 100 Rekhmire. Davies, Norman de Garis. *The tombs of Rekhmire*, pl. XXI.

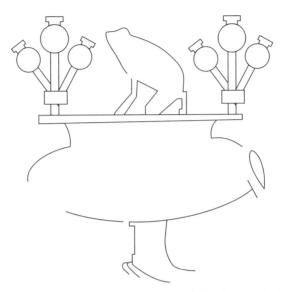

Figure 30 Poppy and frog vase from TT 84 Amunedjeh. After Davies, Nina M. 'Syrians in the Tomb of Amunedjeh', pl. XIII.

crown hangs toward the ground. Poppies, on the other hand, grow from stalks and the crowns are at the top.[26] It is possible that the Egyptians somehow equated Levantines with poppy plants, as they were imported to Egypt from the Levant in the early eighteenth dynasty. Poppies also produce copious amounts of seeds per plant, and they likely evoked ideas of fertility and procreation.[27] They are red flowers and thus likely evoked the associations of the sun and the solar cycle, a concept that was linked to rebirth in the afterlife in Egyptian myth. During the night the sun god, Re, travelled through the underworld fighting off demonic forces. Dawn was representative of the victory of Re over chaotic forces, the triumph of life over death.[28]

Papyrus reeds grow in marshy areas, and when liquid was poured into these vases, the plant stalks would seem to be coming out of a marsh, a clear allusion to the primordial marsh and the Hathor-in-the-marsh motif. Such ideas were associated with birth and regeneration in ancient Egypt.[29] The primordial marsh is a myth where originally, out of the watery abyss of nothingness came the generative god, Atum. This first deity was thus responsible for the creation of the world.[30] In the Hathor-in-the-marsh myth, the cow goddess could also

Figure 31 Vase with duck decorations from TT 89 Amenmosi. After Hartwig, Melinda K. *Tomb Painting and Identity in Ancient Thebes*, fig. 32. Reprinted with permission from author.

be the mother of Atum, again referencing the primordial marsh, life, birth and generation.[31]

Besides frogs, another symbolic animal depicted on vases presented by the Levantines are ducks. They are also animals that live in marshes and were associated with the inundation of the Nile because they migrated to Egypt every year during the flood. On some Levantine vessels the duck heads and necks form a row above the vase rim (Fig. 31). In ancient Egyptian art ducks have been shown to be symbols of fertility within a tomb context, as the inundation was related to the fertility of the land.[32]

Lions are another animal type depicted on these vases. In ancient Egypt the depiction of two lions, called *rutiu*, was thought to represent the horizon. Usually facing away from one another, the motif of two lions served as guardians to the entrance and exit of the underworld, through which the sun made its daily journey. The dead also had to enter through the passage to the underworld to be reborn. It seems likely that these lions within an ancient Egyptian funerary setting also evoke the symbolism of death and rebirth. However, heraldic creatures also tend to be an Ancient Near Eastern motif and lions are one type of international iconography that was popular in the Late Bronze Age, during the eighteenth dynasty. Therefore, these animals, depicted on rhyta in these scenes, likely evoked concepts of luxury and foreignness, as well as concepts of death and rebirth for the ancient Egyptian viewer.

In addition to wide-rimmed vases, lotiform chalices and lion rhyta, Levantine vessels can take many other forms including situlae, vases with

carinated 'fish fin' decoration, which could indicate the associations with fish seen in the fishing and fowling scene. One object with carination had a papyrus umbel foot (and perhaps handle ends). Many of the various vessel types are represented with bands of decoration, and these decorations consist of circular flowers with a dot in the middle or continuous spirals. In one scene (TT 239) the situlae are in the shape of *tyet* knots. In Egypt *tyet* amulets were used in funerary contexts and evoked protection from the goddess Isis. These amulets represented a red, knotted cloth that evokes the concepts of protection and life.[33]

Levantines and Aegeans are the only people types that bring weapons. In Levantine tribute-bearer scenes, the figures bring daggers, bows, arrows and quivers, falchions, swords and maces. They also bring battle equipment, helmets and chariot accessories. Chariots and horses were only owned by the very wealthy in ancient Egypt, and were thus status markers in these scenes.

Not much can be deciphered from the images of Levantine women in the tribute scenes because there is little variation in the way that they look. The women in TT 42, TT 100 and TT 81 wear long dresses with three tiers of fabric on the skirt.[34] Over their shoulders they wear a cape and they are always shown with long hair. When red-haired women are depicted they have lines on their faces, which do not conform to the ancient Egyptian ideal of beauty, where all individuals are shown with youthful, smooth skin. The same combination of features with lined skin and unkempt hairstyles are also seen in the red-headed Levantine men. It thus seems likely that the Egyptians did not find redheads aesthetically pleasing and emphasized these other unattractive traits on images of redheads. In fact, you can recognize redheads in black and white line drawings as the least aesthetically pleasing figure(s). This is perhaps due to the Egyptian association of the colour red with the concept of chaos.[35]

Sometimes the children in these scenes are shown with their hand to their mouth, the way that the ancient Egyptians depicted Egyptian youth. Levantine children in tomb scenes sometimes attract the viewer through emotional gestures. For example, in TT 81, a Levantine woman turns back toward her child, and another protects himself from the Egyptian soldier wielding a stick.[36]

The Aegean (tombs 39, 71, 85, 86, 89, 100, 131 and 155)[37]

Tribute goods

Few animal products are depicted in the Aegean tribute scenes, namely two horns and a tusk. Horns can be differentiated from tusks because they are more sharply curved.[38] Interestingly, one horn (in tomb 63) is decorated with the head of a woman wearing a feather representing the goddess Maat, the embodiment of order, the very concept that is being portrayed by the rest of the orderly figures on the tomb wall of foreigners. There are a number of different minerals that are brought, consisting of silver, lapis lazuli, turquoise, copper oxide ingots and beads.[39] In tomb 86 two strips of cloth with tassels are included as tribute.[40]

There are two statuettes represented in the Aegean tribute scenes (Figs 32 and 33).[41] Both are bulls, one galloping and the other standing. Other gifts in bull form are bull's head rhyta.[42] The horns of the bulls are portrayed in an Aegean manner, in a profile view.[43] Bull's head rhyta are also seen in T T 91 and 89 in the hands of Levantines, though Wachsmann attributes this to transference, not historical accuracy.[44] Jackal-head rhyta are represented in the tombs of Useramun, Rekhmire and Menkheperrasonb. Those in Useramun are white, possibly representing silver or alabaster, and the one in Menkheperrasonb is blue, indicating lapis lazuli.

Lion-headed rhyta appear in these scenes, coloured yellow, indicating gold,[45] and a lioness rhyton is part of the Aegean tribute in the tombs of

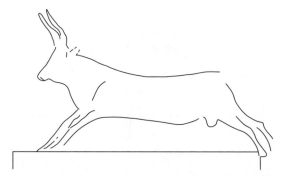

Figure 32 Galloping bull statuette from T T 131 Useramun. Dziobek, Eberhard. *Die Gräber des Vezirs User-Amun: Theben Nr. 61 und 131*, pl. 92. Image courtesy of Deutsches Archäologisches Institut, Cairo.

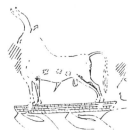

Figure 33 Standing bull statuette from TT 86 Menkheperrasonb. Davies, Nina M. and Norman de Garis Davies. *The Tombs of Menkheperrasonb, Amenmose, and Another*, pl. V.

Menkheperrasonb and Rekhmire (Fig. 34). In TT 89 a similar one is also carried by a Levantine man. In the tombs of Useramun and Rekhmire griffin head rhyta are depicted (Fig. 35),[46] and a Levantine in the tomb of Sobekhotep also carries one.[47] Griffins were mythical creatures with the head and wings of an eagle and the hindquarters of a lion, an artistic motif commonly found in the Aegean.[48]

Aegeans also carry vessels with animals perched on pedestals on the interior of the vases. Like those seen in the Levantine registers, the animal is usually a frog. There are many different types of decoration represented on the various vessels depicted in the Aegean tribute-bearer registers. Common decorative designs include rosettes, imbrication, circular poppy flowers, spirals, bucrania and fan shapes.[49]

As in the Levantine scenes, many Aegean vases show interior decorations, such as bud stems, circular flowers and rosettes. Lion handles are represented on

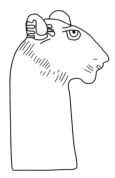

Figure 34 Lion rhyta from TT 100 Rekhmire. Davies, Nina M. and Norman de Garis Davies. *The tombs of Rekhmire*, pl. XVIII.

Figure 35 Griffin head from TT 131 Useramun. Dziobek, Eberhard. *Die Gräber des Vezirs User-Amun: Theben Nr. 61 und 131*, pl. 22. Image courtesy of Deutsches Archäologisches Institut, Cairo.

vases in tombs 100 and 86.[50] Also in each of these tombs there are vases with animal head lids among the Aegean tribute. Tomb 86 has a vessel with a bull lid, and tomb 100 has a lid in the shape of an ibex. Again, like their Levantine counterparts, Aegean vessels are depicted in a number of different shapes such as pots, jugs, jars and cups. There is one golden situla from the tomb of Rekhmire, and also two *hes* vases (with handles) in the same tomb. One is painted blue and fitted with golden handles and bands, and the other is labelled as being made of lapis lazuli. In the tomb of Senenmut there are disproportionately large vapheio-like cups brought by the Aegean tribute bearers (see Pl. 9).

Aegeans also bring swords, sheathed and unsheathed, and in one case a whip. There is one curious round object in Useramun's tomb, which has been described as a shield.[51] Ingots in the shape of oxhides are only brought by Aegeans in one tomb scene, though these too are attributed to the Levant.[52] There are also three other ornate vases with water lilies rising from the interior of the vessels (Fig. 36).[53]

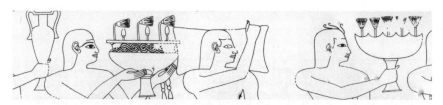

Figure 36 Examples of vases with water lily decorations from TT 100 Rekhmire. Davies, Norman de Garis. *The Tombs of Rekhmire*, pl. XX.

Symbolism

Water lilies represent regeneration and rebirth through the solar cycle.[54] The Egyptians believed that before creation there was a watery primordial abyss. Then a mound in the water gave rise to a water lily and the sun god came from the water lily. Following these events, the sun god then produced all other gods and mankind.[55]

Other vessels in these tombs are also related to birth and rebirth. The jackal head in the tomb of Useramun resembles Anubis, the Egyptian deity of mummification and the afterlife, a symbol that the ancient Egyptian tomb visitor would have recognized (Fig. 37). Also, the imbricated fish scale design on the two cone-rhyta would have evoked the concepts associated with fish. As discussed regarding the fishing and fowling scenes, fish can allude to regeneration and rebirth in the afterlife.

It is also strange that in a procession of Aegeans, and supposed Aegean goods, there are large vessels in the shape of *hes* vases (Fig. 38). In ancient Egypt, *hes* vases were used for libations. Small lapis or faience models were often placed in the tombs and were essential for performing rituals for the deceased that granted the tomb owner continued life in eternity.[56] In my view these vessels are shown as overly large because of the importance of the object in the scene.[57]

Wachsmann analyses the historicity of objects shown in the Aegean tribute scenes. He found that 'it was perfectly normal for Egyptian artists, when

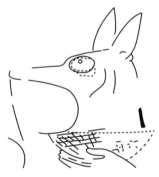

Figure 37 Jackal head from TT 131 Useramun. Dziobek, Eberhard. *Die Gräber des Vezirs User-Amun: Theben Nr. 61 und 131*, pl. 92. Image courtesy of Deutsches Archäologisches Institut, Cairo.

Figure 38 *Hes* vase from TT 100 Rekhmire. Davies, Norman de Garis. *The Tombs of Rekhmire*, pl. XVIII.

dealing with foreign objects, *to construct non-existent vessels by uniting elements taken from several different sources. In doing this the artists felt no compunction in using Egyptian elements in their constructions.*[58] Further, like hybridization in the human figures, there are numerous instances of object transference. Wachsmann further states that 'Aegean articles are put in the hands of Syrian tributaries and Aegeans bring merchandise of obvious Egyptian workmanship to Egypt. In itself this does not prove that Syrians transported Minoan wares to Egypt nor that Aegeans did so with Egyptian stuffs.'[59] For example, in the tomb of Rekhmire,[60] lapis lazuli is brought by the Aegeans though it would have had to be imported from northern Afghanistan.[61] Also, as mentioned above, the Levantines and Aegeans often brought the exact same vessel types.

The scale is also skewed in the rendering of animals, especially bears and elephants. In tribute scenes such dangerous animals are leashed and very small. As mentioned above, the leashes indicate that their role as agents of chaos has been negated and their size makes them easier to control.

As for the Aegeans and the way they are depicted, Rehak argues that the different costumes do not reflect the different Minoan and Mycenaean cultures, since the costume change does not coincide with Minoan and Mycenaean depictions.[62] People all over the Aegean world wore breechcloths and kilts. He suggests that the costume differences relate to age or status difference, with breechcloths on young men, and kilts on older men.[63] So why was one depicted before the other, and why was there a change in costume in the tomb of

Rekhmire? Rehak suggests that either there is a change in the status or age of the tribute bearers coming to Egypt or these paintings are based on two separate groups of embassies that went to Egypt, one in the reign of Hatshepsut, another in the reign of Thutmose III.[64] Clearly this change in attire was meaningful to the Egyptians, but what it meant is not clearly understood today.

The oases (tombs 39, 81, 86, 131 and 155)

Tribute goods

In the tomb of Ineni a tree is carried in netting, attached to a pole, and in Antef's tomb a basket full of grapes is being presented. In both of these tombs, woven baskets seem to be one of the more valuable and well-represented goods brought to Egypt from the oases, as are large wine jars and other woven goods, such as the hive-shaped basket only seen in oases tribute images.[65] In the tomb from Puyemre (and possibly in the tomb of Ineni), cloth is also a part of the tribute delivery.

Symbolism

The difference in hair between the chiefs and the tribute bearers in the registers indicates that the artist is trying to differentiate between the wealthier, and perhaps Egyptianized, chiefs and the less prestigious and less wealthy oases dwellers. Unfortunately, not much of the female figures is preserved, but it seems that, unlike the Levantine and Nubian women, the oases women bring objects such as woven goods, not children. It is perhaps likely that the women wove the objects that they carry. Depictions of people from the oases are relatively rare in tribute scenes, probably because they do not effectively convey the ideas of foreignness and opulence.

Wat-hor (tomb 39)

The figures from this locale are not represented with foreign iconographic characteristics. In comparison with the people from Wat-hor, the people from

the oases have Egyptian-looking chiefs in the front of the register, and contrasting figures with different attire and physical attributes in the rear of the register. There is no differentiation of people in the scene from Wat-hor. The products brought from this locale are not entirely foreign. It is therefore evident that the Wat-hor tribute scene does not exhibit the same messages of foreignness that the other tribute-bearing scenes portray. Since wealth and exoticism are the primary purposes of foreigner scenes, conceptually, this tribute register is ineffective. This is likely why this locale is only portrayed once in a tribute scene.

Punt (tombs 39, 100 and 143)

Tribute goods

The animals and animal products brought from Punt include the ibex, monkey and cheetah, as well as cheetah pelts, bags made out of cow hides, ostrich eggs, giraffe tails, ostrich feathers and ivory. Plants in the tribute include whole incense trees.[66] The wood from Punt is typically wrapped in bundles for transport and is labelled as *tšps*, *mry* and *ḥbny* (ebony). One type of object that is unique to Punt and is also seen in the Puntite scenes from Deir el Bahri is a wooden throw stick (*ʿȝmw*).[67] This throw stick is only seen in images of tribute from Punt.

Puntite tribute scenes consist of an abnormally large amount of raw minerals and goods. For instance, mimicking the scene of Puntites from Hatshepsut's mortuary temple at Deir el Bahri, a whole register in TT 39 has no human figures, just tribute items. Most of these objects and piles are painted a dark red and speckled. Tribute bearers from Punt also carry numerous baskets of materials in the procession, many of which are labeled as gold rings, gold dust, *ḥnt*, dark stone (*kȝ km*), white stone (*kȝ ḥḏ*), *mena* stone(?), electrum, a white material, and various other unlabelled minerals.[68] They also carry beads in long strands. Only one vase is portrayed as an offering brought by the Puntites, and it is undecorated.

In TT 39, the hieroglyphs label the tribute bearers as from Punt on one register and from *tȝ-nṯr* in another. In the latter register the figures alternate between having long, Levantine-style hair and having shoulder-length hair

that ends in jagged edges. These figures bring a baboon, an unidentified animal (perhaps an ibex), ostrich feathers, ostrich eggs and cheetah skins. The material presented in this scene is placed in small bags and piled high in baskets.

Symbolism

The term *tꜣ-ntr* or 'land of the god' is a name associated with Punt and also applied to the area in the Levant where cedar trees grew. Both places also grew resinous trees, which are depicted in this scene.[69] The throw sticks are only seen in images of tribute from Punt where they are either labelled as 'ꜥꜣmw' or as 'mtny'.

Also noteworthy is the prominence of the red and black speckled material, an aromatic gum from Punt. To the Egyptian eye this was represented in a similar way to red granite, a material often associated with the sun. Some of the gum in this scene is shaped like an obelisk, also indicating solar associations to the Egyptians. In Egyptian myth the solar cycle, as mentioned above, was associated with death and resurrection as the sun was born again each day.

Chapter conclusions

In conducting this research, it has been important to distinguish between ancient racial biases and those of the early Egyptologists who recorded these tomb scenes. It has also been a challenge not to interpret these images through my own view of different people types and gender roles. My goal has been to interpret this material in order to understand what ideas and concepts the Egyptians were attempting to portray in these scenes. With this as my objective, it seems as if the questions that previous Egyptologists were asking do not correlate well with what the Egyptians intended to portray. For instance, after looking at all of the extant tribute scenes, it is apparent that the northern foreigner types are functioning separately from the texts that identify them. When specific place names are mentioned they do not inevitably pair up with a specific ethnic representation. This phenomenon is counter-intuitive because we expect the text and image to correlate, and in fact it does so when identifying the objects in the scene.

The form of the foreigner figures is instead closely aligned to the function that these images served. One of the most important and obvious purposes of these scenes is the emphasis on opulence and foreignness. For instance, within each register there is a hierarchy of peoples and goods. Before the foreigners with luxury goods there is a pile of offerings. Then the offerings are usually carried in an order, with precious metals, vases and unprocessed raw materials in front, and the less exotic goods tend to follow. In some of the tribute scenes, with the best examples being from the tombs of Senenmut (Pl. 9) and Amenmose,[70] the goods are disproportionately large in comparison to the people carrying them. This again emphasizes the importance of the exotic luxury goods being brought to Egypt.

A second function of these images is to convey the tomb owner's prestige by showing the power of the king and the king's relationship to the tomb owner. In these tribute scenes the tomb owner often stands between the king and the foreigners, acting as an intermediary. If, however, the king is not present, the tomb owner himself oversees the offering bringers. Power, and access to it, is a message that the Egyptian viewer would have recognized in these images. The king, and sometimes a goddess who stands behind the king, are the most powerful figures depicted. Before the king is the tomb owner, then the Egyptian administrators who record the tribute.

After the Egyptian administrators is the pile of offerings and then the chiefs follow. They are sometimes identified and are often prostrating themselves or kneeling with their arms in praise. Male tribute bearers follow and they are sometimes arranged in order of the value of the goods that they carry. In Nubian and Levantine scenes women are shown in a specific order as well. The women and children generally follow the men and the foreign goods. In these instances, the women and children themselves are the goods being delivered. The children were likely intended to be raised in the *kap* (royal nursery).[71] The childless women are presumably there to work for elite Egyptians. In these instances, the women and children rank lowest in the power hierarchy. Indeed, they may not have had agency over themselves at all. These representations of foreign women in the tribute scenes are a reflection of women and children from an ancient Egyptian perspective. There is no indication that these images illustrate the status of women in non-Egyptian cultures.

The third attribute being distributed in this scene is the breath of life, which the foreigners often request from the king.[72] In a number of the tribute scenes the foreigners are offering the frog in marsh vase to the tomb owner. In ancient Egypt, frogs were symbols that represented fertility and life. In fact, the goddess of birth, Hekat, was often represented as a frog and her name ended in a frog determinative.[73] Also, the life cycle of frogs was a mystery for the ancient Egyptians, who believed that they were self-created. Because of the numerous swarming tadpoles evident after the Nile's inundation, frogs and tadpoles became symbols of birth and regeneration.[74]

Many of the most highly valued gifts were vases that are often adorned with what Davies calls 'rim ornaments'. Davies describes the vessels as such because plants (indeed, often marsh plants like papyrus) are seen rising from the rim. In actuality, these marsh plants were probably on the interior of the vase, rising from the middle. Then, when a liquid filled the vessel, the plants would emerge from the water, evoking the setting of a marsh. Marshes are places of life and rebirth for the ancient Egyptians, so such images would have been highly appropriate in a funerary context.[75]

Between Symbolism and Historical Veracity

I argue that the primary reason that tribute scene images were created was because of the conceptual role they played in an ideological and religious setting within the Egyptian tomb. However, these images were not created in a historical vacuum. It is likely that the costumes and accoutrements represented on foreigners in these scenes are probably out of style, or are in some cases misunderstood or overly embellished. These iconographical elements, however, have to remain constant to create and reify the various foreigner types so they are recognizable to the Egyptian viewer. These paintings, even if somehow distorted through an Egyptian view, are grounded in a historical reality. This is true even if said reality is morphed through a filter of symbolism and a canonized system of representation.

Clearly we are too far removed from the ancient Egyptian culture to tease out what is strictly fictional from what is historical. However, we must see that these two elements, that of Egyptian ideology and that of historical reality, are not mutually exclusive. I have introduced the symbolic in this study because it has not been discussed before. Historicity has been the only way that these images have been interpreted. I am proposing here to open up the conversation about the use of images in ideology and the accuracy of images in identifying physical elements of cultures from the past that we know very little about.

If we are looking to these images from the Egyptian tombs for clues about other cultures, sometimes an ideological answer may be more appropriate than a historical one. For instance, one of Wachsmann's main conclusions in his study of Aegeans in the Theban tombs is that the disappearance of the *Keftiu* from tomb walls after the reign of Amenhotep II is because 'the last recorded visit by the Aegeans to Egypt took place in the latter part of Thutmose

III's reign and indicates that even if they were painted in Rechmire's tomb at the beginning of the reign of Amenhotep II, they were at that time anachronistic.'[1] He thus concludes that 'the Egyptians ceased to draw the Aegeans because direct contact with the Aegean ceased when the Minoan culture fell and was not revived by the Myceneans after they consolidated their hold on Crete.'[2]

However, when we look at *all* of the tomb imagery it is apparent that there was much more experimentation with foreigner types when the tribute scenes were first introduced, and that this experimentation ends in the reign of Amenhotep II. The new focus is to *just* represent Nubians and Levantines. I believe this was an ideological move to focus on dualities and expand the borders north and south, to create simplicity and balance on the tomb walls both aesthetically and conceptually. Since the Egyptians thought in terms of North and South Egypt, the natural extension of this would be the Levant and Nubia. Also, as stated in Chapter 3, if the northerners and southerners were depicted on different walls, the Levantines (from the North) would be on the right side while the Nubians (from the South) would be on the left side, thus creating a microcosm of the world for the living, the deceased and the outliers on the periphery of the known world.

If you were just looking at the evidence from a historical standpoint, Wachsmann's conclusions would be the only logical and reasonable deduction that you could make. Indeed, when beginning this research, I was convinced that the wall paintings were reflective of a historical cessation of the relationship between the Aegean and Egypt. It is important to take into consideration the function of the images in addition to the history of the foreigners that are represented.

In Roth's article discussing foreigner iconography, she asserts that some images are 'historical'. Her analysis is that the non-royal images and literature tend to be positive, focusing on their assistance to Egyptians abroad in literature and in art, as they bring wonderful things to Egypt. By contrast, royal inscriptions and images show and describe foreigners as the enemy.[3] She also notes that the main change in New Kingdom representations of foreigners is the appearance of foreigners in non-royal contexts, which she states is probably the 'side effect of the inclusion in tomb chapels of scenes of the king and of the tomb owner's professional life'.[4]

While I agree with Roth in her conclusions, that royal iconography evokes negative connotations and non-royal imagery alludes to positive associations, I do think that the tribute scenes are referencing much more than an elite professional life. It seems that at least one layer of meaning in these scenes is the regional understanding of the system that these images are referencing. This is what Kantor, after William Stevenson Smith, calls the 'international style' and Feldman coins the 'international artistic koiné'.[5] Both terms refer to products circulated on an international stage of brother kings and power brokerage. Here the exchange physically manifests and reifies a social force. This international system can be described as 'the visual expression of a specific intercultural superregional communities of rulers that coalesced as a distinct sociopolitical entity during the Late Bronze Age'.[6] The tomb owners wanted to be recognized as part of these elite exchanges, which is why they chose that the tribute scene be represented on the focal wall(s) of their tomb. It is for this reason that the tribute scene is represented so few times in the Theban tombs: not many people had the privilege of assisting the king in his role of international power broker.

The tribute scenes recall a real system of luxury trade in which the Egyptian state was taking part where goods were circulating all over the known world – Egypt, Mesopotamia, Anatolia, the Levant, Cyprus and the Aegean. During this time the kings exchanged letters to one another in Akkadian, which was the lingua franca. Here it is important to note that the Egyptian king was willing to write in another language for correspondence. According to Feldman, 'the letters construct a world (patently idealized) of brotherly reciprocity among rulers in which exchanges are equal and emphasis is placed on acquiring prestige through giving rather than receiving.'[7] However, this is not the case in the Egyptian schema, as represented visually on the Theban tomb walls.

International diplomacy and trade

Where an actual international system intersects with the Egyptian view of the world, the latter prevails within an Egyptian tomb setting; though it should be noted that, even in ancient times, the inaccuracy of the way the Egyptian king

represented gifts was acknowledged by at least one foreign king. In one correspondence, the Babylonian king wrote to the Egyptian king complaining that his gifts, chariots, were displayed with tribute from Egyptian vassal states when they were to be received as gifts.[8] Within the internal state the king portrayed himself as second only to the gods, with no equals. However, in the international diplomatic sphere, 'kings of culturally disparate states interacted with one another in an idealized rhetorical mode of parity and reciprocity'.[9]

This diplomatic arena ascribed symbolic value to the objects, which in turn conferred prestige and status on their owners.[10] Also, the luxury goods exchanged in this system – those that are found in the archaeological records – have complex and often confusing iconography. Such objects found in archaeological contexts have hybrid imagery that combines essential elements from numerous cultures. The gifts helped to create and maintain a complicated international multicultural system. Indeed these objects, when depicted in tomb paintings, would hold various meanings for the Egyptian within a tomb context. Not only were they displaying wealth, opulence, exoticism and a personal relationship with the king, they were also displaying their access to the foreign and exotic, and their involvement in the international culture of which they were a part.

This complex network of exchanges connected the continents of Africa, Asia and Europe. One of the most interesting sites, besides the Theban necropolis, to study this international exchange system is approximately 9 km off the coast of Turkey in the Mediterranean Sea. The Uluburun shipwreck, an underwater archaeological site, which gives us a rare glimpse inside a ship transporting goods in the Late Bronze Age, the time of Egypt's early eighteenth dynasty.[11] At this site many objects recovered were similar to those depicted on the Theban tomb walls. Such objects include copper ingots, animal head rhyta, metal vases, ivory tusks and copious amounts of pottery (filled with expensive trade goods: olive oil, resin, beads and other goods). This trade mission was likely on its way to mainland Greece from the Levant. As far as I am aware, we do not have images of foreigners bringing 'tribute' to sites in the Aegean or the Levant from the Late Bronze Age, though these trade missions clearly existed.[12] The Uluburun shipwreck carried some of the same luxury goods seen on Theban tomb walls, the prestige items that the tomb owners, who were often international diplomats, wanted to take to the afterlife.

Campaigns of the early eighteenth dynasty kings

The purpose of my book is not to examine whether these images are historically accurate.[13] I am instead interested in discovering what these images meant to the tomb owner and the ancient viewer. Nevertheless, these paintings are not removed from time, but were a product of their period – during the height of Egyptian imperialism, when Egyptian kings were actively involved in campaigns to expand their kingdom. In order, therefore, to situate these tombs and their paintings within a historical framework, I will briefly discuss what is known historically about this period.

What should be obvious to the viewer of these scenes, both ancient and modern, is that, in reality, the relationship between the Egyptians king and each foreign locale would be different. However, visually, all of the foreigner scenes show the same relationship with the Egyptian king, one of humble obedience and complete, voluntary submission. The entities in Nubia, the Levant and the Aegean, for instance, had three very different relationships with the state of Egypt, though they are represented as having the exact same power structure in each painting. The actual possibility of such a scene actually happening in terms of delegations arriving at the same time and simple logistics is difficult to imagine. But the iconographical message received by the ancient viewer is strikingly simple and straightforward. The king is the ruler of the whole world.

Also, unfortunately for the ancient historian, these geographical divisions (i.e. 'the Levant') actually consist of numerous groups that have different relationships with the king depending on the time period. So, for instance, the goods involved in the international trade from the Levant could be from Babylonia, Mittani, Hatti, Amurru, Assyria or Ugarit. However, the representation of them and the offerings they bring are not visually differentiated from one another in the tomb scenes and are in fact sometimes hybridized with foreigners and tribute objects from the Aegean. Any information we know now will soon be outdated in terms of historical information as new finds are discovered, but a brief discussion of Egypt's conquests is as follows.

Shaheen, in his dissertation 'Historical Significance of Selected Scenes Involving Western Asiatics and Nubians in the Private Theban Tombs of the XVIIIth Dynasty,' takes a historical approach to the images. In this text he

takes an in-depth look into the campaigns against the Nubians and Levantines in the eighteenth dynasty. The documentation of Egyptian campaigns in these regions at this time is far more advanced than the understanding of the relations between Egypt and Punt, the Aegean, the oases or other locales. For our purposes we will begin with Hatshepsut/Thutmose III's campaigns in Asia and Nubia,[14] as no Theban tombs with the tribute scene motif exist before this time.

While it has been argued that Hatshepsut had a peaceful reign (*c.* 1479–1457 BC),[15] it has been made clear that the queen conducted at least one campaign into Nubia.[16] The final Nubian campaign seems to have been carried out with Thutmose III as the leader, shortly before the queen died.[17] In this campaign Thutmose III travels to Miw[18] (likely south of the fifth cataract);[19] this is probably the force that fought with Hatshepsut/Thutmose III during their co-reign. It is also possible that Hatshepsut led campaigns in the Levant,[20] though this hypothesis cannot be confirmed. Shaheen says that Gaza was defeated probably towards the end of the co-rule with Thutmose III.[21]

Thutmose III in his sole rule went on many campaigns to Egypt's north and south,[22] During this period (*c.* 1479–1425 BC), Egypt became a permanent part of the political structure in parts of the Levant.[23] During the reign of Thutmose III, Retenu (Palestine) was conquered in the first campaign, and the land of Djahy (Palestine) was also conquered by Thutmose III. In the seventh year of his reign he established maritime bases on the coast of Phoenicia and he invaded Mitanni-Naharin in his eighth and tenth campaigns.[24] Additionally, the biography of Amenemhab from his Theban tomb (No. 85) mentions the campaigns in Negeb, Naharin and Kadesh and elephant hunting at Niy.[25] The annals of Thutmose III also list the various expeditions and the amount of *inw*,[26] *bꜣkw* (revenue or taxes) and *ḥꜣk* (spoils) as a result of these campaigns. In year 24, Thutmose III campaigned in the land of Retenu, thus receiving the produce of both Retenu and Assur,[27] and a treaty between Egypt and Assur was created to assist Assur in its conflict with the Mitanni.[28] In Thutmose III's twenty-ninth year, he was in the land of Djahy to quell rebellions. He also captured the site of *w-r-ṯ-t*, near Ullaza. The king 'plundered' Tunip[29] and overtook Arvad[30] (6 km from Tripoli) on his fifth campaign.[31] Beginning in his sixth year, Thutmose III overthrew Kadesh and received produce from Retenu. He also went to the Simira and additionally he 'punished' Arvad.[32] After this,

the practice of bringing Levantine princes to Egypt to be reared began.[33] Beginning in the thirtieth year the Battle of Meggido begins to be mentioned, in both daybooks and additional sources.[34] As a result of this siege, Palestine, the northern Jordan Valley and perhaps parts of Damascus were under Egyptian authority.[35] In the thirty-first year of Thutmose III's reign, the king turned his attention to Phoenicia and captured Ullaza.[36]

As mentioned in the annals, the king received gifts from the south and the north. In the south, the places of Genebtyw were brought by *wpwty* (messengers) instead of chiefs. He also received taxes from Wawat.[37] In Thutmose III's twenty-second or twenty-third year he oversaw the campaigns of Kadesh, on the middle Orontes, and Tunip, somewhere in the basin of the lower Orontes, whose influence extended to the Mediterranean coast.[38] He then attacked the Mitanni. After all of these campaigns, Babylon, Assur and Kheta recognized Egypt's rule over Syria.[39] The military control over the Mitanni benefitted the Hittites, who sent produce to Egypt. The Hittites and Egyptians made a treaty for the first time during the reign of Thutmose III.[40] In year 34 (the king's ninth campaign), Djahy surrendered to Egypt, and the king received the produce of Retenu, Cyprus, and the *bꜣkw* from Kush and Wawat,[41] and four sons of the rulers of Irem (which lies outside of or in Upper Nubia).[42] In Thutmose III's tenth campaign (year 35) the king won a victory over the Mitanni near a place called Iryn.[43] Unfortunately, the records from the king's eleventh and twelfth campaigns were lost. However, the records from his thirteenth campaign (year 38) contain the receipt of goods from Nugus, Asiatic harbours, gifts from Cyprus and Arrapakhitis, goods from Punt and taxes from Wawat.[44]

In his thirty-ninth year Thutmose III went to Retenu for his fourteenth victorious campaign. He also fought against the Shasu people.[45] In the tomb of Amenemheb (TT 85), the tomb owner states that the king also acted in the lands of Negeb[46] and Tekhsy[47] (which was located in northern Syria, near Alalakh). The king's fifteenth campaign, in year 40, lists produce (*inw*) from Cyprus (Jsr) and taxes (*bꜣk*) from Kush and Wawat.[48] From the seventeenth year of the king's reign records exist documenting the spoils (*ḥꜣk*) from campaigns against Kadesh, Erkatu and Tunip.[49]

In year 49 or 50, the king had some sort of involvement in Elesiyeh and Amada.[50] In the annals it states that taxes were collected from Wawat for eight

years and from Kush for five years.[51] During Thutmose III's long reign Egypt expanded its borders over Nubia and Palestine, and Egypt had extended its great military might over its neighbours to the north.

While there is no existing evidence of Amenhotep II's[52] campaigning in Nubia, they were certainly keeping the Nubians at bay through fear. One story exists where he sent a Levantine prince of Tekhsy to be hung on the walls at Napata.[53] An inscription from year 4 of Amenhotep II's reign at Tura's quarry[54] references boundary steles that stretch as far south as the fourth cataract of the Nile.[55]

More evidence exists about Amenhotep II's activities in the Levant, where he led three campaigns in the north, in years 3, 7 and 9 of his reign.[56] In year 3, while co-reigning with his father, Amenhotep II went to the district of Takhsy in the northern part of Syria, north or south of the Orontes and near Alalakh.[57] Evidence for the campaigns of year 7 and 9 is located on the Karnak and Memphis stelae.[58] Also, a letter from Amenhotep II to Prince Taanach documents Egypt's campaigning against an unidentified place called Shemesh-Edom (*šmsw jtm*).[59] In the campaign of year 7, the king went to Nij (*Qalat el Mediq*), a town that had a supplicant population because the chief of Aku-ta (likely Ugarit) was loyal to Amenhotep II.[60] Also, during his reign, Kadesh was allied with Amenhotep II.[61] During the campaign of year 7, Amenhotep II intercepted a messenger from the Mitanni who was trying to agitate the city states of southern Palestine against Egypt.[62]

In Amenhotep II's campaign in year 9 he led his army into the city *I-p-q*, then travelled to *Ja-h-ma*, and he plundered two unidentified villages, '*Ma-pa-si-n*' and '*Ha-ta-si-n*'.[63] Also mentioned in relation to this campaign are the sites of '*A-nu-har-ta*' and '*Q(a)-ca-su-mi-n*'.[64] Spalinger and Edel both believe that this campaign did not actually take place, but was instead a 'literary convention'[65] or 'A dream of the king'.[66] The Memphis Stela (Cairo Museum no. 6301) states that, after the campaign of year 9, Nahrarin, Hittites and Babylonian princes came to the Egyptian king grovelling and asking for peace.[67] Redford notes that the alliance of these groups with Egypt had to do with Egyptian domination; they could have easily switched allegiance to the Mitanni if the Mitanni gained power.[68] Regarding the Mitanni, Amenhotep II signed a treaty during his reign where all of northern Syria was ruled by the Mitanni, under

which all of the cities on the Phoenician coast up to the modern town of Tripoli went to Egypt.[69]

The campaigns in the reign of Thutmose IV[70] are at least as ambiguous as those of Amenhotep II. Some scholars believe that this king did not take military action in the Levant,[71] while others think that the king only engaged in minor campaigns to maintain bases in the Levant and Nubia.[72] There are a few references to a possible campaign against Naharin and the resulting spoils.[73] Additionally, an alliance was made through a political marriage with a Mittanian princess, as a measure to protect both Mitanni and Egypt from the Hittites who were gaining power at the time.[74] An alliance also existed between Egypt and Babylon during the reign of Thutmose IV.[75]

The king settled Canaanite prisoners from the land of Gezer (*ḳdr*) in Palestine on his temple estate.[76] In the Amarna letters, it is attested that Thutmose IV visited Sidon and had 'friendly relations' with Babylon.[77] Thutmose IV[78] also had a campaign against Nubia, perhaps in response to a northern Nubian revolt in his eighth year.[79] This violence was likely directed at the Nehasyu in the region of Wawat.[80] The king possibly also battled the Irem and two additional Nubian areas, the *Gwrss* and *ṯkr*.[81]

During the final reign examined in this study, that of Amenhotep III,[82] it seems as if the king did not even set foot in the Levant.[83] Amenhotep III married Giluhepa, the daughter of the Mitanian ruler,[84] and maintained good relations with Nineveh, Alasia and the Mitanni.[85] This was the height of Egyptian supremacy before its decline in the later eighteenth dynasty. The power of the Mitanni was also declining and at this time the Hittites were gaining power.[86] It is noted by Kemp that Amenhotep III referred to the *'prw*, a term which may be a pejorative reference to 'enemies'.[87] It is likely that during this period the Egyptian kingdom stretched from Napata to Naharin.[88] As for Nubia, during the king's fifth year there was a rebellion in the district of Ibhet (east of Wawat).[89] The rebels possibly included some people of the *Jrm* region.[90] Also during this king's fifth year of reign, an army (we're not sure which) sailed along the coast of the Red Sea 'harassing' the Nehasyu peoples of the Wrš[k] region.[91] Finally, Amenhotep III's troops seemed to dominate four Nubian lands: Kush, Rem, Tarek and Waresh.[92]

The interactions between Egypt and areas other than Nubia and the Levant are not fully understood. Wachsmann, in his study of the depictions of the

images of the *Keftiu* in the eighteenth dynasty concludes that the Egyptians only directly interacted with the Minoans and that this began in the reign of Hatshepsut and ended in the reign of Thutmose III. At this point in history the Minoan culture ends.[93] He believes that *Keftiu* images present in the tombs of Menkheperrasonb and Rekhmire follow a model from earlier tombs and were anachronistic when they were painted. Indeed, after Rekhmire, the representation of the *Keftiu* ceases.[94] One of Wachsmann's 'crucial' questions in examining these scenes is 'why did the Egyptians stop representing the Aegeans in their scenes of foreign tribute?'[95]

The better question to ask here is why only Nubians and Levantines are represented in tribute scenes after the tomb of Rekhmire.[96] A reasonable hypothesis is that this is an artistic convention in which only the two most important groups from the north and south are depicted and represent foreigners as a whole. It is likely that by contrasting these images the ancient viewer would see that both the north and south were under the control of Egypt. This was a conceptual overlap between the tribute scenes and the bound and trampled foreigner images. The groups omitted in these later depictions are not only the *Keftiu*, but also the oases dwellers, Puntites and inhabitants of Wat-hor and Ta-Netjer.

The earlier inclusion of Punt on tomb walls is based on Hatshepsut's drawings of the Puntites in her funerary temple.[97] They are symbols of exoticism, one of the primary functions of these images. Wat-hor was a highway that went along the northern edge of the Arabia mountain system into Syria.[98] The people from this land are only represented once, in the tomb of Puyemre. The people represented from Wat-hor are Egyptian colonists and it is likely that this region was incorporated into Egypt proper shortly after this depiction was created.[99]

The western oases have a long history of interaction with Egypt,[100] and in ancient Egypt the oases were referred to as two separate places, the southern and northern oases. After studying the tribute scene paintings it seems that five out of ten tribute scenes before TT 42 (the tomb immediately following Rekhmire in chronology) represent the oases, so it was more common than has been previously noticed. These scenes are not usually identified or discussed because they are not as visually alluring as the more exotic Nubian or Levantine registers. Besides Punt, there is another locale that is not well understood. Ta-Netjer, which means 'land of the god', is another locale

represented in Puyemre's tribute scene. This term/place is associated with Punt and also the mountainous lands of Syria (where cedar was grown). Little information exists about the relations or even the existence of this locale as a separate entity from Punt.[101]

It is clear that ancient Egyptian kings desired to expand their borders north and south. They seem to have had more success in conquering sites in Nubia than they had in maintaining stable control in the north. To the ancient Egyptians it would have seemed natural to the king to rule over all peoples, beginning with those closest to Egypt. This control over foreigners was a kingly duty – he was charged to actively maintain order and destroy chaos. Additionally, the taxes, produce and booty that the king received for such ventures further justified the campaigns. My goal in briefly outlining the historical campaigns during the time period under study is to show that this era was a time of expansion and that it is possible that the images of foreigners bringing wealth to Egypt at one level is a display of the king's ability to obtain assets through foreign conquests, another means of creating order out of chaos.

9

Conclusions

This study of paintings in early eighteenth-dynasty Theban tombs establishes the purpose of foreigner images within their original context and with the intended ancient viewer in mind. As shown in this work, foreigners in tribute scenes are organized in coded terms that were understood by the ancient Egyptian viewers. Paintings of foreigners in the Theban tombs relate to a pre-conceived perception of the other through the eyes of the culture. In fact, the image of the other is a veiled political statement that emphasizes the potential danger, alluring otherness, and the wealth and luxury of the foreigner.

Why are we, as modern scholars, drawn to these images? Why is there interest in ancient Egyptian tombs? Or perhaps I should be asking: why are we so captivated by the culture of the ancient Egyptians? I believe that the enchantment ancient Egypt holds for us is based largely on the same basic set of ideas that we see expressed in these ancient tomb paintings. We are at least on some level intrigued by the opulence, wealth and foreignness of the Egyptians, who are so far removed from us culturally. The ancient Egyptians fascinate us. They intrigue us, at least in part, because of their exoticism, their foreignness, the richness and the opulence we imagine them all to have had. This study is focused on looking at who fascinated the ancient Egyptians – for the same reasons. This reveals similarities between us and ancient Egyptians in the ways that we think and experience the world. Or perhaps I am just pointing out one of the cognitive traits that unite all of us as humans.

Elite officials in Egypt built large, intricate and expensive tombs to ensure their eternal afterlife. These tombs were created in order to perpetuate the tomb owner's favour from the king and high status from this life to the next. Such concepts of societal rank and abundance were perhaps best expressed in scenes where the tomb owner acts as an intermediary, presenting foreign

offerings to the king. Implied in this image is the expectation of returned offerings to the official in the afterlife. One strategy that these tomb owners used to catch the attention and thus the remembrance of the visitor was to represent foreigners on their tomb walls. Indeed, these depictions of foreigners are the reason that these specific tombs are discussed in this work. It is through these tomb paintings that we can understand the deceased's perceived role in the maintenance of order within the Egyptian conception of the cosmos. The very fact that the tomb owners are here documented and discussed shows that this strategy of tomb decoration is particularly effective. Though it has been only 3,500 years, and not an eternity, the tomb owners are here remembered, and through us their immortality has been achieved.[1]

In this work I am asking the reader to think in terms of what the Egyptians wanted to represent in their tombs. The information that these images were created to convey is not, in many instances, what the modern researcher is hoping to discover. However, it is worth understanding these images in relation to the cultural context that constructed them.

In these tomb paintings we find that the ancient Egyptians are concerned with regeneration and rebirth, preserving order over chaos, and representing high status in their funerary monuments. These ideas are also clearly expressed in other tomb paintings located on the focal wall of early eighteenth-dynasty Theban tombs. That these concepts have not been identified in the tribute scenes before is surprising, considering the function of funerary monuments and the iconography therein. This oversight was likely due to an extreme desire to understand the history of the foreigners represented on the Theban tomb walls.

In fact, one main reason that Egyptology, a discipline devoted to the study of an ancient culture in Africa, is often labelled as 'western' art in the oversimplistic and highly problematic system of categorization is because of the search for the origins of biblical locales. As Pritchard stated, these are the principal images of the peoples from the Levant from the second half of the second millennium BC.[2] Since these images have been so important in the study of these cultures, no one has thought to question whether or not these images work within a system of representations or if they are likely to be accurate representations of those who they are depicting. Recognizing the system in which these paintings were created helps us to better understand the

ancient Egyptians and their beliefs in the afterlife. Through identifying such a system of representation we are also able to see trends popular in the culture at this time period. This research also aids in identifying foreigners as the Egyptians constructed them visually.

The Egyptians did this in a way very similar to how we construct foreign cultures in modern popular culture. The best study of this phenomenon is Edward Said's *Orientalism*, where we emphasize 'otherness' and heighten distinctions between 'us' and 'them'. Said noted that ideas of 'the other' are often heavily biased and they can help reify stereotypes and perpetuate the hierarchy that already exists within a culture. Images of 'the other' have been used as political tools in cultures worldwide, and they are also part of a larger conceptual mode centred on the collective identity of a society.[3]

Ironically, this imperialistic interest in 'the other' is also what began the field of Egyptology. When Napoleon and his troops went to Egypt the reports of what they found there aroused an interest in 'the Orient' that became pervasive in the western world. This interest, in turn, created Orientalist artwork,[4] where images of foreigners were used as symbols for ideology that both perpetuated and rationalized international conquests. A focus on 'the other' and the use of foreigners as symbols to suit an ideology is not just found in Orientalism; it is a universal concept. Yet one of the earliest recognized examples of this type of visual system, found in a non-western, pre-Greek society in Africa, in the tombs of elite ancient Egyptians, has never been couched within this context.

This study identifies and explains the foreigner images on the tribute tomb walls as the Egyptians would have understood them. Also, the representation of foreigners in a luxurious, opulent and likely somewhat inaccurate fashion is a phenomenon not limited to a discussion on east versus west, as is done in Orientalism, but one rooted in imperialist endeavours. Such imperialist agendas are likely tied to obtaining precious resources, one of the main visual messages being conveyed in the tribute scenes.

Perhaps the most pressing questions that I had while researching these images is why were foreigners, who are often associated with chaos in Egyptian ideology, depicted on tomb walls? What relationship do these images have to the afterlife? These tribute images become popular in this period, but only within the funerary context. The way foreigners are shown here is modelled on

processions of Egyptian offering bearers that are found in tombs as early as the Old Kingdom. Instead of being rendered in a chaotic form with their arms bound and their necks tied to control their chaotic natures, foreign tribute bearers are instead shown unbound in an orderly fashion, under the control of the king. This transformation from chaos to order mimics the transition from the chaotic state of death to the orderly afterlife. They serve as a parallel for the journey of the deceased.

Appendix 1

Tribute scenes

	Levant	Nubia	Aegean	Punt	Oases	Wat-hor
TT 39 Puyemre	X	X	X	X	X	X
TT 42 Amenmose	X					
TT 63 Sobekhotep	X	X				
TT 71 Senenmut			X			
TT 78 Haremheb	X	X				
TT 81 Ineni	X	X			X	
TT 84 Amunedjeh	X	X				
TT 85 Amenemhab	X		X			
TT 86 Menkheperrasonb	X		X		X	
TT 89 Amenmose	X	X	X			
TT 90 Nebamun	X					
TT 91 Name Lost	X	X				
TT 100 Rekhmire	X	X	X	X		
TT 119 Name Lost	X					
TT 131 Useramun	X		X		X	
TT 143 Name Lost				X		
TT 155 Antef	X		X		X	
TT 239 Penhet	X					
TT 256 Nebenkemet	X					
TT 276 Amenemopet	X					

Appendix 2

I. The king's captives

TT 42 Amenmose, Captain of troops, Eyes of the king in the two lands of the Retenu, Thutmose III

Davies, Nina M. and Norman de Garis Davies. *The Tombs of Menkheperrasonb, Amenmose, and Another (nos. 86, 112, 42, 226).* London: EES, 1933, 27–34.

El-Bialy, Mohammed. 'Récéntes recherches effectuées dans la tombe No 42 de la Vallée des Rois'. *Memnonia* 10 (1999): 161–178.

TT 47 Userhet, Overseer of the Royal Harim, Amenhotep III

Carter, Howard. 'Report on General Work done in the Southern Inspectorate'. *ASAE* 4 (1903): 177–178.

Eigner, Diethelm. 'Das thebanische Grab des Amenhotep, Wesir von Unterägypten: Die Arkitektur'. *MDAIK* 39 (1983): 39–50.

TT 48 Surero (Amenemhet) Chief Steward, at the Head of the King, Overseer of the Cattle of Amun, Amenhotep III

Säve-Söderbergh, Torgny. *Four Eighteenth Dynasty Tombs* (Private Tombs at Thebes, 1). Oxford, 1957, 34–48.

TT 57 Khaemhet, called Mahu, Royal Scribe Overseer of the Granaries of Upper and Lower Egypt, King Amenhotep III

Assmann, Jan. *Sonnenhymnen in thebanischen Gräbern.* (Theben, 1). Mainz, 1983.

Brock, Lyla Pinch. 'The Tomb of Khaemhat'. In: *Valley of the Kings: The Tombs and the Funerary Temples of Thebes West,* edited by Kent R. Weeks, 364–375. Vercelli: WhiteStar and Cairo: American University in Cairo Press, 2001.

Loret, Victor. 'La tombe de Khâ-m-hâ'. (*MMAF*, 1). Cairo, 1889, 113–132.

Mond, Robert. 'Report of Work in the Necropolis of Thebes during the Winter of 1903–1904'. *ASAE* 6 (1905): 65–96.

Pino, Cristina. 'The Market Scene in the Tomb of Khaemhet (TT 57)'. *JEA* 91 (2005): 95–106.

TT 58 Name Unknown, Title Unknown, Amenhotep III

Polz, Daniel. 'Bemerkungen der Grabbenutzung in der thebanischen Nekropole'. *MDAIK* 46 (1990): 301–336.

Saleh, Mohammed. 'Das Totenbuch in den thebanischen Beamtengräbern des Neuen Reiches'. *ArchVer* 46 (1984) 80, Abb. 101.

TT 63 Sobekhotep, Mayor of the Southern Lake and the Lake of Sobek, King Thutmose IV

Dziobeck, Eberhard and Muhammad Mahmud Abd al-Raziq. *Das Grab des Sobekhotep: Theben Nr. 63*. Mainz am Rhein: Philipp von Zabern, 1990.

TT 64 Hekarneheh (or Heqaheru), Nurse of the King's Son Amenhotep, Thutmose IV[1]

Hartwig, Melinda. *Tomb Painting an Identity in Ancient Thebes, 1419–1372 BCE*, fig. 13.

TT 74 Tjanuny, Royal Scribe, Commander of Soldiers, Thutmose IV

Brack, Annelies and Artur Brack. 'Vorbericht über Arbeiten im Grab des Tjanuni' (PM 74) 1973/74. *MDAIK* 31 (1975): 15–26.

Brack, Annelies and Artur Brack. *Das Grab des Tjanuni: Theben Nr. 74 (ArchVer, 19)*. Mainz, 1977.

Scheil, Jean Vincent. 'Le tombeau de Djanni'. In: *Sept tombeaux thébains (MMAF 5, 2)*, edited by Philippe Virey, 591–612, Cairo, 1889.

TT 77 Ptahemhet, Child of the Nursery, Overseer of Works in the Temple of Amun, Standard Bearer of the Lord of Two Lands. Usurped by Roy, Overseer of Sculptors of the Lord of the Two Lands, Thutmose IV

Manniche, Lise. *The Wall Decoration of Three Theban Tombs (TT 77, 175 and 249) (Carsten Niebuhr Institute of Ancient Near Eastern Studies, 4)*. Copenhagen: Carsten Neibuhr Institute of Ancient Near Eastern Studies: Museum Tusculanum Press, University of Copenhagen, 1988.

Polz, Daniel. 'Bemerkungen der Grabbenutzung in der thebanischen Nekropole'. *MDAIK* 46 (1990): 301–336.

TT 78 Haremhab, Royal Scribe, Scribe of Recruits, Thutmose III–Amenhotep III.

Bouriant, Urbain. 'Tombeau de Harmhabi'. In *Sept tombeaux thébaines (MMAF 5, 2)*, edited by Philippe Virey, 413–434. Cairo, 1889.

Brack, Annelies and Artur Brack. *Das Grab des Haremhab, Theben Nr. 78* (*ArchVer*, 35). Mainz, 1980.

Mekhitarian, Arpag. 'Un peintre thébain de la XVIIIe dynastie,' *Fs Junker* (1957), 1: 186–192.

Saleh, Mohammed. 'Das Totenbuch in den thebanischen Beamtengräbern des Neuen Reiches'. *ArchVer* 46 (1984): 64, Abb. 74.

TT 93 Kenamun, Chief Steward of the King, Amenhotep II

Davies, Norman de Garis. *The Tomb of Ken-Amun at Thebes* (*PMMA*, 5). New York, 1930.

Dewachter, Michel. 'Un nouveau "fils royal" de la XVIIIe dynastie: Qenamon'. *RdE* 32 (1980): 69–73.

TT 120 Anen, Second Prophet of Amun, Amenhotep III

Brock, Lyla Pinch. 'Jewels in the Gebel: A Preliminary Report on the Tomb of Anen'. *Journal of the American Research Center in Egypt* 36, (1999): 71–85.

Davies, Norman de Garis. 'The Graphic Work of the Expedition'. *BMMA* (November, 1929): 35–46.

TT 155 Antef, Great Herald of the King, Hatshepsut and Thutmosis III

Säve-Söderbergh, Torgny. *Four Eighteenth Dynasty Tombs* (*Private Tombs at Thebes*, 1). Oxford, 1957, 11–21.

TT 192 Kheruef, Steward of the Great Royal Wife, Teye, Amenhotep III

Hodel-Hoenes, Sigrid. *Life and Death in Ancient Egypt: Scenes from Private Tombs in New Kingdom Thebes*. Ithaca, NY: Cornell University Press, 2000, 203–246.

University of Chicago, Oriental Institute Epigraphic Survey Egypt, Maṣlaḥat al-Āthār. *The Tomb of Kheruef: Theban Tomb 192*. Chicago, Ill.: Oriental Institute of the University of Chicago, 1980.

TT 226 A Royal Scribe, Overseer of the Royal Nurses, Amenhotep III

Davies, Nina M. and Norman de Garis Davies. *The Tombs of Menkheperrasonb, Amenmose, and Another (nos. 86, 112, 42, 226)* (= *TTS*, 5). London: EES, 1933, 35–40.

Habachi, Labib. Tomb No, 226 of the Theban Necropolis and its Unknown Owner. In: *Fs Schott* (1968), pp. 61–70.

II. Tribute scenes

TT 39 Puyemre, Second Prophet of Amun, Hatshepsut–Thutmose III

Davies, N. de Garis. *The Tomb of Puyemré at Thebes.* 2 vols. New York: MMA, 1923.

Louant, Emmanuel. *Comment Pouiemrê triompha de la mort: analyse du programme iconographique de la tombe thébaine no. 39.* Leuven: Peeters, 2000.

TT 42 Amenmose, Captian of the Troops, Eyes of the King in the two lands of the Retenu, Overseer of the Harem, Thutmose III–Amenhotep II

Davies, Nina M. and Norman de Garis Davies. *The Tombs of Menkheperrasonb, Amenmose, and Another (nos. 86, 112, 42, 226).* London: Egyptian Exploration Society, 1933, 27–34.

El-Bialy, Mohammed. 'Récéntes recherches effectuées dans la tombe No 42 de la Vallée des Rois'. *Memnonia: Bulletin édité par l'Association pour la sauvegarde de Ramesseum* 10 (1999), 161–178.

TT 63 Sobekhotep-Mayor of the Southern Lake and Lake of Sobek: Thutmose IV–Amenhotep III

Dziobek, Eberhard. and Mahmoud Abdel Raziq. *Das Grab des Sobekhotep: Theban Nr 63.* Mainz: von Zabern, 1990.

Wasmuth, Melanie. *Innovation und Extravaganzen: Ein Beitrag zur Architektur des thebanischen Beamtengräber der 18. Dynastie.* Oxford: British Archaeological Reports, 2003, 93.

TT 71 Senenmut, Chief Steward, Steward of Amun, Hatshepsut

Dorman, Peter F. *The Monuments of Senenmut.* London: KPI, 1988.

Dorman, Peter F. *The Tombs of Senenmut: The Architecture and Decoration of Tombs 71 and 353.* New York: Metropolitan Museum of Art, 1991.

TT 78 Haremheb, Royal Scribe, Scribe of Recruits, Thutmosis III–Amenhotep III

Bouriant, Urbain. 'Tombeau de Harmhabi'. In *Sept tombeaux thébaines (MMAF 5, 2)*, edited by Philippe Virey, 413–434. Cairo, 1889.

Brack, Annelies and Artur Brack. *Das Grab des Haremhab, Theben Nr. 78 (ArchVer, 35).* Mainz, 1980.

Hartwig, Melinda K. *Tomb Painting and Identity in Ancient Thebes, 1419–1372 BCE.* [Brussels]; Turnhout, Belgium: Fondation Égyptologique Reine Élisabeth; Brepols, 2004, fig. 25.

Mekhitarian, Arpag. 'Un peintre thébain de la XVIIIe dynastie', *Fs Junker* (1957), 1: 186–192.

Saleh, Mohammed. 'Das Totenbuch in den thebanischen Beamtengräbern des Neuen Reiches'. *ArchVer* 46 (1984): 64, Abb. 74.

Wreszinski, Walter. *Atlas zur Altaegyptischen Kulturgeschichte*. Leipzig: J.C. Hinrichs, 1914, pl. 248.

TT 81 Ineni, Overseer of the Granary of Amun, Amenhotep I–Thutmose III

Boussac, H. *Le Tombeau d'Anna*. Mémoires. Paris: Les Membres de la Mission Archéologique Française au Caire, 1896.

Davies, Nina M. *Scenes from Some Theban Tombs (Nos. 38, 66, 162, with excerpts from 81*. Oxford: Griffith Institute, 1963.

Dziobek, Eberhard. *Das Grab des Ineni: Theben Nr. 81*. Mainz am Rhein: Philipp von Zabern, 1992.

Müller, Wilhelm Max and Carnegie Institution (Washington DC). *Egyptological Researches 1: Results of a Journey in 1904*. Carnegie Institution of Washington: Washington, DC, 1906.

TT 84 Iamunedjeh, First Royal Herald, Overseer of the Gate, Thutmose III

Davies, Nina M. 'Syrians in the Tomb of Amunedjeh'. *Journal of Egyptian Archaeology* 27 (1941): 96–98.

Gnirs, Andrea, Elina Grothe and Heike Guksch. 'Zweiter Vorbericht über die Aufnahme und Publikation von Gräbern der 18. Dynastie der thebanischen Beamtennekropole'. *Mitteilungen des Deutschen Archäologischen Instituts* 53 (1997): 57–83.

Müller, Wilhelm Max and Carnegie Institution (Washington DC). *Egyptological Researches 2: Results of a Journey in 1906*. Carnegie Institution of Washington: Washington, DC, 1910.

Polz, Daniel. 'Bemerkungen der Grabbenutzung in der thebanischen Nekropole'. *Mitteilungen des Deutschen Archäologischen Instituts* 46 (1990): 301–336.

Virey, Philippe. 'Le tombeau d'Am-n-teh et la fonction de [hieroglyphs]'. *Recueil de traveaux relatifs à la philologie et à l'archéologie égyptiennes et assyriennes* 7 (1886): 32–46.

Virey, Philippe. *Sept tombeaux thébains de la XVIIIe dynastie*. Paris: Leroux, 337–361.

Wreszinski, Walter. *Atlas zur Altaegyptischen Kulturgeschichte*. Leipzig: J.C. Hinrichs, 1914.

TT 85 Amenemhab, Lieutenatn-Commander of Soldiers, Thutmose III–Amenhotep II

Davies, Norman. 'Foreigners in the Tomb of Amenemhab (No. 85)'. *JEA* 20 No. 3/4 (No. 1934): 189–192

Di Cossato, Yvonne M.F. 'L'applicazione della difrattometria di polveri con camera Gandolfi nell'analisi dei piGottMiszenti e delle pitture murali: il caso della tomba n. 85 a Tebe ouest'. In: *Sesto Congresso Internazionale di Egittologia, Atti* (Turin: ICE, 1992), I: 441–451.

Eisermann, Sigrid. 'Die Gräber des Imenemhet und des Pehsucher-Vorbild und Kopie?' in: *Thebanische Beamtennekropolen: Neue Perspektiven archäologischen Forschung (SAGA, 12)*, edited by Jan Assmann, Eberhard Dziobek, Heike Guksch and Friederike Kampp, 65–80. Heidelberg, 1995.

Gnirs, Andrea, Elina Grothe and Heike Guksch. 'Zweiter Vorbericht über die Aufnahme und Publikation von Gräbern der 18. Dynastie der thebanischen Beamtennekropole,' *MDAIK* 53 (1997): 57–83.

Virey, Philippe. *Sept tombeaux thébains de la XVIIIe dynastie. (MMAF, 2).* Paris: Leroux 1889, 224–285.

TT 86 Menkheperrasenb, First Prophet of Amun, Thutmose III

Davies, Nina M. and Norman de Garis Davies. *The Tombs of Menkheperrasonb, Amenmose, and Another (nos. 86, 112, 42, 226)*. London: Egyptian Exploration Society, 1933.

Davies, Nina M. and Alan H. Gardiner. *Ancient Egyptian Paintings* [Special publication of the Oriental Institute of the University of Chicago]. Chicago, Ill.: The University of Chicago Press, 1936.

Dorman, Peter. 'Two Tombs and One Owner'. In: *Thebanische Beamtennekropolen: Neue Perspektiven archäologischen Forschung*, edited by Jan Assmann, Eberhard Dziobek, Heike Guksch and Friederike Kampp. Heidelberg: Heidelberger Oreintverlag, 1995, 141–154.

Mond, Robert. 'Report of Work in the Necropolis of Thebes during the Winter of 1903–1904'. *Annales du Service des Antiquités de l'Égypte* 6 (1905): 65–96.

Virey, Philippe. 'Tombe de Ramenkhepersenb'. In: *Sept tombeaux thébains de la XVIIIe dynastie*. Paris: Leroux 1889, 197–215.

TT 89 Amenmose, Steward in the Southern City, Amenhotep III

Brock, Lyla Pinch. 'Art, Industry and the Aegeans in the Tomb of Amenmose'. *Aegypten und Levante* 10 (2000): 129–137.

Brock, Lyla Pinch and Roberta L. Shaw. 'The Royal Ontario Museum Epigraphic Project: Theban Tomb 89: Preliminary Report'. *Journal of the American Research Center in Egypt* 34 (1997): 167–177.

Davies, Nina M. and Norman de Garis Davies. 'The Tomb of Amenmose (No. 89) at Thebes'. *Journal of Egyptian Archaeology* 26 (1940): 131–136.

Mond, Robert. 'Report of Work in the Necropolis of Thebes during the Winter of 1903–1904'. *Annales du Service des Antiquités de l'Égypte* 6 (1905): 65–96.

Sakurai, K., Sakuji Yoshimura and Jiro Kondo. *Comparative Studies of Noble Tombs in Theban Necropolis*. Tokyo: Waseda University, 1988.

Shaw, Roberta. 'The Decorative Scheme in TT 89 (Amenmose)'. *Journal of the Society of the Study of Egyptian Antiquities* 33 (2006): 205–234.

TT 90 Nebamun, Captain of Troops of the Police on the West Bank of Thebes, Thutmose IV–Amenhotep III

Davies, Nina M. and Norman de Garis Davies. *The Tombs of Two Officials of Tuthmosis the Fourth (nos. 75 and 90)*. London: Egyptian Exploration Society, 1923, 1–18.

Davies, Nina M. and Alan H. Gardiner. *Ancient Egyptian Paintings* [Special publication of the Oriental Institute of the University of Chicago]. Chicago, Ill.: The University of Chicago Press, 1936.

Hartwig, Melinda K. *Tomb Painting and Identity in Ancient Thebes, 1419–1372 BCE*. [Brussels]; Turnhout, Belgium: Fondation Ègyptologique Reine Élisabeth; Brepols, 2004.

TT 91 Name Lost, Captain of the Troops … Overseer of Horses, Thutmose IV–Amenhotep III

Hartwig, Melinda K. *Tomb painting and Identity in Ancient Thebes, 1419–1372 BCE*. [Brussels]; Turnhout, Belgium: Fondation Égyptologique Reine Élisabeth; Brepols, 2004, fig. 31–32.

Sakurai, K., Sakuji Yoshimura and Jiro Kondo. *Comparative Studies of Nobles Tombs in Theban Necropolis*. Tokyo: Waseda University, 1988, 18.

TT 100 Rekhmire, Governer of the Town and Vizier, Thutmose III–Amenhotep II

Balcz, Heinrich. 'Zur Komposition der Malereien im Grabmal des Wesirs Rechmire'. *Belvedere* 8 (1925): 74–86.

Davies, Norman de Garis. 'The Defacement of the Tomb of Rekhmirê'. *Chronique d'Égypte; Bulletin périodique de la Fondation Égyptologique Reine Élisabeth, Bruxelles* 15 (1940): 115.

Davies, Norman de Garis. *Paintings from the Tomb of Rekh-mi-Re' at Thebes*. New York: Plantin Press, 1935.

Davies, Norman de Garis. *The Tombs of Rekh-mi-Re' at Thebes*, 2 vols. New York: Arno Press 1973.

Hay, R. *British Museum Additional* MSS.29817.

Hodel-Hoenes, Sigrid. *Leben und Tod im Alten Ägypten: Thebanische Privatgräber des Neuen Reiches*. Darmstadt: Wissenschaftliche Buchgesellschaft, 1991, 123–159.

Newberry, Percy E. *The Life of Rekhmara, Vezîr of Upper Egypt under Thotmes III and Amenhotep II*. Westminster: Constable, 1900.

Schoske, Sylvia. 'Rekhmire'. In *LÄ* V: 180–182.

Virey, Philippe. 'Le Tombeau de Rekhmare, Préfet de Thèbes sous la XVIIIe Dynastie'. Mémoires publiés par les membres de la mission archéologique française au Caire 5,1 (Paris) 1889.

TT 119 Name Lost, Hatshepsut–Thutmose III

Meyer, Eduard. *Bericht Über eine Expedition nach Ägypten zur Erforschung der Darstellungen der Fremdvölker micr, Fremdvölkerdarstellungen Altägyptische Denkmäler: Sammlung Photographischer Aufnahmen aus den Jahren 1912–1913*. Wiesbaden: Harrassowitz Microfiche Service, 1973, 592–593.

Wreszinski, Walter. *Atlas zur Altaegyptischen Kulturgeschichte*. Leipzig: J.C. Hinrichs, 1914.

TT 131 Useramun- Governor of the Town and Vizier, Thutmose I-Thutmose III

Davies, Norman de Garis. 'The Egyptian Expedition, 1924–1925'. *Bulletin of the Metropolitan Museum of Art* (1926): 44–50.

Dziobek, Eberhard. 'Eine grabpyramide des frühen NR in Theben'. *Mitteilungen des Deutschen Archäologischen Instituts, Abteilung Kairo* 45 (1989): 109–132.

Dziobek, Eberhard. *Die Gräber des Vezirs User-Amun: Theben Nr. 61 und 131* (= *ArchVer*, 84). Mainz: von Zabern, 1994.

Dziobek, Eberhard. 'Theban Tombs as a Source for Historical and Biographical Evaluation: The Case of User-Amun'. *Studien zur Archäologie und Geschichte Altägyptens* 12 (Heidelberg, 1995): 129–140.

Hornung, Erik. 'Die Grabkammer des Vezirs User'. *Nachrichten der Akademie der Wissenschaften zu Göttingen, Phil.-hist. Klasse* 5 (1961): 99–120.

TT 143 Name Lost, Title Lost, Thutmose III–Amenhotep II

Davies, Norman de Garis. 'The Work of the Graphic Branch of the Expedition'. *Metropolitan Museum of Art Bulletin* Vol. 30, No. 11, Part 2 (1935): 46–57.

TT 155 Antef, Great Herald of the King- Hatshepsut-Thutmose III

Säve-Söderbergh, Torgny. *Four Eighteenth Dynasty Tombs (Private Tombs at Thebes*, 1). Oxford, 1957, 11–21.

TT 239 Penhet, Governor of All Northern Lands, Tuthmosis IV to Amenophis III

Hartwig, Melinda K. *Tomb Painting and Identity in Ancient Thebes, 1419–1372 BCE.* [Brussels]; Turnhout, Belgium: Fondation Égyptologique Reine Élisabeth; Brepols, 2004, fig. 45.

TT 256 Nebenkemet, Overseer of the Cabine, Amenhotep II

Saleh, Mohammed. 'Das Totenbuch in den thebanischen Beamtengräbern des Neuen Reiches,' *Archäologische Veröffentlichungen, Deutschen Archäologisches Institut, Abteilung Kairo* 46 (1984), 74, Abb. 91.

TT 276 Amenemopet, Overseer of the Treasury of Gold and Silver, Thutmose III–Amenhotep II

Gabolde, Luc. 'Autour de la tombe 276: pourquoi va-t-on se faire enterrer à Gournet Mourai au début du Nouvel Empire?' in *Thebanische Beamtennekropolen: Neue Perspektiven archäologischer Forschung (SAGA, 12)*, edited by Jan Assmann, Eberhard Dziobek, Heike Guksch and Friederike Kampp, 155–165. Heidelberg, 1995.

Gautier, Henri. 'Rappport sommaire sur les fouilles de l'Institut français d'archéologie orientale dans les nécropole thébaine en 1917 et 1918'. *ASAE* 19 (1920): 1–12.

Spiegel, Joachim. 'Ptah-Verehrung in Theben'. *ASAE* 40 (1940): 257–271.

Notes

Chapter 1: Introduction

1 See Bruce R. Dain, *A Hideous Monster of the Mind: American Race Theory in the Early Republic* (Cambridge, Mass.: Harvard University Press, 2002), 59 and Edith Sanders, 'The Hamitic Hypothesis: Its Origin and Functions in Time Perspective', *The Journal of African History*, Vol. 10, No. 4 (1969), 521–532.

2 James B. Pritchard, 'Syrians as Pictured in the Paintings of the Theban Tombs', *Bulletin of the American Schools of Oriental Research*, no. 122 (1951), 36.

3 Gay Robins, *The Art of Ancient Egypt* (Cambridge, Mass.: Harvard University Press, 1997), 32–34. For more on the smiting motif see Emma Swan Hall, *The Pharaoh Smites his Enemies: A Comparative Study* (Munich: Deutscher Kunstverlag, 1986).

4 See Ann Macy Roth, 'Representing the Other: Non-Egyptians in Pharaonic Iconography'. In Melinda Hartwig, *A Companion to Ancient Egyptian Art* (Boston and Oxford:Wiley-Blackwell, 2015), 155–174 for a discussion on royal iconography in relation to the king's physical body.

5 See Friederike Kampp, *Die Thebanische Nekropole: Zum Wandel des Grabgedankens von der XVIII bis XX Dynastie*, 2 vols, Theban Bd. 13 (Mainz am Rhein: Verlag Phillipp von Zabern, 1996) for more information on Theban tomb shapes from the eighteenth to twentieth dynasties.

6 Gay Robins, *The Art of Ancient Egypt*, 139.

7 Melinda Hartwig, *Tomb Painting and Identity in Ancient Thebes, 1419–1372 BCE*, Monumenta Aegyptiaca (Turnhout, Belgium: Fondation Égyptologique Reine Élisabeth: Brepols, 2004), 49–51.

8 See Annie Caubet, 'The International Style: A Point of View from the Levant and Syria', in *The Aegean and the Orient in the Second Millennium: Proceedings of the 50th Anniversary Symposium, Cincinnati, 18–20 April 1997*, ed. Eric H. Cline and Diane Harris (Liège, Belgium; Austin, Texas: Université de Liège, Histoire de l'art et archéologie de la Grèce antique; University of Texas at Austin, Program in Aegean scripts and prehistory, 1998), 105–115 and Helene J. Kantor, *The Aegean and the Orient in the Second Millennium B.C.* (Bloomington, Ind.: Principia Press, 1947).

9 See 'Previous Scholarship' in Eric H. Cline, *Sailing the Wine-Dark Sea: International Trade and the Late Bronze Age Aegean* (Oxford: Tempus Reparatum, 1994), 3–5.

10 For a catalogue of Orientalia and Occidentalia in the Late Bronze Age Aegean see Eric H. Cline, *Sailing the Wine-Dark Sea.*

11 See Gary M. Beckman and Harry A. Hoffner, *Hittite Diplomatic Texts* (Atlanta: Society of Biblical Literature, 1999); David B. O'Connor and Eric H. Cline, *Amenhotep III: Perspectives on His Reign* (Ann Arbor: University of Michigan Press, 1998); Stephen Bourke and Jean-Paul Descœudres, *Trade, Contact, and the Movement of Peoples in the Eastern Mediterranean: Studies in Honour of J. Basil Hennessy* (Sydney: Mediterranean Archaeology Supplement 3, 1995); W. Vivien Davies and Louise Schofield, *Egypt, the Aegean and the Levant: Interconnections in the Second Millennium BC* (London: British Museum Press, 1995); Eric H. Cline, *Sailing the Wine-Dark Sea*; O. T. P. K. Dickinson, *The Aegean Bronze Age* (Cambridge: Cambridge University Press, 1994); Inga Jacobsson, *Aegyptiaca from Late Bronze Age Cyprus* (Jonsered: P. Åströms Förlag, 1994); P. A. Mountjoy, *Mycenaean Pottery: An Introduction* (Oxford University Committee for Archaeology Monograph No. 36. Oxford, 1993); William L. Moran, *The Amarna Letters* (Baltimore: Johns Hopkins University Press, 1992); C. Lambrou-Phillipson, *Hellenorientalia: the Near Eastern Presence in the Bronze Age Aegean, ca. 3000– 1100 B.C.: Interconnections Based on the Material Record and the Written Evidence; Plus Orientalia: a Catalogue of Egyptian, Mesopotamian, Mitannian, Syro-Palestinian, Cypriot and Asia Minor Objects from the Bronze Age Aegean* (Göteborg: P. Åströms Förlag, 1990); N. H. Gale, *Bronze Age Trade in the Mediterranean: Papers Presented at the Conference Held at Rewley House, Oxford, in December 1989* (Jonsered: P. Åströms Förlag, 1991); Shelley Wachsmann, *Aegeans in the Theban Tombs* (Leuven: Peeters, 1987); Philip P. Betancourt, *The History of Minoan Pottery* (Princeton, NJ: Princeton University Press, 1985); Vassos Karageorghis, *Cyprus, from the Stone Age to the Romans* (London: Thames and Hudson, 1982); Barry J. Kemp and Robert S. Merrillees, *Minoan Pottery in Second Millennium Egypt* (Mainz am Rhein: Von Zabern, 1980); Lennart Hellbing, *Alasia Problems.* (Göteborg: P. Åströms, 1979); James Macqueen, *The Hittites and their Contemporaries in Asia Minor* (Boulder, Colo.: Westview Press, 1975); Robert William Ehrich (ed.), *Chronologies in Old World Archaeology* (Chicago and London: University of Chicago Press, 1965).

12 Alaa El-Din M. Shaheen, 'Historical Significance of Selected Scenes Involving Western Asiatics and Nubians in the Private Theban Tombs of the XVIIIth Dynasty', (PhD diss., University of Pennsylvania, 1988).

13 Oric Bates, *The Eastern Libyans* (London, 1914); Lisa L. Giddy, *Egyptian oases: Baḥariya, Dakhla, Farafra, and Kharga during Pharaonic Times* (Warminster: Aris & Phillips, 1987); Wilhelm Hölscher, *Libyer und Ägypter: Beiträge zur Ethnologie und Geschichte libyscher Völkerschaften nach den altägyptischen Quellen* (Glückstadt; New York: J.J. Augustin, 1937); David O'Connor, 'The Nature of Tjemhu (Libyan) Society in the Later New Kingdom' in *Libya and Egypt c. 1300– 750 BC*, ed. Anthony Leahy, (London: University of London, 1990), 29–113; J. Osing, 'Libyen, Libyer', in *Lexikon der Ägyptologie*, 3 (Wiesbaden, 1980), 1015–1033.

14 Louise Bradbury, '*Kpn*-Boats, Punt Trade, and a Lost Emporium', *Journal of the American Research Center in Egypt* 33 (1996), 37–60; Rodolfo Fattovich, 'The Problem of Punt in the Light of Recent Fieldwork in the Eastern Sudan' in *Akten des vierten internationalen Ägyptologen Kongresses München 1985*, 4, ed. Sylvia Schoske (Hamburg, 1991), 257–272; K. A. Kitchen, *Punt and How to Get There* (Rome: Biblical Institute Press, 1971); K. A. Kitchen, 'The Land of Punt' in *The Archaeology of Africa, Food, Metals and Towns*, ed. Thurstan Shaw, Paul Sinclair, Bassey Andah and Alex Okpoko (London/New York: Routledge, 1993), 587–608; K. A. Kitchen, 'Further Thoughts on Punt and its Neighbours' in *Egyptology Studies*, ed. J. W. Tait (London, Egypt Exploration Society: 1999), 173–178; Edouard Henry Naville (ed.), *The Temple of Deir el-Bahari*, vol. 3 (London, 1898); William Stevenson Smith, 'The Land of Punt', *Journal of the American Research Center in Egypt* 1 (1962), 59–61.

Chapter 2: Background

1 Max Müller, *Asien und Europa nach altägyptischen denkmälern* (Leipzig: W. Engelmann, 1893).

2 Wolfgang Helck, 'Fremdvölkerdarstellung', in Wolfgang Helck and Otto Herausgegeben, *Lexikon der Ägyptologie, Band II* (Otto Harrassowitz: Wiesbaden, 1977), 315–321.

3 Melinda Hartwig, *Tomb Painting and Identity in Ancient Thebes.*

4 Ibid., 73–76.

5 Charlotte Booth, *The Role of Foreigners in Ancient Egypt: A Study of Non-Stereotypical Artistic Representations* (Bar International Series. Oxford: Archaeopress, 2005).

6 See ch. 4, 'Unique Foreigner Scenes' in Flora Anthony, 'Paintings of Foreigners in 18th Dynasty Theban Tombs, 1550–1372 BCE' (PhD Diss., Emory University, 2014), 79–91.

7 Flora Anthony, 'Paintings of Foreigners in 18th Dynasty Theban Tombs', 79.

8 Antonio Loprieno, *Topos und Mimesis: zum Ausländer in der Ägyptischen Literatur*, Ägyptologisch Abhandlungen, Bd. 48 (Wiesbaden: O. Harrassowitz, 1988).

9 Stuart Tyson Smith, *Wretched Kush: Ethnic Identities and Boundaries in Egypt's Nubian Empire* (London and New York: Routledge, 2003), 26–29.

10 Ann Macy Roth, 'Representing the Other: Non-Egyptians in Pharaonic Iconography', in *A Companion to Ancient Egyptian Art*, ed. Melinda Hartwig (Hoboken: Wiley), 155–174.

11 Erik Hornung, *Conceptions of God in Ancient Egypt: The One and the Many* (Ithaca: Cornell University Press, 1982), 172–185.

12 Ann Macy Roth, 'Representing the Other', 159.

13 Mu-chou Poo, *Enemies of Civilization Attitudes Toward Foreigners in Ancient Mesopotamia, Egypt, and China* (Albany: State University of New York Press), 2005.

14 Alaa El-Din M. Shaheen', Historical Significance of Selected Scenes Involving Western Asiatics and Nubians in the Private Theban Tombs of the XVIIIth Dynasty'.

15 Shelley Wachsmann, *Aegeans in the Theban Tombs*.

16 See Diamantis Panagiotopolous, 'Foreigners in Egypt in the Time of Hatshepsut and Thutmose III', in *Thutmose III: A New Biography*, ed. Erik H. Cline and David B. O'Connor (Ann Arbor: University of Michigan Press, 2006), 370–413.

17 Diamantis Panagiotopolous, 'Keftiu in Context: Theban Tomb Paintings as a Historical Source', *Oxford Journal of Archaeology* 20 (2001), 263–283.

Chapter 3: The Cosmic Significance of the Tomb

1 K. J. Seyfried, 'Entwicklung in der Grabarchitektur des Neuen Reiches als eine weitere Quelle für teologische Konzeptionen des Ramessidenzeit', in *Problems and Priorities in Egyptian Archaeology*, ed. J. Assmann, G. Burkard and V. Davies (London, New York: KPI, 1987), 219–222.

2 Melinda K. Hartwig, *Tomb Painting and Identity in Ancient Thebes, 1419–1372 BCE*, 1.

3 Friederike Kampp-Seyfried, 'The Theban Necropolis: An Overview of Topography and Tomb Development from the Middle Kingdom to the Ramesside Period', in *The Theban Necropolis: Past, Present and Future*, ed. Nigel Strudwick and John H. Taylor (London: British Museum Press, 2003), 2–10.

4 For more on funerary rituals see Melinda K. Hartwig, *Tomb Painting and Identity in Ancient Thebes, 1419–1372 BCE*, 7–15.

5 Lise Manniche, 'The So-called Scenes of Daily Life in the Private Tombs of the Eighteenth Dynasty: An Overview', in *The Theban Necropolis: Past, Present and Future*, ed. Nigel Strudwick and John H. Taylor (London: British Museum Press, 2003), 42–45.

6 Gay Robins, 'Birds, Blooms and Butterflies, Representing the "Natural World" in New Kingdom Egyptian Art', in progress.

7 Friederike Kampp, 'Overcoming Death: The Private Tombs of Thebes', in *Egypt: The World of the Pharaohs*, ed. Regine Schulz and Matthias Seidel (Cologne: Könnemann, 1998), 250.

8 Ibid., 253–254.

9 Ibid.

10 See Hartwig, 17 fn. 100. 'Various interpretations on the meaning and function of the *Blickpunktsbild* are presented by Fitzenreiter, *SAK* 22 (1995), 95–130 esp. 105, n. 36, who addresses its function as the "icon of social representation" within the realm of the hereafter; and Engelmann-von Carnap, *Thebanische Beamtennekropolen*, 127; idem, *Struktur des thebanischen Beamtenfriedhofs*, 379, 411–417, who argues (along with Fitzenreiter) that the status of the deceased dictated the contents of the *Blickpunktsbild*. While both of these scholars present compelling arguments, they do not examine the full meaning of the *Blickpunktsbild*, which must be analysed both in terms of the tomb's purpose as a regenerative machine and as a living, commemorative monument.'

11 Max Wegner, 'Die Stilentwickelung der thebanischen Beamtengräber', *Mitteilungen des Deutschen Archäologischen Instituts* 4 (1993), 95.

12 Melinda K. Hartwig, *Tomb Painting and Identity in Ancient Thebes, 1419–1372 BCE*, 51. Also see Martin Fitzenreiter, 'Totenverehrung und soziale Repräsentation im thebanischen Beamtengrab der 18. Dynastie', *SAK* 22 (1995), 95–130.

13 Jan Burkard Assmann and Günter Heidelberger Schloss, *5000 Jahre Ägypten: Genese und Permanenz pharaonischer Kunst* (Nussloch: IS-Edition, 1983), 29.

Chapter 4: Foreigner Types

1 John Baines identifies a colour in Ancient Egypt called 'variegated'. This colour indicates texture. For more information see John Baines, 'Color Terminology and Color Classification: Ancient Egyptian Color Terminology and Polychromy', *American Anthropologist* 87, no. 2 (1985): 282–297.

2 For an example of this attire see TT 226, Nina M. Davies and Alan H. Gardiner, *Ancient Egyptian Paintings* [special publication of the Oriental Institute of the

University of Chicago] (Chicago, Ill.: The University of Chicago Press, 1936), Vol. 2, pl. LVIII.

3 For examples of cowhide kilts see the fourth and eighth captives represented on the throne dais from TT 120 see pl. 7. The Nubian figures from this tomb scene also have rosette embellishments on their red sashes.

4 See TT 120 for colour examples of these attributes, pl. 7.

5 See the dais from TT 226, Nina M. Davies, and Alan H. Gardiner, *Ancient Egyptian Paintings*, Vol. 2 pl. LVIII, for examples of foxtails.

6 See TT 192 (Kheruef) for examples of female Nubian captives, Oriental Institute, *The Tomb of Kheruef* (Chicago, Ill.: The Oriental Institute of the University of Chicago, 1980), pl. 49.

7 Barbara S. Lesko, *The Great Goddesses of Egypt* (Norman: University of Oklahoma Press, 1999), 30, 101 and 102.

8 See Wilhelm Max Müller and Carnegie Institution, *Egyptological Researches 2: Results of a Journey in 1904* (Carnegie Institution of Washington: Washington DC, 1906), pl. 30.

9 For examples of male Nubian hair shapes and patterns Norman de Garis Davies, *The Tomb of Rekh-mi-re at Thebes* (New York: Arno Press, 1973), pl. XIX and XX.

10 See the leaders in the tribute scene, ibid., pl. XVIII.

11 See Nina and Norman de Garis Davies, 'The Tomb of Amenmose (No. 89) at Thebes', *JEA* 29 (1940), pl. XXIV and Eberhard Dziobek and Mahmoud Abdel Raziq, *Das Grab des Sobekhotep, Theban Nr. 63*, pl. 3.

12 See Melinda K. Hartwig, *Tomb Painting and Identity in Ancient Thebes*, fig. 31.

13 See Norman de Garis Davies, *The Tombs of Rekhmire at Thebes*, pl. XVIII and Eberhard Dziobek and Mahmoud Abdel Raziq, *Das Grab des Sobekhotep, Theban Nr. 63*, pl. 3. For more on fly amulets see Carol Andrews, *Amulets of Ancient Egypt* (Austin: University of Texas Press, 1994), 62–63.

14 For more on the flies as jewellery, see Susanne Binder, *The Gold of Honour in New Kingdom Egypt* (Warminster: Aris and Phillips Ltd, 2008), 49–55.

15 See Melinda K. Hartwig, *Tomb Painting and Identity in Ancient Thebes, 1419–1372 BCE*, fig. 25; Norman de Garis Davies, *The Tombs of Rekhmire at Thebes*, pl. XX.

16 See Eberhard Dziobek, *Das Grab des Ineni: Theban Nr. 81* (Mainz am Rhein: Philipp von Zabern 1992), pl. 1A.

17 Norman de Garis Davies, *The Tombs of Rekhmire at Thebes*, XXI.

18 See Sobekhotep TT 63, Chic Photo 10342 B_S 10513.

19 See Haremheb (TT 78) Melinda K. Hartwig, *Tomb Painting and Identity in Ancient Thebes, 1419-1372 BCE*, fig. 25 and Nina M. Davies and Alan H. Gardiner, *Ancient Egyptian Paintings*, Vol. 1, pl. XXIX.

20 See Eberhard Dziobek, *Das Grab des Ineni: Theban Nr. 81*, pl. XXII.

21 Norman de Garis Davies, *The Tombs of Rekhmire at Thebes*, XXII.

22 See Sobekhotep (TT 63), Chic. or Inst. photo 07874.A_S

23 For an example see Eberhard Dziobek, *Das Grab des Ineni, Theban Nr. 81*, pl. 1A

24 Hartwig, *Tomb Painting and Identity in Ancient Thebes, 1419–1372 BCE*, fig. 25 and 35.

25 See University of Chicago Photograph 10342 B_S10513.

26 Nina M. Davies and Alan H. Gardiner, *Ancient Egyptian Paintings*, Vol. 2, pl. LVIII.

27 See University of Chicago, Oriental Institute Photograph 10339 B_S. 10507.

28 For an image of the foreigners on the footstool in TT 58, see Nina M. Davies, and Alan H. Gardiner, *Ancient Egyptian Paintings*, Vol. 2, pl. LX.

29 Nina M. Davies, 'Syrians in the Tomb of Amunedjh', *JEA* 27 (1941), XIII.

30 Norman de Garis Davies, *The Tombs of Rekhmire at Thebes*, pl. XXIII.

31 For examples of the two clothing types see Torgny Säve-Söderbergh, Norman de Garis Davies and Nina M. Davies, *Four Eighteenth Dynasty Tombs* (Oxford: Printed for the Griffith Institute at the University Press by C. Batey, 1957), pl. XIII.

32 Pritchard calls this group 'A'. See James B. Pritchard, 'Syrians as Pictured in the Paintings of the Theban Tombs', *Bulletin of the American Schools of Oriental Research*, no. 122 (1951): 36–41.

33 For an example see Nina M. Davies and Norman de Garis Davies, *The Tombs of Menkheperrasonb, Amenmose and Another (nos. 86, 112, 42, 226)* (London: Egypt Exploration Society, 1933), pl. 5.

34 See Davies, *The Tombs of Rekhmire*, XXII.

35 Pritchard, 'Syrians as Pictured in the Paintings of the Theban Tombs', 40.

36 This is type 'D' according to Pritchard.

37 Pritchard identified those with capes as a separate category, group 'C', which persists in images after the eighteenth dynasty.

38 For an example of this see Norman de Garis Davies, *The Tomb of Puyemrê at Thebes* (New York: MMA, 1923), pl. XXXI.

39 For comparanda see Cemal Pulak, 'The Uluburun Shipwreck and Late Bronze Age Trade', in *Beyond Babylon: Art, Trade, and Diplomacy in the Second Millennium B.C.*, ed. Joan Aruz, Kim Benzel and Jean M. Evans (New York: Metropolitan Museum of Art, 2008), 350–352.

40 In TT 84, Davies even goes so far as to say that Levantines with long hair are a different race from Levantines with short hair. He then admits in TT 100 that it is difficult to assign hair styles to different races.

41 For an example of a red-headed Levantine see Davies, *Paintings from the Tomb of Rekh-mi-Re at Thebes* (New York: Plantin Press, 1935), pl. XI.

42 Except for instances in the tombs of Menkheperrasonb and Sobekhotep where children are shown as offerings held by male figures. In these instances it is perhaps likely that the children are being sent to the royal nursery (*kap*). For more information about this see Erika Feucht, 'Kinder fremder Völker in Ägypten', *Studien zur Altägyptischen Kultur* 17 (1990), 177–204.

43 Emily Teeter states that the feather is associated with foreigners, though she doesn't state which specific feather types are associated with the different foreigner people types. See Emily Teeter, 'Feathers', in *UCLA Encyclopedia of Egyptology*, ed. Willeke Wendrich (Los Angeles: UCLA, 2010). http://digital2library.ucla.edu/viewItemdo?ark=21198/zz00256swd

44 Gay Robins, *Women in Ancient Egypt* (Cambridge, Mass.: Harvard University Press, 1993), 185.

45 There are a number of references at Medinet Habu to Libyans who are having pains in childbirth because of their defeat in the battle. See David B. O'Connor and Stephen Quirke, *Mysterious Lands* (London and Portland, Or.: UCL, Institute of Archaeology; Cavendish, 2003), 17.

46 For an example of this see Nina M. Davies and Norman de Garis Davies, *The Tombs of Menkheperrasonb, Amenmose, and Another (nos. 86, 112, 42, 226)*, pl. V.

47 For an example see TT 71 Senenmut: Davies, *Ancient Egyptian Paintings*, I, pl. XIV.

48 See Paul Rehak, 'Aegean Breechcloths, Kilts and the Keftiu', *American Journal of Archaeology* 100 (1996): 33–51 and also by Rehak, 'Aegean Natives in the Theban Tomb Paintings, The *Keftiu* Revisited', in *The Aegean and the Orient in the Second Millennium: Proceedings of the 50th Anniversary Symposium, Cincinatti 18–20 April 1997*, ed. Eric H. Cline and Diane Harris. (Liège, Belgium; Austin, Tex.: Université de Liège, Histoire de l'art et archéologie de la Grèce antique; University of Texas at Austin, Program in Aegean scripts and prehistory, 1998), 39–50.

49 Eberhard Dziobek, *Die Gräber des Vezirs User-Amun: Theben Nr. 61 und 131* (Mainz: von Zabern 1994), pl. 21 and Nina Davies and Alan H. Gardiner, *Ancient Egyptian Paintings*, pl. XIV.

50 Davies, *The Tombs of Menkheperrasonb, Amenmose, and Another*, pl. 4 and Davies, Rekhmire, pl. XVIII, XIX and XX.

51 See Jean Vercoutter, *Essai sur les relations entre Égyptiens et Préhellènes* (Paris: A. Maisonneuve, 1954), 230–236.

52 For an example of these elaborate shoes see Davies, *The Tombs of Rekhmire*, pl. XVIII.

53 Gay Robins, 'Hair and the Construction of Identity in Ancient Egypt, c. 1480–1350 B.C.', *Journal of the American Research Center in Egypt* 36, (1999): 63.

54 In TT 100 there are images of the offerings of the Road of Horus and the Delta (pl. XLV), which is located east of the Nile Valley. People from Wat-hor are not pictured in this scene, and therefore not included in this summary. See Rekhmire, 42 for a list of offerings.

55 In *The Tomb of Rekhmire*, Davies says that the Road of Horus is 'a district on the eastern border fertile enough to be celebrated for its wines down to the Middle Ages', 42. See also Emmanuel Louant, *Comment Pouiemrê triompha de la mort: analyse du programme iconographique de la tombe thébaine no. 39* (Leuven: Peeters, 2000), 62.

56 For more on the Way of Horus see Al Ayedi Tharu, 'The Starting Point on the "Ways of Horus"', (MA thesis, University of Toronto), 2000; James K. Hoffmeier and Stephen O. Moshier, 'A Highway Out of Egypt: the Main Road from Egypt to Canaan', in *Desert Road Archaeology in Ancient Egypt and Beyond*, ed. Frank Förster and Heiko Riemer (Cologne: Heinrich-Barth-Institut, 2013), 485–510.

57 See Torgny Säve-Söderbergh, Norman de Garis Davies and Nina M. Davies, *Four Eighteenth Dynasty Tombs*, pl. XIII.

58 Davies, *The Tombs of Rekhmire*, pl. XVII.

59 Nina M. Davies and Norman de Garis Davies, *The Tombs of Menkheperrasonb, Amenmose, and Another (nos. 86, 112, 42, 226)*, pl. XXV.

60 Davies, *The Tomb of Puyemrê*, pl. XXXII.

61 An earlier example similar to this is found in Ludwig Borchardt, *Das Grabdenkmal des Königs Sáḥu-re*. Vol. 2 (Osnabrück: O. Zeller, 1982), figs. 2, 5 and 6.

62 There seem to be two profiles of this figure's face, but the doubling does not occur on the lower portion of the body, making this image visually confusing.

63 Davies, *The Tomb of Puyemrê*, pl. XXXII.

64 Norman de Garis Davies, 'The Work of the Graphic Branch of the Expedition', *Metropolitan Museum of Art Bulletin* Vol. 30, No. 11, Part 2 (1935), 46.

65 Davies, *The Tombs of Rekhmire*, pl. XVII.

66 Ibid. The men from Punt in the reliefs from Deir el Bahri show the men with black skin and short hair or with shoulder-length hair, thus combining traits from Nubia and the Levant in a unique combination only seen in the reliefs representing Puntites. See Edouard Henry Naville, *The Temple of Deir el-Bahari* III, Pl. LXXIV.

67 Nina and Norman de Garis Davies, 'The Tomb of Amenmose (No. 89) at Thebes', pl. XXV.

68 Davies, *The Tombs of Rekhmire*, pl. XVII.

69 See Dimitri Meeks 'Locating Punt', in *Mysterious Lands*, ed. David O'Connor and Stephen Quirke (London; Portland, Or.: UCL Press, Institute of Archaeology;

Cavendish Pub, 2003); and K. A. Kitchen, 'Further thoughts on Punt and its neighbours', in Anthony Leahy, W. J. Tait and H. S. Smith (eds), *Studies on Ancient Egypt in Honour of H.S. Smith* (London: Egypt Exploration Society, 1999).

70 For more information on the other foreigner scenes in these tombs see the chapter on 'unique scenes' in Flora Brooke Anthony, 'Paintings of Foreigners in 18th Dynasty Theban Tombs', 79–91.

71 See Chapter 5.

72 See the appendix for a list of publications on each tomb.

73 Gay Robins, 'Hair and the Construction of Identity in Ancient Egypt, c. 1480–1350 B.C.', 55–69.

74 Gay Robins, *The Art of Ancient Egypt*, 138.

Chapter 5: Palatial Decorations

1 For more examples of the smiting motif see Emma Swan Hall, *The Pharaoh Smites His Enemies: A Comparative Study*.

2 Andrew Gordon, 'Foreigners', in *The Oxford Encyclopedia of Ancient Egypt*, Vol. 1, ed. Donald B. Redford (Oxford: Oxford University Press, 2001), 544.

3 Melinda K. Hartwig, *Tomb Painting and Identity in Ancient Thebes, 1419–1372 BCE*, 55–73.

4 Egyptian nouns have singular, dual and plural forms. The plural is represented in hieroglyphic writing by three lines and the dual is represented by two lines. Therefore three, instead of two, was the smallest number that formed a plural.

5 James Allen, *Middle Egyptian: An Introduction to the Language and Culture of Hieroglyphs* (Cambridge: Cambridge University Press, 2000), 37–38.

6 The term 'nine bows' was also used by the ancient Egyptians in reference to Egypt's enemies as early as the Pyramid Texts. See Eric Uphill, 'The Nine Bows', *Jaarbericht van het Vooraziatisch-Egyptisch Gezelschap Ex Oriente Lux VI* 19, (1967), 393–420.

7 For more on this mace head see James Edward Quibell and F. W. Green, *Hierakonpolis 2* (London: Quaritch, 1902), 63–64.

8 For more on the history of the nine bows see Eric Uphill, 'The Nine Bows'.

9 For a very early example of crenellated city walls, see the Libyan Palette in W. M. Flinders Petrie, Hilda Flinders Petrie and Margaret Alice Murray. *Ceremonial Slate Palettes* (London: British School of Egyptian Archaeology), 15, pl. G19, G20.

10 Contra Uphill, who states that the first example dates to the reign of Amenhotep III.

11 Rarely, the nine bows can be extended to include additional locales Egypt interacted with in the New Kingdom. For instance in TT 93 the figures include Upper Retenu (*rtnw- Hrt*), Naharin (*nhrn*), Keftiu (*kftyw*) and Menenus (*mnnws*). See Norman de Garis Davies, *The Tomb of Ken-Amun at Thebes* (New York, 1930), pl. XI.

12 Eric Uphill, 'The Nine Bows'.

13 For an attempt at pinpointing the locations of these various locales see Eric Uphill, 'The Nine Bows'.

14 Ibid., 401.

15 'An oval escutcheon or shield bears the name of the people whose face vary for their locality' (Uphill, 'The Nine Bows', 395).

16 See sign A13 of Gardiner's sign list for the foreigner determinative. See James P. Allen, *Middle Egyptian: An Introduction to the Language and Culture of Hieroglyphs*, 423.

17 See Chicago Oriental Institute photographs 10339 B_S. 10507 and 10339A_S.10506.

18 Walter Wreszinski, *Atlas Zur Altaegyptischen Kulturgeschichte* (Leipzig: J.C. Hinrichs, 1914), 88b.

19 Melinda K. Hartwig, *Tomb Painting and Identity in Ancient Thebes, 1419–1372 BCE*, 55.

20 Ibid., cf. fn 15.

21 For an image of this see Oriental Institute, *The Tomb of Kheruef [2] Key Plans and Plates* (Chicago, Ill: The Oriental Institute of the University of Chicago, 1980), pl. 47.

22 For an illustration of this tomb scene see Torgny Säve-Söderbergh, Norman de Garis Davies and Nina M. Davies, *Four Eighteenth Dynasty Tombs* (Oxford: Printed for the Griffith Institute at the University Press by C. Batey, 1957), pl. XVIII.

23 William Stevenson Smith and William Kelly Simpson, *The Art and Architecture of Ancient Egypt* (Harmondsworth: Penguin Books, 1981), 12.

24 Torgny Säve-Söderbergh, Norman de Garis Davies and Nina M. Davies, *Four Eighteenth Dynasty Tombs*, pl. XXX.

25 For an image of Amenhotep III and Queen Tiye from the tomb of Anen, see Gay Robins, *The Art of Ancient Egypt*, 137.

26 For an image of this tomb scene see Torgny Säve-Söderbergh, Norman de Garis Davies and Nina M. Davies, *Four Eighteenth Dynasty Tombs*, pl. XXV.

27 Torgny Säve-Söderbergh, Norman de Garis Davies and Nina M. Davies, *Four Eighteenth Dynasty Tombs*, pl. XXXV.

28 Oriental Institute, *The Tomb of Kheruef [2] Key Plans and Plates* (Chicago, Ill: The Oriental Institute of the University of Chicago, 1980), pl. 47.

29 For a study of palatial decoration see Patrick C. Salland, 'Palatial Paintings and Programs; The Symbolic World of the Egyptian Palace in the New Kingdom'. PhD diss., Institute of Fine Arts New York University, in progress.

30 Annelies and Artur Brack, *Das Grab des Haremheb: Theban Nr. 78* (Mainz am Rhein: Phillip von Zabern), pl. 86.

31 The *rekhyt* can also be translated as 'plebeians', 'subjects' or 'common people'. See Kenneth Griffin, 'Images of the *Rekhyt* from Ancient Egypt' *Ancient Egypt*, Nov. 2006.

32 See Annelies and Artur Brack, *Das Grab des Haremheb: Theban Nr. 78*, pl. 86.

33 Oriental Institute, *The Tomb of Kheruef*, pl. 26.

34 Yasutada Watanabe and Kazuaki Seki, *The Architecture of 'Kom el Samak' at Malkata-South: A Study of Architectural Restoration*, Studies in Egyptian Culture, no. 5 (Tokyo: Waseda University, 1986), pl. 3.

35 For images of these objects and others see Zahi Hawass and Sandro Vannini, *King Tutankhamun: The Treasures of the Tomb* (New York: Thames & Hudson, 2008).

36 Though Tutankhamun is not in the range of this study, his tomb objects help us to see what a king would have owned (in terms of royal accoutrements).

37 This inscription is found on one of the footstools from King Tutankhamun's tomb. For more on King Tutankhamun's footstools see Marianne Eaton-Krauss and Walter Segal, *The Thrones, Chairs, Stools, and Footstools from the Tomb of Tutankhamun* (Oxford: Griffith Institute, 2008).

38 These inlaid tiles, and a statue of a foreigner being devoured by a lion (who is presumably an embodiment of the king), can be seen on display in the Egyptian Gallery at the Metropolitan Museum of Art. See also William Christopher Hayes, *The Scepter of Egypt* (Cambridge, Mass., Published for the Metropolitan Museum of Art by Harvard University Press, 1953), 234.

39 See Norman de Garis Davies, *The Tomb of Ken-Amun at Thebes*, 23; Uphill, 'The Nine Bows', 401.

40 Hannig translates *Iutiu-Setet* as 'Nubian nomads'. See Rainer Hannig, *Großes Handwörterbuch Ägyptisch-Deutsch: Die Sprache der Pharaonen* (Mainz: von Zabern, 1995, 35).

41 This combination of individual elements in innovative fashions is also apparent in the many ways that offering tables are rendered in Egyptian art. See Gay Robins, 'Piles of Offerings: Paradigms of Limitation and Creativity in Ancient Egyptian

Art', in *Proceedings of the Seventh Congress of Egyptologists, 1995*, ed. C. Eyre (Leuven: Peeters 1998), 957–963.

Chapter 6: Underlying Egyptian Concepts in Tribute Scenes

1 See Edward Bleiberg, 'The Redistributive Economy in the New Kingdom Egypt: An Examination of bꜣkw(t)', *Journal of the American Research Center in Egypt 25* (1988), 157–168. Also idem., *The Official Gift in Ancient Egypt* (Norman: University of Oklahoma Press, 1996), 115–125, and Renate Müller-Wollerman. 'Bemerkungen ze den sogenannten Tributen', *Göttinger Miszellen* 66 (1984), 83–83.

2 For more information on how these scenes possibly relate to reality, see Chapter 8.

3 Miriam Lichtheim, *Ancient Egyptian Literature: A Book of Readings, Vol. 2: The New Kingdom* (Berkeley: University of California Press, 1976), 29–35.

4 For more on funerary rites and the standard offering formula that begins with 'an offering that the king gives' see Ann Macy Roth, 'Funerary Ritual' in *OEAE*.

5 For example see Kurt Sethe, *Urkunden der 18. Dynastie*, 4 vols, 2nd ed., (Berlin, 1955–1961) (*Urk*), 1597–1598.

6 Melinda K. Hartwig, *Tomb Painting and Identity in Ancient Thebes, 1419–1372 BCE*, 73. Also see David Lorton, *The Judicial Terminology of International Relations in Egyptian Texts Through Dyn. XVIII* (Baltimore: Johns Hopkins University Press, 1974), 136–148 for specific references to 'the breath of life'.

7 One example of the king receiving the breath of life from a deity is on the southern wall of the burial chamber in the tomb of King Tutankhamun. Here the king is given the breath of life from Hathor.

8 For more information on international exchange in the Late Bronze Age see Chapter 8.

9 Erika Feucht, 'Fishing and Fowling with the Spear and the Throw-Stick Reconsidered', in *The Intellectual Heritage of Egypt: Studies Presented to László Kákosy by Friends and Colleagues on the Occasion of his 60th Birthday*, ed. U. Luft, Studia Aegyptiaca 14 (Budapest, 1992), 168; Jan Assmann, 'Spruch 63 der Sargtexte und die ägyptischen Totenliturgien', in *The World of the Coffin Texts: Proceedings of the Symposium Held on the Occasion of the 100th Birthday of Adriaan de Buck, Leiden, December 17–19, 1992*, ed. H. Willems, EU 9 (Leiden, 1996), 25–26.

10 Westendorf, *ZÄS* 94 (1970), 142–143; Derchain, *SAK* 2(1975), 62–64; Phillippe Derchain, 'Symbols and Metaphors in Literature and Representations of Private

Life', *Royal Anthropological Institute Newsletter* (*RAIN*) 15 (1976), 8010; Lise Manniche, *Sacred Luxuries: Fragrance, Aromatherapy, and Cosmetics in Ancient Egypt* (New York: Cornell University Press, 1999),103–106.

11 For more on Hathor and her cult see Geraldine Pinch, *Votive Offerings to Hathor* (Oxford: Griffith Institute, Ashmolean Museum, 1993).

12 Gay Robins, *Women in Ancient Egypt*, 188.

13 Dimitri Laboury, 'Une relecture de la tombe de Nakht (TT 52, Cheikh 'Abd el-Gourna)', in *La peinture égyptienne ancienne: un monde de signes à préserver: actes du Colloque international de Bruxelles, avril 1994*, ed. Roland Tefnin (Bruxelles: Fondation Égyptologique Reine Élisabeth, 1997), 70–71.

14 The text of the Book of Going Forth By Day provided instructions on how to avoid a torturous afterlife. See Raymond Oliver Faulkner, O. Goelet, Eva Melita von Dassow and James Wasserman, *The Egyptian Book of the Dead: The Book of Going Forth by Day, Being the Papyrus of Ani* (San Francisco, Cal.: Chronicle Books, 1998).

15 Douglas J. Brewer, 'Fish', *OEAE* I (2001), 535; Ingrid Gamer-Wallert, 'Fische und Fischkulte im alten Ägypten', *ÄA* 21 (1970), 128–130; idem, 'Fische religiös', *LÄ* II (1977), 230.

16 Hartwig, 105, fn. 460. Ingrid Gamer-Wallert, 'Fische und Fischkulte im alten Ägypten', 110–111; Martin Dambach and Ingrid Wallert, 'Das Tilapia-Motiv in der altägyptischen Kunst', *Chronique d'Égypte: Bulletin périodique de la Fondation Égyptologique Reine Élisabeth*, Bruxelles 41, no. 82 (1966) 283–294; Dietrich Sahrhage, 'Fischfang und Fischkult im alten Ägypten', *Kulturgeschichte der Antiken Welt* 70 (Mainz, 1998), 137–138, Gay Robins, 'Ancient Egyptian Sexuality', *DIE* 17 (1990), 50; Douglas J. Brewer, 'Fish', *OEAE* I, 533.

17 Douglas J. Brewer and Renée F. Friedman, *Fish and Fishing in Ancient Egypt*. Warminster: Aris & Phillips, 1989; Ingrid Gamer-Wallert, 'Fische und Fischkulte im alten Ägypten', *ÄA* II 1877, 232–233.

18 Gay Robins, 'Ancient Egyptian Sexuality', *DIE* 17 (1990), 61–72; Abdel Ghaffar Shedid and Matthias Seidel, *The Tomb of Nakht*, trans. M. Eaton Krauss (Mainz: Philipp von Zabern, 1996), 17, Sigrid Hodel-Hoenes, *Life and Death in Ancient Egypt: Scenes from Private Tombs in New Kingdom Thebes* (Ithaca, NY: Cornell University Press, 2000), 39.

19 For an argument against this interpretation see E. Feucht, 'Fishing and Fowling with the Spear and Throw Stick Reconsidered', in *The Intellectual Heritage of Egypt: Studies Presented to Lazlo Kokosy by Friends and Colleagues on the Occasion of his 60th Birthday*, ed. U. Luft (Studia Aegyptiaca 14.Budapest, La Chaire d'Egyptologie 1992), 157–169.

20 Wolfhart Westendorf, 'Bemerkungen zur "Kammerder Wiedergeburt"' im Tutanchamungrab', *ZÄS* 94 (1967), 142.

21 Philippe Derchain, 'La perruque et le cristal', *SAK* 2 (1975): 55–74; Gay Robins, 'Hair and the Construction of Identity in Ancient Egypt c. 1480–1350 B.C.', *Journal of the American Research Center in Egypt* 36 (1999), 63.

22 Philippe Derchain, 'La perruque et le cristal', 63. Patrick F. Houlihan and Steven M. Goodman, *The Birds of Ancient Egypt* (Warminster: Aris & Phillips, 1986), 62–65.

23 See Appendix 1.

24 Victoria A. Russell, 'Foreigners in the Tomb of Rekhmire (Theban Tomb 100)', Master's thesis, University of Memphis, 2007, IV.

25 Ibid.

26 However, sometimes children are carried by men in the front of the register. When this occurs, they are held out before them as if they were tribute goods. For an example see TT 63, Eberhard Dziobeck and Mahmud Abd al-Raziq Muhammad, *Das Grab des Sobekhotep: Theben Nr. 63* (Mainz am Rhein: Philipp von Zabern, 1990), pl. 3.

27 David B. O'Connor, 'Manipulating the Image: Minor Arts and the Egyptian World Order', American Research Center in Egypt Conference, 2010.

28 See Pierre Lacau, 'Suppressions et modifications de signes dans les textes funéraires', *Zeitschrift für ägyptische Sprache und Altertumskunde* 51, (1914), 1–64.

29 For more about the concept of destroying chaos within a tomb context see Robert Kriech Ritner, *The Mechanics of Ancient Egyptian Magical Practice*, Studies in Ancient Oriental Civilization (Chicago, Ill.: Oriental Institute of University of Chicago, 1993), 157.

30 For an image of this scene, see Andrew Middleton and Ken Uprichard, *The Nebamun Wall Paintings: Conservation, Scientific Analysis and Display at the British Museum* (London: Archetype Publications, 2008), pl. 2.

31 For examples see J. Vandier d'Abbadie, *Catalogue des objets de toilette égyptiens* (Paris: Éditions des musées nationaux, 1972).

32 For more on symbols of sexuality in ancient Egypt see Lise Manniche, *Sexual Life in Ancient Egypt* (London and New York: KPI; distributed by Methuen Inc., Routledge & Kegan Paul, 1987).

33 Indeed there is even a naked Nubian girl swimming with a duck on a cosmetic spoon. See Jean Vercoutter, 'The Iconography of the Black in Ancient Egypt: From the Beginnings to the Twenty-Fifth Dynasty', in *The Image of the Black in Western Art*, ed. David Bindman and Henry Louis Gates (Cambridge, Mass. and London: Belknap Press of Harvard University Press; in collaboration with the W.E.B. DuBois Institute for African and African American Research and the Menil Collection, 2010), 33–89.

34 Lise Manniche, *Sexual Life in Ancient Egypt*, 46.

35 Though there is intense debate about exact dates regarding trade in the Levant, Egypt and the Aegean. See Eric H. Cline, *Sailing the Wine-Dark Sea: International Trade and the Late Bronze Age Aegean.*

36 Helene J. Kantor, *The Aegean and the Orient in the Second Millenium B.C.* (Bloomington, Ind.: Principia Press, 1947); Janice L. Crowley, *The Aegean and the East: An Investigation into the Transference of Artistic Motifs Between the Aegean, Egypt, and the Near East in the Bronze Age* (Jonsered [Partille, Sweden]: Paul Åströms Förlag, 1989).

37 Annie Caubet, 'The International Style', in *The Aegean and the Orient in the Second Millennium: Proceedings of the 50th Anniversary Symposium, Cincinnati, 18–20 April 1997*, ed. Eric H. Cline and Diane Harris, 110.

38 For more information on the regional exchange systems in the Late Bronze Age see Mario Liverani, *Prestige and Interest: International Relations in the Near East ca. 1600–1100 B.C. History of the Ancient Near East* (Padova: Sargon, 1990).

39 Marian H. Feldman, *Diplomacy by Design: Luxury Arts and an 'International Style' in the Ancient Near East, 1400–1200 BCE* (Chicago: University of Chicago Press, 2006), 59–71.

40 For more on this see the section 'hybridism' in Shelley Wachsmann, *Aegeans in the Theban Tombs*, 4–11.

41 See Nina M. Davies and Norman de Garis Davies, *The Tombs of Menkheperrasonb, Amenmose, and Another (nos. 86, 112, 42, 226)*, pl. IV.

42 See Melinda Hartwig, *Tomb Painting and Identity in Ancient Thebes, 1419–1372 BCE*, fig. 12.

Chapter 7: Funerary Symbolism in Tribute Scenes

1 Jean Vercoutter, *Essai sur les relations entre Égyptiens et Préhellènes* (Paris: A. Maisonneuve, 1954); Paul Rehak, 'Aegean Natives in the Theban Tomb Paintings' in *The Aegean and the Orient in the Second Millennium: Proceedings of the 50th Anniversary Symposium, Cincinatti 18–20 April 1997*, ed. Eric H. Cline and Diane Harris; Robert Laffineur, 'From West to East: the Aegean and Egypt in the Early Late Bronze Age', also in *The Aegean and the Orient*; Shelley Wachsmann, *Aegeans in the Theban Tombs*; Eric H. Cline, *Sailing the Wine-Dark Sea: International Trade and the Late Bronze Age Aegean*; and Pierre Montet, *Les reliques de l'art syrien dans l'Égypte du nouvel empire* (Paris: Société d'édition: Les belles lettres, 1937).

2 See Norman de Garis Davies, *The Tombs of Rekhmire at Thebes*, 26.

3 Including 'a green monkey on its special stool'. For a colour image see Nina M. Davies and Alan H. Gardiner, *Ancient Egyptian Paintings 1*, pl. XVI.

4 Linda Evans, *Animal Behaviour in Egyptian Art: Representations of the Natural World in Memphite Tomb Scenes* (Oxford: Aris and Phillips, 2010).

5 The most complete image of these animals is in Norman de Garis Davies, *The Tombs of Rekhmire at Thebes*, pl. XIX.

6 For an example of ebony and other natural products brought from Nubia see Nina M. Davies and Alan H. Gardiner, *Ancient Egyptian Paintings 1*, pl. XVI.

7 Norman de Garis Davies, *The Tombs of Rekhmire at Thebes*, pl. XVIII.

8 See Melinda K. Hartwig, *Tomb Painting and Identity in Ancient Thebes*, fig. 25.

9 Ibid., fig. 28.

10 Melinda K. Hartwig, *Tomb Painting and Identity in Ancient Thebes*, fig. 31.

11 John Coleman Darnell and Coleen Manassa, *Tutankhamun's Armies: Battle and Conquest During Ancient Egypt's Late Eighteenth Dynasty* (Hoboken, NJ: John Wiley & Sons, 2007), 67.

12 Since these representations are anomalous to this tomb, and indeed this recording, it is possible that Müller's colours are inaccurate.

13 Robins, *Women in Ancient Egypt*, 185–186.

14 For more on this myth see Claas Jouco Bleeker, *Hathor and Thoth; Two Key Figures of the Ancient Egyptian Religion* (Leiden: Brill, 1973), 130 and 131.

15 Mario Liverani, *Prestige and Interest: International Relations in the Near East ca. 1600–1100 B.C*, 38.

16 For an image of the Narmer Palette see Figure 1 and William Stevenson Smith, *The Art and Architecture of Ancient Egypt*, 12.

17 Melinda K. Hartwig, *Tomb Painting and Identity in Ancient Thebes*, fig. 30.

18 For more on the Levantines see Rolf Gundlach, 'Asiaten' in *LÄ* 1 (1975), 462–471.

19 Contra Norman de Garis Davies, 'Review of Pierre Montet, *Les reliques de l'art syrien dans l'Égypte du nouvel empire*', *JEA* 24 No. 2 (1938): 253–254.

20 For a more in-depth discussion on Levantine vase types in these scnes, see Pierre Montet, *Les reliques de l'art syrien dans l'Égypte du nouvel empire*.

21 Norman de Garis Davies, *The Tombs of Rekhmire*, pl. XXI.

22 For an example see Nina M. Davies and Norman de Garis Davies, *The Tombs of Menkheperrasonb, Amenmose, and Another (nos. 86, 112, 42, 226)*, pl. XXIV.

23 Nina M. Davies, 'Syrians in the Tomb of Amunedjeh', XIII.

24 Nina M. Davies and Norman de Garis Davies, *The Tombs of Menkheperrasonb, Amenmose, and Another (nos. 86, 112, 42, 226)*, pl. IV.

25 Though poppies do not grow in marsh environments.

26 In the ancient Mediterranean pomegranates were associated with immortality, so their presence in these scenes would be appropriate. However, I believe that the images in the Theban tombs are indeed poppy plants. See Mark David Merlin, *On the Trail of the Ancient Opium Poppy* (Rutherford, London and Cranbury, NJ: Fairleigh Dickinson University Press; Associated University Presses, 1984), 200–201.

27 For more information on poppies see L. D. Kapoor, *Opium Poppy: Botany, Chemistry, and Pharmacology* (New York: Food Products Press, 1995).

28 J. Gwyn Griffiths, 'Solar Cycle', *OEAE* II, 476–480.

29 Araldo De Luca, Alessandro Bongioanni, Maria Sole Croce and Laura Accomazzo, *The Illustrated Guide to the Egyptian Museum in Cairo* (Cairo: American University in Cairo Press, 2001), 150.

30 Vincent Arieh Tobin, 'Creation Myths', *OEAE* II, 469–472.

31 P. Barguet, 'L'origine de la signification du contrepoids de collier-menat', *BIFAO* 52, 103–111. For more iconography of Hathor in the Marsh see Geraldine Pinch, *Votive offerings to Hathor* (Oxford: Griffith Institute, Ashmolean Museum, 1993), 175–176.

32 Lise Manniche, 'Sexuality', in *OEAE* III, 274–276.

33 Carol Andrews, *Amulets of Ancient Egypt*, 44.

34 Norman de Garis Davies, *The Tombs of Rekhmire*, pl. XXIII, Wilhelm Max Müller and Carnegie Institution (Washington, DC), *Egyptological Researches 1: Results of a Journey in 1904* (Washington, DC: Carnegie Institution of Washington, 1906), vol. 1 pl. 9, and Nina M. Davies and Norman de Garis Davies, *The Tombs of Menkheperrasonb, Amenmose, and Another* Amenmose TT 42, pl. XXXIV.

35 Richard H. Wilkinson, *Symbol and Magic in Egyptian Art* (New York: Thames and Hudson, 1994), 106. Also see Geraldine Pinch 'Red Things: The Symbolism of Colour in Magic', in *Colour and Painting in Ancient Egypt*, ed. W. V. Davies (London: British Museum Press, 2001), 182–191.

36 Eberhard Dziobek, *Das Grab des Ineni: Theben Nr.81*, pl. 1a.

37 For a summary on Egypt and the Aegean, see *Lexikon der Ägyptologie*, 'Ägäis und Ägypten' vol I, 69–76

38 Shelley Wachsmann discusses all of the tribute brought from the Aegean in his book *Aegeans in the Theban Tombs Orientalia Lovaniensia Analecta.*

39 For more on the Aegean tribute, see Wachsmann, *Aegeans in the Theban Tombs*, 41–77.

40 Nina M. Davies and Norman de Garis Davies, *The Tombs of Menkheperrasonb, Amenmose, and Another (nos. 86, 112, 42, 226)* pl.V and VI.

41 Ibid., and Eberhard Dziobek, *Die Gräber des Vezirs User-Amun: Theben Nr. 61 und 131*, pl. 92.2

42 See Shelley Wachsmann, *Aegeans in the Theban Tombs*, 56–57.

43 Jean Vercoutter, *Essai sur les relations entre Égyptiens et Préhellènes*, 317–318, docs. 270–272.

44 Ibid.

45 One is brought in the tomb of Useramun, two in Menkheparrasonb and once in Rekhmire.

46 Helene J. Kantor, 'The Aegean and the Orient in the Second Millennium B.C', *American Journal of Archaeology* 51, no. 1 (1947): 47.

47 Shelley Wachsmann, *Aegeans in the Theban Tombs*, 61.

48 Helene J. Kantor, *The Aegean and the Orient in the Second Millennium B.C.* (Bloomington, Ind.: Principia Press, 1947), 47 and Jean Vercoutter, *Essai sur les relations entre Égyptiens et Préhellènes*, 315.

49 Sometimes the Egyptian artist(s) takes the liberty to add details depending on their aesthetic preferences. For instance, in the tomb of Rekhmire the artists seem to like S-scroll handles (Aegean in origin) on many of their vessels. For a summary of dating methods based on archaeological records see Paul Rehak, 'Aegean Natives in the Theban Tomb Paintings'.

50 Shelley Wachsmann, *Aegeans in the Theban Tombs*, 61–62.

51 Jean Vercoutter, *Essai sur les relations entre Égyptiens et Préhellènes*, 363 and pl. LXIII.

52 For more on oxhide ingots see Rehak and Laffineur's articles in *The Aegean and the Orient*.

53 See Shelley Wachsmann, *Aegeans in the Theban Tombs*, 49–77 for a discussion of all of the goods brought in the Aegean tribute scenes.

54 An example of this is the model head arising from a water lily in the tomb of Tutankhamun.

55 I. E. S. Edwards and the National Gallery of Art, *Treasures of Tutankhamun* (New York: Ballantine Books, 1976), 99.

56 '*Hes* vase', Brooklyn Museum, accessed 21 April 2016, https://www. brooklynmuseum.org/opencollection/objects/3500/Hes_Vase_with_Cover.

57 Contra Vercoutter, *Essai sur les relations entre Égyptiens et Préhellènes*, 190 and Ellen N. Davis, *The Vapheio Cups and Aegean Gold and Silver Ware* (New York: Garland Pub., 1977), 49. For another example of an impossibly large vessel being presented in a Levantine scene, see the tomb of Amenmose.

58 See Shelley Wachsmann, *Aegeans in the Theban Tombs*, 5 (emphasis added).

59 Ibid., 12.

60 Norman de Garis Davies, *The Tombs of Rekhmire*, pl. XLII.

61 G. Hermann, 'Lapis Lazuli: The Early Phases of its Trade', in *Iraq* 30 1968, 29 and J. D. Muhly, 'Copper and Tin: The Distribution of Mineral Resources and the

Nature of the Metals Trade in the Bronze Age', in *Transactions of the Connecticut Academy of Arts and Sciences* 43 (New Haven, Connecticut, 1973), 155–535.

62 See Paul Rehak, 'Aegean Breechcloths, Kilts and the Keftiu'. *American Journal of Archaeology* 100 (1996), 33–51.

63 Ibid., 50.

64 Ibid., 51.

65 See more information about wine in ancient Egypt in Mu-chou Poo, *Wine and Wine Offering in the Religion of Ancient Egypt* (London and New York: Kegan Paul International; distributed by Columbia University Press, 1995).

66 See Norman de Garis Davies, *The Tomb of Puyemrê at Thebes*, pl. XXXII for examples of incense trees from Punt.

67 Which is distinctly modelled on the scenes from the middle terrace of Deir el Bahri. See Edouard Henry Naville, *The Temple of Deir el-Bahari*, pls LXXVI–LXXIX. Faulkner uses the term 'throwstick', 38. For the same word, *aAmw*, Davies uses 'club' or 'sword' and Naville translates it as 'boomerang'.

68 Not much is known about the various stone types and what their modern names are. For more on materials in ancient Egypt see Paul T. Nicholson and Ian Shaw, *Ancient Egyptian Materials and Technology* (Cambridge; New York: Cambridge University Press, 2000).

69 See Dimitri Meeks, 'Locating Punt', in *Mysterious Lands*, 67–68; and K. A. Kitchen, 'Further thoughts on Punt and its Neighbours', 173–178.

70 Nina M. Davies and Norman de Garis Davies, *The Tombs of Menkheperrasonb, Amenmose, and Another (nos. 86, 112, 42, 226)*, pl. XXXVI.

71 See Erika Feucht 'Kinder fremder Völker in Ägypten'.

72 For example see TT 86; Nina M. Davies and Norman de Garis Davies, *The Tombs of Menkheperrasonb, Amenmose, and Another (nos. 86, 112, 42, 226)*, pl. 3. For more on the breath of life see David Lorton's *The Juridical Terminology of International Relations in Egyptian Texts Through Dyn. XVIII* (Baltimore: Johns Hopkins University Press), 1974.

73 Raymond O. Faulkner, *A Concise Dictionary of Middle Egyptian* (Oxford: Printed for the Griffith Institute at the University Press by V. Ridler, 1962), 148.

74 See Patrick Houlihan, 'Frogs', *OEAE* 1, 563.

75 Melinda Hartwig, *Tomb Painting and Identity in Ancient Thebes, 1419–1372 BCE*, 104.

Chapter 8: Between Symbolism and Historical Veracity

1 Shelley Wachsmann, *Aegeans in the Theban Tombs*, 105.

2 Ibid.

3 Ann Macy Roth, 'Representing the Other: Non-Egyptians in Pharaonic Iconography', 171

4 Ibid.

5 Marian H. Feldman, *Diplomacy by Design: Luxury Arts and an 'International Style' in the Ancient Near East, 1400–1200 BCE*, 1–20.

6 Ibid., 8.

7 Ibid., 16.

8 Ibid., 20.

9 Ibid., 8.

10 Ibid.

11 Cemal Pulak, 'The Uluburun Shipwreck and Late Bronze Age Trade', in *Beyond Babylon: Art, Trade and Diplomacy in the Second Millennium BC*, 289–310.

12 There are Minoan cupbearer frescos at Knossos that do resemble the Minoans from the Theban tribute scenes. For more information on these images see Arthur Evans and Joan Evans, *The Palace of Minos; A Comparative Account of the Successive Stages of the Early Cretan Civilization As Illustrated by the Discoveries at Knossos* (London: Macmillan and Co., Limited, 1921), 719–758.

13 Such issues are better addressed by Panagiotopolous and Shaheen. See Diamantis Panagiotopolous, 'Foreigners in Egypt in the Time of Hatshepsut and Thutmose III', in *Thutmose III: A New Biography*, ed. Erik H. Cline and David B. O'Connor (Ann Arbor: University of Michigan Press, 2006), 370–413; as well as his 'Kefitu in Context: Theban Tomb-Paintings as a Historical Source', *Oxford Journal of Archaeology* 20 (2001), 263–283; and Alaa El-Din M. Shaheen, 'Historical Significance of Selected Scenes Involving Western Asiatics and Nubians in the Private Theban Tombs of the XVIIIth Dynasty'.

14 Alaa El-Din M. Shaheen, 'Historical Significance of Selected Scenes Involving Western Asiatics and Nubians in the Private Theban Tombs of the XVIIIth Dynasty'; Wilifried Seipel, 'Hatschepsut I', *LÄ* II (1977), 1045–1051.

15 Etienne Drioton and Jacques Vandier. *L'Egypte: Introduction aux études historiques: Les Peuples de l'Orient méditerranean, II/ 4th edition* (Paris 1962), 398; A. J. Arkell, *A History of the Sudan: From the Earliest Times to 1821* (London: University of London, Athlone Press, 1961), 87; Alan H. Gardiner, *Egypt of the Pharaohs: An Introduction* (Oxford: Clarendon Press, 1961), 189; Torgny Säve-Söderbergh, *The Navy of the Eighteenth Egyptian Dynasty* (Uppsala: University of Uppsala, 1946), 17.

16 Labib Habachi, 'Two Graffiti at Sehel from the Reign of Queen Hatshepsut', *JNES* 16 (1957), 99. Also see Donald Redford, *The History and Chronology of the Eighteenth Dynasty of Egypt: Seven Studies* (Toronto: University of Toronto Press, 1967), 58; Edouard Naville, *The Temple of Deir el Bahari VI*, pl. 152.

17 Donald Redford, *The History and Chronology of the Eighteenth Dynasty of Egypt*, 60.

18 David O'Connor, 'The Location of Irem', *JEA* 73 (1987), 126.

19 Ibid., 122–124, fig. 2.

20 Donald Redford, *History and Chronology of the Eighteenth Dynasty of Egypt*, 62.

21 Alaa El-Din Shaheen, 'Historical Significance of Selected Scenes Involving Western Asiatics and Nubians in the Private Theban Tombs of the XVIIIth Dynasty', 17.

22 Donald B. Redford, 'Thutmosis III', *LÄ* VI, (1985), 540–548. See also Donald Redford, 'The Northern Wars of Thutmose III', in *Thutmose III: A New Biography*, ed. Eric H. Cline and David B. O'Connor (Ann Arbor: University of Michigan Press, 2006), 325–343; and Anthony Spalinger, 'Covetous Eyes South: The Background to Egypt's Domination of Nubia by the Reign of Thutmose III' in the same volume.

23 D. G. Hogarth, 'Egyptian Empire in Asia', *JEA* 1 (1914), 11

24 Etienne Drioton and Jacques Vandier, *L'Egypte*, 399. See also Donald Redford, 'A Bronze Age Itinerary in Transjordan', *JSSEA* 12 (1982), 58; James Weinstein, 'The Egyptian Empire in Palestine: A Reassessment', *Bulletin of the American Schools of Oriental Research*, no. 241, 4.

25 *Urk*, IV, 890–97

26 For a better understanding of the term *inw* in all periods of ancient Egyptian history see Edward Bleiberg, *The Official Gift in Ancient Egypt* (Norman: University of Oklahoma Press, 1996).

27 Hermann Grapow, *Studien zu den Annalen Thutmosis des Dritten und zu ihnen verwandten historischen Berichten des neuen Reiches* (Berlin: Akademie-Verlag, 1949), 8; *BAR* II, 444–449.

28 W. F. Albright and A. Rowe, 'A Royal Stele of the New Empire from Galilee', *JEA* 14 (1928), 283; 285.

29 For a full list of these conquests see Anthony Spalinger, 'A Critical Analysis of the Annals of Thutmose III (Stucke V–VI), *JARCE* XIV (1977), 41–54.

30 Michael C. Astour, 'Tunip-hamath and its Region: A Contribution to the Historical Geography of Central Syria', *Orientalia* 46 (1) (Gregorian Biblical Press, 1977), 64.

31 Hermann Grapow, *Studien zu den Annalen Thutmosis des Dritten und zu ihnen verwandten historischen Berichten des neuen Reiches* (Berlin: Akademie-Verlag, 1949), 8; *BAR* II, 454–62, Wolfgang Helck, *Die Beziehungen Ägyptens zu Vorderasien im 3. und 2. Jahrtausend v[or] Chr[istus]* (Wiesbaden: Harrassowitz, 1971), 137.

32 Quote from Alaa El-Din Shaheen, 'Historical Significance of Selected Scenes Involving Western Asiatics and Nubians in the Private Theban Tombs of the

XVIIIth Dynasty', 20. Information from Hermann Grapow, *Studien zu den Annalen*, 9; *BAR* II, 63–67.

33 Alaa El-Din Shaheen, 'Historical Significance of Selected Scenes Involving Western Asiatics and Nubians in the Private Theban Tombs of the XVIIIth Dynasty', 20.

34 For more on Megiddo, the reality versus tradition, see Donald Redford, 'The Northern Wars of Thutmose III', 329–332.

35 Ibid., 329–330.

36 Wolfgang Helck, *Die Beziehungen*, 138. For more info on this strategy and how it involves the Akra Plain see Donald Redford, 'The Northern Wars of Thutmose III', 332.

37 Michel Valloggia, *Recherches sur les 'messagers' (Wpwtyw) dans les sources Egyptiennes profanes* (Geneva and Paris: Droz, 1976), 93.

38 Alaa El-Din Shaheen, 'Historical Significance of Selected Scenes Involving Western Asiatics and Nubians in the Private Theban Tombs of the XVIIIth Dynasty', 21.

39 Wolfgang Helck, *Die Beziehungen*, 129.

40 O. R. Gurney, 'Anatolia c. 1750–1600 BC', *CAH* II, I, 671

41 *BAR* II, 488–95

42 David O'Connor, 'The Location of Irem', 108–110.

43 *BAR* II, 285.

44 *BAR* II, 506–515.

45 Raphael Giveon, *Les Bédouins Shosou des documents égyptiens* (Leiden: E.J. Brill, 1971), 10.

46 Manfred Görg, 'Thutmosis III. Und Die Shasu-region', *JNES* 38 (1979): 190–202.

47 *Urk* IV, 893, 6.

48 *BAR* II 520–539.

49 Ibid.

50 See Donald Redford, *The Wars in Syria and Palestine of Thutmose III* (Leiden and Boston: Brill, 2003) for more detailed information on these conquests.

51 *Urk* IV, 702, 9; 703, 4; 708, 9; 709, 5; 716, 4; 721, 2; 725, 10; 727, 16; 728, 11; 733, 9; 734, 2; Torgny Säve-Söderbergh, *Ägypten und Nubien: ein Beitrag zur Geschichte altägyptischer Aussenpolitik* (Lund: Håkan Ohlssons Boktryckeri, 1941), 153.

52 *LÄ* I, 1975, 204.

53 For more information on the military campaigns of Amenhotep II, see Peter Der Manuelian, *Studies in the Reign of Amenhotep II* (Hildesheim: Gerstenberg, 1987).

54 *LÄ* I, 20.

55 Söderbergh, *Ägypten Und Nubien*, 156.

56 For more on these campaigns see Part Two of Peter Der Manuelian, *Studies in the Reign of Amenophis II*, 45–83.

57 Alaa El-Din Shaheen, 'Historical Significance of Selected Scenes Involving Western Asiatics and Nubians in the Private Theban Tombs of the XVIIIth Dynasty', 27.

58 *Urk* IV, 1297, 3–4.

59 *AEO* I, 164.

60 Wolfgang Helck, *Die Beziehungen*, 158.

61 Wolfgang Helck, *Die Beziehungen*, 159.

62 Quote from Alaa El-Din Shaheen, 'Historical Significance of Selected Scenes Involving Western Asiatics and Nubians in the Private Theban Tombs of the XVIIIth Dynasty', 28. Information from Georg Steindorff and Keith C. Seele, *When Egypt Ruled the East* (Chicago: University of Chicago Press, 1957), 69; and R. Giveon, 'Thutmosis IV and Asia', *JNES* 28 (1969), 51–59.

63 Wolfgang Helck, *Die Beziehungen*, 160–61.

64 Ibid., 163.

65 Elmar Edel, *Die Stelen Amenophis II. aus Karnak und Memphis: mit dem Bericht über d. asiatischen Feldzüge des Königs* (Wiesbaden: Harrassowitz, 1953), 173–199.

66 Anthony Spalinger, 'A Critical Analysis of the "Annals" of Thutmose III (Stucke V–VI), *JARCE* XIV (1977), 95.

67 *Urk* IV, 1309; Giveon, 'Thutmosis IV and Asia', 54.

68 Donald B. Redford, *Akhenaten, the Heretic King* (Princeton: Princeton University Press, 1984), 19.

69 Ibid., 19.

70 *LÄ* VI, (1985), 550.

71 Alan Henderson Gardiner, *Egypt of the Pharaohs* (Oxford: Clarendon Press, 1966), 204.

72 R. Gundlach, 'Thutmosis IV', *LÄ* VI (1985), 550.

73 Alaa El-Din Shaheen, 'Historical Significance of Selected Scenes Involving Western Asiatics and Nubians in the Private Theban Tombs of the XVIIIth Dynasty', 32–33.

74 Gundach, 'Thutmosis IV', 550; Alan Schulman, 'Diplomatic Marriage in the Egyptian New Kingdom', *JNES* 38,3 (1979), 177.

75 Donald B. Redford, *Akhenaten, the Heretic King* (Princeton, NJ: Princeton University Press, 1984), 20.

76 *Urk* IV, 1554, 17–18, AEO, I, 164; Abraham Malamat, 'Campaigns of Amenhotep II and Thutmose IV to Canaan', *Scripta Heirosolymitana*, 8, (1961), 229–230.

77 Donald Redford, *Akhentaten*, 20.

78 For more information on Thutmose IV see Betsy Morrell Bryan, *The Reign of Thutmose IV* (Baltimore: Johns Hopkins University Press), 1991.

79 James Henry Breasted, *A History of the Ancient Egyptians* (New York: C. Scribner's Sons, 1908), 248; W. C. Hayes, 'Egypt: Internal Affairs from Tuthmosis I to the Death of Amenophis III', *CAH*, II, I, Chapter IX (1973), 321.

80 Torgny Säve-Söderbergh, *Ägypten und Nubien*, 156. Walter B. Emery, *Egypt in Nubia* (London: Hutchinson, 1965).

81 David B. O'Connor, 'New Kingdom and Third Intermediate Period: 1552–664 BC', in *Ancient Egypt: A Social History*, ed. Bruce G. Trigger (Cambridge: Cambridge University Press, 1983), 259.

82 *LÄ* I, (1975), 106–210. See also James M. Weinstein, Eric H. Cline, Kenneth A. Kitchen and David O'Connor, 'The World Abroad', in *Amenhotep III: Perspectives on His Reign*, ed. David B. O'Connor and Eric H. Cline (Ann Arbor: University of Michigan Press, 1998); and Arielle P. Kozloff, *Amenhotep III: Egypt's Radiant Pharaoh* (Cambridge: Cambridge University Press, 2012).

83 James M. Weinstein, 'Egypt and the Levant in the Reign of Amenhotep III' from 'The World Abroad', 224.

84 Wolfgang Helck, *Die Beziehungen*,169.

85 George Steindorff and Keith C. Seele, *When Egypt Ruled the East*, 72. James Henry Breasted, *A History of the Ancient Egyptians*, 25.

86 Alaa El-Din Shaheen, 'Historical Significance of Selected Scenes Involving Western Asiatics and Nubians in the Private Theban Tombs of the XVIIIth Dynasty', 37.

87 B. J. Kemp, 'Imperialism and Empire in New Kingdom Egypt (c. 1575–1087 B.C.)', in *Imperialism in the Ancient World*, ed. P. Garnsey and C. R. Whittaker (Cambridge: Cambridge University Press, 1983), 55.

88 Ibid.

89 David O'Connor, 'New Kingdom and Third Intermediate Period: 1552–664 B.C.', in B. G. Trigger, B. J. Kemp, D. O'Connor and A. B. Lloyd, *Ancient Egypt: A Social History* (Cambridge: Cambridge University Press, 1983), 259.

90 Alaa El-Din Shaheen, 'Historical Significance of Selected Scenes Involving Western Asiatics and Nubians in the Private Theban Tombs of the XVIIIth Dynasty', 35.

91 Ibid., 36.

92 David O'Connor, 'Amenhotep III and Nubia' in 'The World Abroad', 266.

93 Shelley Wachsmann, *Aegeans in the Theban Tombs*, 105. This is the transition from LM IB to LM II.

94 Ibid., 105.

95 Ibid.

96 Tombs 42, 256, 63, 90, 91, 239 and 89.

97 See Edouard Henry Naville, *Deir el Bahari*, Pls LXXVI–LXXIX.

98 Norman de Garis Davies, *The Tomb of Puyemrê at Thebes*, 81 cf. fn. 3 for more info on Wady Tumilat. See also Emmanuel Louant, *Comment Pouiemrê triompha de la mort: analyse du programme iconographique de la tombe thébaine no. 39* (Leuven: Peeters, 2000), 62–63. For more on the Way of Horus see Al Ayedi Tharu, 'The Starting Point on the "Ways of Horus"', (MA thesis, University of Toronto, 2000); James K. Hoffmeier and Stephen O. Moshier, 'A Highway Out of Egypt: The Main Road from Egypt to Canaan', in *Desert Road Archaeology in Ancient Egypt and Beyond*, ed. Frank Förster and Heiko Riemer (Cologne: Heinrich-Barth-Institut, 2013), 485–510.

99 Norman de Garis Davies, *The Tomb of Puyemrê at Thebes*, 82.

100 See Lisa L. Giddy, *Egyptian oases: Baḥariya, Dakhla, Farafra, and Kharga during Pharaonic Times* (Warminster: Aris & Phillips), 1987.

101 See Dimitri Meeks, 'Locating Punt', in *Mysterious Lands*, ed. David O'Connor and Stephen Quirke, 67–68; and K. A. Kitchen, 'Further thoughts on Punt and its Neighbours', 173–178.

Chapter 9: Conclusions

1 See Appendix 2

2 James B. Pritchard, 'Syrians as Pictured in the Paintings of the Theban Tombs', 36.

3 Stuart Tyson Smith, *Wretched Kush: Ethnic Identities and Boundaries in Egypt's Nubian Empire* (London and New York: Routledge, 2003), 19–29.

4 For more on Orientalist artwork see Linda Nochlin, 'The Imaginary Orient', in *Visual Culture: Spaces of Visual Culture*, ed. Marquard Smith and Joanne Morra (New York: Routledge, 2006), 19–35; and Edward W. Said, *Orientalism* (New York: Pantheon Books, 1978).

Appendix 2

1 The ownership of this tomb is debated, see Erdmann Schott, *Wort und Gemeinde. Festschrift für Erdmann Schott zum 65. Gebrutstag* (Berlin: Evangelische Verlaganstalt, 1967), 61–70; Percy Newberry, 'The Sons of Thutmosis IV', *JEA* 14 (1928), 82–85; and Paul John Frandsen, 'Heqasheru and the Family of Tuthmosis IV', *Acta Orientalia: Ediderunt Societates Orientales Batava, Danica, Norwegica* 37 (1967), 5–10.

Bibliography

Allen, James P. *Middle Egyptian: An Introduction to the Language and Culture of Hieroglyphs*. Cambridge: Cambridge University Press, 2010.

Andrews, Carol. *Amulets of Ancient Egypt*. Austin: University of Texas Press, 1994.

Aruz, Joan, Kim Benzel and Jean M. Evans. *Beyond Babylon: Art, Trade, and Diplomacy in the Second Millennium B.C.* New York: Metropolitan Museum of Art, 2008.

Assmann, Jan. *Der König als Sonnenpriester: ein kosmographischer Begleittext zur kultischen Sonnenhymnik in thebanischen Tempeln und Gräbern*. Abhandlungen des Deutschen Archäologischen Instituts Kairo, Ägyptologische Reihe 7. Glückstadt: Augustin, 1970.

Assmann, Jan. *Sonnenhymnen in thebanischen Gräbern*. Mainz am Rhein: Von Zabern, 1983.

Assmann, Jan Burkard and Günter Heidelberger Schloss. *5000 Jahre Ägypten: Genese und Permanenz pharaonischer Kunst*. Nussloch: IS-Edition, 1983.

Assmann, Jan. 'Spruch 63 der Sargtexte und die ägyptischen Totenliturgien'. In *The World of the Coffin Texts: Proceedings of the Symposium Held on the Occasion of the 100th Birthday of Adriaan de Buck, Leiden, December 17–19, 1992*, ed. H. Willems, 25–26. Leiden, 1996.

Baines, John. 'Color Terminology and Color Classification: Ancient Egyptian Color Terminology and Polychromy'. *American Anthropologist* 87, no. 2 (1985): 282–297.

Balcz, Heinrich. 'Zur Komposition der Malereien im Grabmal des Wesirs Rechmire'. *Belvedere* 8 (1925): 74–86.

Barguet, P. 'L'origine de la signification du contrepoids de collier-menat'. *BIFAO* 52, 103–111.

Bates, Oric. *The Eastern Libyans: An Essay*. London: F. Cass, 1970.

Baud, Marcelle. *Les dessins ébauchés de la nécropole thébaine: au temps du nouvel empire. Ouvrage publié avec le concours de l'Académie des Inscriptions et Belles Lettres, Fondation Catenacci*. Le Caire: Imprimerie de l'Institut Français d'Archéologie Orientale, 1935.

Baud, Marcelle. 'Le tombeau de Khâemouast (No. 261 à Thèbes)'. *RdE* 19 (1967): 21–28.

Beckman, Gary M. and Harry A. Hoffner. *Hittite Diplomatic Texts.* Atlanta: Society of Biblical Literature, 1999.

Behn, C. Pedro. *The Use of Opium in the Bronze Age in the Eastern Mediterranean.* Prague: [Ceskoslovenska akademie véd], 1986.

Betancourt, Philip P. *The History of Minoan Pottery.* Princeton, NJ: Princeton University Press, 1985.

Binder, Susanne. *The Gold of Honour in New Kingdom Egypt.* Warminster: Aris and Phillips Ltd, 2008.

Bindman, David and Henry Louis Gates. *The Image of the Black in Western Art: I, I.* Cambridge, Mass. and London: Belknap Press of Harvard University Press; in collaboration with the W.E.B. DuBois Institute for African and African American Research and the Menil Collection, 2010.

Bleeker, Claas Jouco. *Hathor and Thoth: Two Key Figures of the Ancient Egyptian Religion.* Leiden: Brill, 1973.

Bleiberg, Edward. 'The Redistributive Economy in the New Kingdom Egypt: An Examination of bȝkw(t)'. *Journal of the American Research Center in Egypt 25* (1988): 157–168.

Bleiberg, Edward. *The Official Gift in Ancient Egypt.* Norman: University of Oklahoma Press, 1996.

Booth, Charlotte. *The Role of Foreigners in Ancient Egypt: A Study of Non-Stereotypical Artistic Representations.* Bar International Series. Oxford: Archaeopress, 2005.

Borchardt, Ludwig. *Das Grabdenkmal des Königs Sáḥu-re'.* Osnabrück: O. Zeller, 1982.

Bosmajian, Haig A. 'Dehumanizing People and Euphemizing War'. In *Exploring Language,* 8th edn, ed. Gary Goshgarian, 215–220. New York: Longman, 1997.

Bourke, Stephen and Jean-Paul Descœudres. *Trade, Contact, and the Movement of Peoples in the Eastern Mediterranean: Studies in Honour of J. Basil Hennessy.* Sydney: Meditarch, 1995.

Boussac, H. *Le Tombeau d'Anna.* Mémoires. Paris: Les Membres de la Mission Archéologique Française au Caire, 1896.

Bouriant, Urbain. 'Tombeau de Harmhabi'. In *Sept tombeaux thébaines (MMAF 5, 2),* ed. Philippe Virey, 413–434. Cairo, 1889.

Brack, Annelies and Artur Brack. 'Vorbericht über Arbeiten im Grab des Tjanuni' *MDAIK 31* (1975): 15–26.

Brack, Annelies and Artur Brack. *Das Grab des Tjanuni: Theben Nr. 74 (ArchVer, 19).* Mainz am Rhein: P. von Zabern, 1977.

Brack, Annelies and Artur Brack. *Das Grab des Haremheb: Theben Nr. 78.* Mainz am Rhein: P. von Zabern, 1980.

Bradbury, Louise. '*Kpn*-Boats, Punt Trade, and a Lost Emporium'. *Journal of the American Research Center in Egypt* 33 (1996): 37–60.

Brewer, Douglas J. and Renée F. Friedman. *Fish and Fishing in Ancient Egypt.* Warminster: Aris & Phillips, 1989.

Brewer, Douglas J. 'Fish'. In *Oxford Encyclopedia of Ancient Egypt* (*OEAE* I) ed. Donald Redford, 532–535. Oxford and New York: Oxford University Press, 2001.

Brier, Bob and Hillwood Art Museum. *Egyptomania.* Brookville, NY: Hillwood Art Museum, 1992.

Brock, Lyla Pinch and Roberta L. Shaw. 'The Royal Ontario Museum Epigraphic Project: Theban Tomb 89: Preliminary Report'. *Journal of the American Research Center in Egypt* 34 (1997): 167–177.

Brock, Lyla Pinch. 'Jewels in the Gebel: A Preliminary Report on the Tomb of Anen'. *Journal of the American Research Center in Egypt* 36 (1999): 71–85.

Brock, Lyla Pinch. 'Art, Industry and the Aegeans in the Tomb of Amenmose'. *Aegypten und Levante* 10 (2000): 129–137.

Brock, Lyla Pinch. 'The Tomb of Khaemhat'. In *Valley of the Kings: The Tombs and the Funerary Temples of Thebes West*, ed. Kent R. Weeks, 364–375. Vercelli: WhiteStar and Cairo: American University in Cairo Press, 2001.

Bryan, Betsy Morrell. *The Reign of Thutmose IV.* Baltimore: Johns Hopkins University Press, 1991.

Carter, Howard. 'Report on General Work done in the Southern Inspectorate'. *ASAE* 4 (1903): 177–178.

Caubet, Annie. 'The International Style: A Point of View from the Levant and Syria'. In *The Aegean and the Orient in the Second Millenium: Proceedings of the 50th Anniversary Symposium, Cincinnati, 18–20 April 1997*, ed. Eric H. Cline and Diane Harris, 105–115. Liège, Belgium; Austin, Tex.: Université de Liège, Histoire de l'art et archéologie de la Grèce antique; University of Texas at Austin, 1998.

Cline, Eric H. *Sailing the Wine-Dark Sea: International Trade and the Late Bronze Age Aegean.* Oxford: Tempus Reparatum, 1994.

Crowley, Janice L. *The Aegean and the East: an Investigation into the Transference of Artistic Motifs Between the Aegean, Egypt, and the Near East in the Bronze Age.* Jonsered [Partille, Sweden]: Paul Åströms Förlag, 1989.

Dain, Bruce R. *A Hideous Monster of the Mind: American Race Theory in the Early Republic.* Cambridge, Mass.: Harvard University Press, 2002.

Dambach, Martin and Ingrid Wallert. 'Das Tilapia-Motiv in der altägyptischen Kunst,' *Chronique d'Égypte: Bulletin périodique de la Fondation Égyptologique Reine Élisabeth*, Bruxelles 41, no. 82 (1966): 273–294.

Darnell, John Coleman and Colleen Manassa. *Tutankhamun's Armies: Battle and Conquest During Ancient Egypt's Late Eighteenth Dynasty*. Hoboken, NJ: John Wiley & Sons, 2007.

Davies, Nina M. 'Syrians in the Tomb of Amunedjeh'. *Journal of Egyptian Archaeology* 27 (1941): 96–98.

Davies, Nina M. *Scenes from Some Theban Tombs (Nos. 38, 66, 162, with excerpts from 81) (Private Tombs at Thebes*, 4). Oxford: Griffith Institute, 1963.

Davies, Nina de Garis and Norman de Garis Davies. *The Tombs of Two Officials of Tuthmosis the Fourth (nos. 75 and 90)*. London: Sold at the Offices of the Egypt Exploration Society [etc.], 1923.

Davies, Nina M. and Norman de Garis Davies. 'The Tomb of Amenmose (No. 89) at Thebes'. *Journal of Egyptian Archaeology* 26 (1940): 131–136.

Davies, Nina M. and Norman de Garis Davies. *The Tombs of Menkheperrasonb, Amenmose, and Another (nos. 86, 112, 42, 226)*. London: Egypt Exploration Society, 1933.

Davies, Nina M. and Alan H. Gardiner. *The Tomb of Huy, Viceroy of Nubia in the Reign of Tut'ankh-amun*. London: Egypt Exploration Society, 1926.

Davies, Nina M. and Alan H. Gardiner. *Ancient Egyptian Paintings* [Special publication of the Oriental Institute of the University of Chicago]. Chicago, Ill.: The University of Chicago Press, 1936.

Davies, Norman de Garis. *Five Theban Tombs (being those of Mentuherkhepeshef, User, Daga, Nehemawy and Tati)*. London and Boston: Sold at the Offices of the Egypt Exploration Fund, 1913.

Davies, Norman de Garis. *The Tomb of Puyemrê at Thebes*. Publications of the Metropolitan Museum of Art Egyptian expedition, ed. Albert M. Lythgoe. Robb de Peyster Tytus Memorial Series. New York, 1922.

Davies, Norman de Garis. 'The Egyptian Expedition, 1924–1925'. *Bulletin of the Metropolitan Museum of Art* (1926): 44–50.

Davies, Norman de Garis. 'An Apparent Instance of Perspectival Drawing', *JEA* 12 No. 1/2 (1926): 110–112.

Davies, Norman de Garis. 'The Graphic Work of the Expedition'. *BMMA* (November, 1929): 35–46.

Davies, Norman de Garis. *The Tomb of Ken-Amun at Thebes*. New York, 1930.

Davies, Norman. 'Foreigners in the Tomb of Amenemhab (No. 85)'. *JEA* 20 No. 3/4 (No. 1934): 189–192.

Davies, Norman de Garis. 'The Work of the Graphic Branch of the Expedition'. *Metropolitan Museum of Art Bulletin* Vol. 30, No. 11, Part 2 (1935): 46–57.

Davies, Norman de Garis. *Paintings from the Tomb of Rekh-mi-Re at Thebes*. New York: [Plantin Press], 1935.

Davies, Norman de Garis. 'Review of Pierre Montet, *Les reliques de l'art syrien dans l'Égypte du nouvel empire*'. *JEA* 24 No. 2 (1938): 253–254.

Davies, Norman de Garis 'The Defacement of the Tomb of Rekhmirê'. *Chronique d'Égypte* 15 (1940): 115.

Davies, Norman de Garis. *The Tomb of Rekh-mi-Re at Thebes*. New York: Arno Press, 1973.

Davies, Norman de G. and R. O. Faulkner. 'A Syrian Trading Venture to Egypt'. *The Journal of Egyptian Archaeology* 33, no. Dec., 1947 Egypt Exploration Society (1947): 40–46.

Davies, W. Vivien and Louise Schofield. *Egypt, the Aegean and the Levant: Interconnections in the Second Millennium BC*. London: British Museum Press, 1995.

Davis, Ellen N. *The Vapheio Cups and Aegean Gold and Silver Ware*. New York: Garland Pub., 1977.

De Luca, Araldo, Alessandro Bongioanni, Maria Sole Croce and Laura Accomazzo. *The Illustrated Guide to the Egyptian Museum in Cairo*. Cairo: American University in Cairo Press, 2001.

Derchain, Philippe. 'La perruque et le cristal'. *Studien zur Altägyptischen Kultur* 2 (1975): 55–74

Derchain, Philippe, 'Symbols and Metaphors in Literature and Representations of Private Life'. *Royal Anthropological Institute News* 15 (1976): 7–10.

Dewachter, Michel. 'Un nouveau "fils royal" de la XVIIIe dynastie: Qenamon'. *RdE* 32 (1980): 69–73.

Di Cossato, Yvonne M.F. 'L'applicazione della difrattometria di polveri con camera Gandolfi nell'analisi dei piGottMiszenti e delle pitture murali: il caso della tomba n. 85 a Tebe ouest'. In *Sesto Congresso Internazionale di Egittologia, Atti* (Turin: ICE, 1992), I: 441–451.

Dickinson, O. T. P. K. *The Aegean Bronze age*. Cambridge and New York: Cambridge University Press, 1994.

Dorman, Peter F. *The Monuments of Senenmut*. London: KPI, 1988.

Dorman, Peter F. *The Tombs of Senenmut: The Architecture and Decoration of Tombs 71 and 353*. New York: Metropolitan Museum of Art, 1991.

Dorman, Peter F. 'Two Tombs and One Owner'. In *Thebanische Beamtennekropolen: Neue Perspektiven archäologischen Forschung*, ed. Jan Assmann, Eberhard Dziobek, Heike Guksch and Friederike Kampp, 141–154. Heidelberg: Heidelberger Oreintverlag, 1995.

Drioton, Etienne and Jacques Vandier. *L'Egypte, Introduction aux études historiques. Les Peuples de l'Orient méditerranean, II/ 4th edition*. Paris, 1962.

Dziobek, Eberhard. 'Eine grabpyramide des frühen NR in Theben'. *Mitteilungen des Deutschen Archäologischen Instituts, Abteilung Kairo* 45 (1989): 109–132.

Dziobeck, Eberhard and Muhammad Mahmud Abd al-Raziq. *Das Grab des Sobekhotep: Theben Nr. 63*. Mainz am Rhein: Philipp von Zabern, 1990.

Dziobek, Eberhard, Thomas Schneyer and Norbert Semmelbauer. *Eine ikonographische Datierungsmethode für thebanische Wandmalereien der 18. Dynastie*. Heidelberg: 1992.

Dziobek, Eberhard. *Das Grab des Ineni: Theben Nr. 81*. Mainz am Rhein: Philipp von Zabern, 1992.

Dziobek, Eberhard. *Die Gräber des Vezirs User-Amun: Theben Nr. 61 und 131* (*ArchVer*, 84). Mainz: Philipp von Zabern, 1994.

Dziobek, Eberhard. 'Theban Tombs as a Source for Historical and Biographical Evaluation: The Case of User-Amun'. *Studien zur Archäologie und Geschichte Altägyptens* 12 (Heidelberg, 1995): 129–140.

Eaton-Krauss, Marianne and Walter Segal. *The Thrones, Chairs, Stools, and Footstools from the Tomb of Tutankhamun*. Oxford: Griffith Institute, 2008.

Eberhard, Otto, *Das ägyptische Mundöffnungsritual 1. 1*. Wiesbaden: Harrassowitz, 1960.

Edel, Elmar, *Die Stelen Amenophis II. aus Karnak und Memphis: mit dem Bericht über d. asiatischen Feldzüge des Königs*. Wiesbaden: Harrassowitz, 1953.

Edwards, I. E. S. and National Gallery of Art. *Treasures of Tutankhamun*. New York: Ballantine Books, 1976.

Ehrich, Robert W. *Chronologies in Old World Archaeology*. Chicago, Ill.: University of Chicago Press, 1965.

Eigner, Diethelm. 'Das thebanische Grab des Amenhotep, Wesir von Unterägypten: Die Arkitektur'. *MDAIK* 39 (1983): 39–50.

Eisermann, Sigrid. 'Die Gräber des Imenemhet und des Pehsucher-Vorbild und Kopie?' In *Thebanische Beamtennekropolen: Neue Perspektiven archäologischen Forschung (SAGA, 12)*, ed. Jan Assmann, Eberhard Dziobek, Heike Guksch and Friederike Kampp, 65–80. Heidelberg, 1995.

El-Bialy, Mohammed. 'Récéntes recherches effectuées dans la tombe No 42 de la Vallée des Rois'. *Memnonia* 10 (1999): 161–178.

Evans, Arthur and Joan Evans. *The Palace of Minos: A Comparative Account of the Successive Stages of the Early Cretan Civilization As Illustrated by the Discoveries at Knossos*. London: Macmillan and Co., Ltd, 1921.

Evans, Linda. *Animal Behaviour in Egyptian Art: Representations of the Natural World in Memphite Tomb Scenes*. Oxford: Aris and Phillips, 2010.

Fakhry, Ahmed. 'A Report on the Inspectorate of Upper Egypt'. *ASAE* 46 (1947): 25–54.

Fattovich, Rodolfo. 'The Problem of Punt in the Light of Recent Fieldwork in the Eastern Sudan'. In *Akten des vierten internationalen Ägyptologen Kongresses München 1985*, 4, ed. Sylvia Schoske, 257–272. Hamburg, 1991.

Faulkner, Raymond O. *A Concise Dictionary of Middle Egyptian*. Oxford: Printed for the Griffith Institute at the University Press by V. Ridler, 1962.

Faulkner, R. O., O. Goelet, Eva Von Dassow and James Wasserman. *The Egyptian Book of the Dead: the Book of Going Forth by Day, Being the Papyrus of Ani*. San Francisco, Cal.: Chronicle Books, 1998.

Feldman, Marian H. *Diplomacy by Design: Luxury Arts and an 'International Style' in the Ancient Near East, 1400–1200 BCE*. Chicago, Ill.: University of Chicago Press, 2006.

Feucht, Erika. 'Kinder fremder Völker in Ägypten'. *Studien zur Altägyptischen Kultur* 17 (1990): 177–204.

Feucht, Erika. 'Fishing and Fowling with the Spear and the Throw-Stick Reconsidered.' In *The Intellectual Heritage of Egypt: Studies Presented to László Kákosy by Friends and Colleagues on the Occasion of his 60th Birthday*, ed. U. Luft, 157–169. Studia Aegyptiaca 14, Budapest, 1992.

Fitzenreiter, Martin. 'Totenverehrung und soziale Repräsentation im thebanischen Beamtengrab der 18. Dynastie'. *SAK* 22 (1995): 95–130.

Frandsen, John Paul. 'Heqasheru and the Family of Tuthmosis IV' *Acta Orientalia: Ediderunt Societates Orientales Batava, Danica Norwegica* 37 (1967): 5–10.

Friedman, Florence Dunn. 'On the Meaning of Akh (3H) in Egyptian Mortuary Texts'. PhD diss., UMI Dissertation Services, 1981.

Gabolde, Luc. 'Autour de la tombe 276: pourquoi va-t-on se faire enterrer à Gournet Mourai au début du Nouvel Empire?' In *Thebanische Beamtennekropolen: Neue Perspektiven archäologischer Forschung (SAGA, 12)*, ed. Jan Assmann, Eberhard Dziobek, Heike Guksch and Friederike Kampp, 155–165. Heidelberg, 1995.

Gabriel, Richard A. *Thutmose III: The Military Biography of Egypt's Greatest Warrior King*. Washington DC: Potomac Books, 2009.

Gale, N. H. *Bronze Age Trade in the Mediterranean: Papers Presented at the Conference Held at Rewley House, Oxford, in December 1989*. Jonsered: P. Åströms Förlag, 1991.

Gamer-Wallert, Ingrid. 'Fische und Fischkulte im alten Ägypten'. *Ägyptologische Abhandelungen (ÄA)* 21 (Wiesbaden, 1970): 128–130.

Gamer-Wallert, 'Fische religiös'. In *LÄ* II (1977): 228–234.

Gardiner, Alan H. *Being an Introduction to the Study of Hieroglyphs*. London: Published on behalf of the Griffith Institute, Ashmolean Museum, by Oxford University Press, 1957.

Gardiner, Alan Henderson. *Egypt of the Pharaohs*. Oxford: Clarendon Press, 1966.

Gautier, Henri. 'Rappport sommaire sur les fouilles de l'Institut français d'archéologie orientale dans les nécropole thébaine en 1917 et 1918'. *ASAE* 19 (1920): 1–12.

Giddy, Lisa L. *Egyptian oases: Baḥariya, Dakhla, Farafra, and Kharga during Pharaonic Times*. Warminster: Aris & Phillips, 1987.

Gnirs, Andrea, Elina Grothe and Heike Guksch. 'Zweiter Vorbericht über die Aufnahme und Publikation von Gräbern der 18. Dynastie der thebanischen Beamtennekropole'. *Mitteilungen des Deutschen Archäologischen Instituts* 53 (1997): 57–83.

Gordon, Andrew. 'Foreigners'. In *The Oxford Encyclopedia of Ancient Egypt* (*OEAE* I) ed. Donald B. Redford, 487–489. Oxford and New York: Oxford University Press, 2001.

Grapow, Hermann. *Studien zu den Annalen Thutmosis des Dritten und zu ihnen verwandten historischen Berichten des neuen Reiches*. Berlin: Akademie-Verlag, 1949.

Griffin, Kenneth, 'Images of the *Rekhyt* from Ancient Egypt'. *Ancient Egypt*, Nov. 2006.

Griffiths, J. Gwyn. 'Solar Cycle'. In *OEAE* II, 476–480.

Guksch, Heike. *Das Grab des Benja, gen. Paheqamen, Theben Nr. 343*. (*AV*, 7). Mainz, 1978. [Summarized in *MDAIK* 38 (1982)]: 195–200.

Gundlach, Rolf, 'Asiaten'. In *Lexikon der Ägyptologie, Band 1*, ed. Maria Plantikow and Wolfgang Helck, 462–471. Wiesbaden: Harrassowitz, 1975.

Habachi, Labib. 'Tomb No, 226 of the Theban Necropolis and its Unknown Owner'. In *Wort und Gemeinde: Festschrift für Erdmann Schott zum 65. Geburtstag*, 61–70. Berlin: Evangelische Verlaganstalt, 1967.

Hall, Emma Swan. *The Pharaoh Smites his Enemies: A Comparative Study*. Munich: Deutscher Kunstverlag, 1986.

Hannig, Rainer. *Großes Handwörterbuch Ägyptisch-Deutsch: Die Sprache der Pharaonen: (2800 – 950 v. Chr.)*. Mainz: von Zabern, 1995.

Hartwig, Melinda K. *Tomb Painting and Identity in Ancient Thebes, 1419–1372 BCE*. Turnhout, Belgium: Fondation Égyptologique Reine Élisabeth; Brepols, 2004.

Hawass, Zahi A. and Māhir Ṭāhā Maḥmūd. *Le tombeau de Menna: TT. no. 69*. Le Caire: Conseil suprême des antiquites, 2002.

Hawass, Zahi and Sandro Vannini. *King Tutankhamun: The Treasures of the Tomb*. New York: Thames & Hudson, 2008.

Hay, R. *British Museum Additional* MSS.29817.

Hayes, William Christopher. *The Scepter of Egypt*. Cambridge, Mass.: Published for the Metropolitan Museum of Art by Harvard University Press, 1953.

Hayes, William C. *The Scepter of Egypt 2, The Hyksos Period and the New Kingdom*. New York: Metropolitan Museum of Art, 1959.

Helck, Wolfgang. *Die Beziehungen Ägyptens zu Vorderasien im 3. und 2. Jahrtausend v. Chr.* Wiesbaden: O. Harrassowitz, 1962.

Helck, Wolfgang. 'Ägäis und Ägypten'. In *Lexikon der Ägyptologie, Band 1*, ed. Maria Plantikow and Wolfgang Helck, 69–75. Wiesbaden: Harrassowitz, 1975.

Helck, Wolfgang. 'Fremdvölkerdarstellung'. In *Lexikon der Ägyptologie, Band 2*, ed. Maria Plantikow and Wolfgang Helck, 315–321. Wiesbaden: Harrassowitz, 1976.

Hellbing, Lennart. *Alasia Problems*. Göteborg: P. Åström, 1979.

Hermann, G. 'Lapis Lazuli: The Early Phases of its Trade', in *Iraq* 30, (1968), 21–61.

Hodel-Hoenes, Sigrid. *Life and Death in Ancient Egypt: Scenes from Private Tombs in New Kingdom Thebes*. Ithaca, NY: Cornell University Press, 2000.

Hoffmeier, James K. and Stephen O. Moshier. 'A Highway Out of Egypt: The Main Road from Egypt to Canaan'. In *Desert Road Archaeology in Ancient Egypt and Beyond*, ed. Frank Förster and Heiko Riemer, 485–510. Cologne: Heinrich-Barth-Institut, 2013.

Hölscher, Wilhelm, *Libyer und Ägypter: Beiträge zur Ethnologie und Geschichte libyscher Völkerschaften nach den ältägyptischen Quellen*. Glückstadt; New York: J.J. Augustin, 1937.

Hornung, Erik. 'Die Grabkammer des Vezirs User'. *Nachrichten der Akademie der Wissenschaften zu Göttingen, Phil.-hist. Klasse* 5 (1961): 99–120.

Hornung, Erik. *Conceptions of God in Ancient Egypt: The One and the Many*. Ithaca, NY: Cornell University Press, 1982.

Houlihan, Patrick F. and Steven M. Goodman. *The Birds of Ancient Egypt*. Warminster: Aris & Phillips, 1986.

Houlihan, Patrick. 'Frogs'. In *OEAE* 1, 563.

Jacobsson, Inga. *Aegyptiaca from Late Bronze Age Cyprus*. Jonsered: P. Åströms Förlag, 1994.

Kampp, Friederike. *Die Thebanische Nekropole: Zum Wandel des Grabgedankens von der XVIII. bis zur XX. Dynastie*. 2 vols. Theben Bd. 13. Mainz am Rhein: Verlag Philipp von Zabern, 1996.

Kampp, Friederike. 'Overcoming Death: The Private Tombs of Thebes'. In *Egypt: The World of the Pharaohs*, ed. Regine Schulz and Matthias Seidel, 259–63. Cologne: Könnemann, 1998.

Kampp-Seyfried, Friederike. 'The Theban Necropolis: An Overview of Topography and Tomb Development from the Middle Kingdom to the Ramesside Period'. In *The Theban Necropolis: Past, Present and Future*, ed. Nigel Strudwick and John H. Taylor, 2–10. London: British Museum Press, 2003.

Kantor, Helene J. *The Aegean and the Orient in the Second Millennium B.C.* Bloomington, Ind.: Principia Press, 1947.

Kantor, Helene J. 'The Aegean and the Orient in the Second Millennium B.C.'. *American Journal of Archaeology* 51, no. 1 (1947): 47.

Kapoor, L. D. *Opium Poppy: Botany, Chemistry, and Pharmacology*. New York: Food Products Press, 1995.

Karageorghis, Vassos. *Cyprus, from the Stone Age to the Romans*. London: Thames and Hudson, 1982.

Kemp, Barry J., R. S. Merrillees and Edel Elmar Deutsches Archäologisches Institut Abteilung Kairo. *Minoan Pottery in Second Millennium Egypt*. Mainz am Rhein: P. von Zabern, 1980.

Kemp, Barry J. 'Imperialism and Empire in New Kingdom Egypt (c. 1575–1087 B.C.)'. In *Imperialism in the Ancient World*, ed. P. Garnsey and C. R. Whittaker, 7–57. Cambridge: Cambridge University Press, 1983.

Kemp, Barry J. *Ancient Egypt: Anatomy of a Civilization*. London: Routledge, 2010.

Kitchen, K. A. *Punt and How to Get There*. Rome: Biblical Institute Press, 1971.

Kitchen, K. A. 'The Land of Punt'. In *The Archaeology of Africa, Food, Metals and Towns*, ed. Thurstan Shaw, Paul Sinclair, Bassey Andah and Alex Okpoko, 587–608. London and New York: Routledge, 1993.

Kitchen, K. A. 'Further Thoughts on Punt and its Neighbours'. In *Egyptology Studies*, ed. J. W. Tait, 173–178. London: Egypt Exploration Society, 1999.

Kozloff, Arielle P. 'Theban Tomb Painting from the Reign of Amenhotep III: Problems in Iconography and Chronology'. In *The Art of Amenhotep III: Art Historical Analysis: Papers Presented at the International Symposium held at the Cleveland Museum of Art, Cleveland, Ohio, 20–21 November 1987*, ed. Lawrence Michael Berman, 55–64. Cleveland, Oh.: Cleveland Museum of Art in cooperation with Indiana University Press, 1990.

Kozloff, Arielle P. *Amenhotep III: Egypt's Radiant Pharaoh*. Cambridge: Cambridge University Press, 2012.

Kuhlmann, Klaus P. *Der Thron im Alten Agypten: Untersuchungen zu Semantik, Ikonographie und Symbolik eines Herrschaftszeichens*. Gluckstadt: Augustin, 1977.

Laboury, Dimitri. 'Une relecture de la tombe de Nakht (TT 52, Cheikh 'Abd el-Gourna)'. In *La peinture égyptienne ancienne: un monde de signes à préserver: actes du Colloque international de Bruxelles, avril 1994*, ed. Roland Tefnin, 70–71. Brussels: Fondation Égyptologique Reine Élisabeth, 1997.

Lacau, Pierre. 'Supressions et modifications de signes dans les texts funéraires'. *Zeitschrift für ägyptische Sprache und Altertumskunde* 51, (1914): 1–64.

Laffineur, Robert. 'From West to East: the Aegean and Egypt in the Early Late Bronze Age'. In *The Aegean and the Orient: Proceedings of the 50th Anniversary Symposium, Cincinnati, 18–20 April 1997*, ed. Eric H. Cline and Diane Harris,

53–67. Liège, Belgium; Austin, Tex.: Université de Liège, Histoire de l'art et archéologie de la Grèce antique; University of Texas at Austin, 1998.

Lambrou-Phillipson, C. *Hellenorientalia: the Near Eastern Presence in the Bronze Age Aegean, ca. 3000–1100 B.C.: Interconnections Based on the Material Record and the Written Evidence; Plus Orientalia: a Catalogue of Egyptian, Mesopotamian, Mitannian, Syro-Palestinian, Cypriot and Asia Minor Objects from the Bronze Age Aegean.* Göteborg: P. Åströms Förlag, 1990.

Leahy, Anthony, W. J. Tait and H. S. Smith. *Studies on Ancient Egypt in Honour of H.S. Smith.* London: Egypt Exploration Society, 1999.

Lesko, Barbara S. *The Great Goddesses of Egypt.* Norman: University of Oklahoma Press, 1999.

Lewis, Bernard. 'The Question of Orientalism'. *The New York Review of Books 29* Issue 11 (1982).

Lewis, Bernard. *Islam and the West.* New York: Oxford University Press, 1993.

Lichtheim, Miriam. *Ancient Egyptian Literature: A Book of Readings, Vol. 2: The New Kingdom.* Berkeley: University of California Press, 1976.

Liverani, Mario. *Prestige and Interest: International Relations in the Near East ca. 1600–1100 B.C.* History of the Ancient Near East. Padova: Sargon, 1990.

Loprieno, Antonio. *Topos und Mimesis: Zum Ausländer in der Ägyptischen Literatur,* Ägyptologische Abhandlungen, Bd. 48. Wiesbaden: O. Harrassowitz, 1988.

Loret, Victor. 'La tombe de Khâ-m-hâ'. (*MMAF,* 1). Cairo, 1889, 113–132.

Lorton, David. *The Juridical Terminology of International Relations in Egyptian Texts Through Dyn. XVIII.* Baltimore: Johns Hopkins University Press, 1974.

Louant, Emmanuel. *Comment Pouiemrê triompha de la mort: analyse du programme iconographique de la tombe thébaine no. 39.* Leuven: Peeters, 2000.

Macqueen, J. G. *The Hittites and Their Contemporaries in Asia Minor.* Boulder, Colo.: Westview Press, 1975.

Manniche, Lise. *Sexual Life in Ancient Egypt.* London; New York: KPI; distributed by Methuen Inc., Routledge & Kegan Paul, 1987.

Manniche, Lise. *The Wall Decoration of Three Theban Tombs (TT 77, 175, and 249).* Copenhagen: Carsten Niebuhr Institute of Ancient Near Eastern Studies, University of Copenhagen: Museum Tusculanum Press, 1988.

Manniche, Lise. *Sacred Luxuries: Fragrance, Aromatherapy, and Cosmetics in Ancient Egypt.* New York: Cornell University Press, 1999.

Manniche, Lise 'The So-called Scenes of Daily Life in the Private Tombs of the Eighteenth Dynasty: An Overview'. In *The Theban Necropolis: Past, Present and Future,* ed. Nigel Strudwick and John H. Taylor, 42–45. London: British Museum Press, 2003.

Manniche, Lise. 'Sexuality'. In *The Oxford Encyclopedia of Ancient Egypt III*, ed. Donald Redford, 274–276. Oxford: Oxford University Press, 2001.

Maspero, Gaston. 'Tombeau de Montouhirkhopshouf'. In *Sept tombeaux thebains de la XVIIIe Dynastie* (*MMAF* 5, 2), ed. Philippe Virey, 435–468. Cairo, 1889.

McDonald, Sally and Michael Rice. *Consuming Ancient Egypt*. Walnut Creek; Chicago: Left Coast Press, 2003.

Meeks, Dimitri. 'Locating Punt'. In *Mysterious Lands*, ed. David O'Connor and Stephen Quirke, 53–80. London; Portland, Or.: UCL Press, Institute of Archaeology; Cavendish, 2003.

Mekhitarian, Arpag. 'Un peintre thébain de la XVIIIe dynastie', *Fs Junker* (1957), 1: 186–192.

Merlin, Mark David. *On the Trail of the Ancient Opium Poppy*. Rutherford, London and Cranbury, NJ: Fairleigh Dickinson University Press; Associated University Presses, 1984.

Meskell, Lynn. *Private Life in New Kingdom Egypt*. Princeton: Princeton University Press, 2002.

Meyer, Eduard. *Bericht Über eine Expedition nach Ägypten zur Erforschung der Darstellungen der Fremdvölker micr, Fremdvölkerdarstellungen Altägyptische Denkmäler: Sammlung Photographischer Aufnahmen aus den Jahren 1912–1913.* Wiesbaden: Harrassowitz Microfiche Service, 1973.

Meyer, Christine. 'Wein'. In *LÄ* VI (1986): 1175–1176.

Middleton, Andrew, Ken Uprichard and the British Museum. *The Nebamun Wall Paintings: Conservation, Scientific Analysis and Display at the British Museum.* London: Archetype Publications: In Association with the British Museum, 2008.

Mond, Robert. 'Report of Work in the Necropolis of Thebes during the Winter of 1903–1904'. *ASAE* 6 (1905): 65–96.

Mond, Robert and Walter B. Emery. 'Excavations at Sheikh Abd el Gurneh, 1925–1926'. *LAAA* 14 (1927): 28–29.

Montet, Pierre. *Les reliques de l'art syrien dans l'Égypte du nouvel empire.* Paris: Société d'édition: Les belles lettres, 1937.

Moran, William L. *The Amarna Letters*. Baltimore: Johns Hopkins University Press, 1992.

Mountjoy, Penelope A. *Mycenaean Pottery: An Introduction*. Oxford: Oxford University Committee for Archaeology, 1993.

Muhly J. D. 'Copper and Tin: The Distribution of Mineral Resources and the Nature of the Metals Trade in the Bronze Age'. In *Transactions of the Connecticut Academy of Arts and Sciences* 43, 155–535. New Haven: Connecticut, 1973.

Müller, W. Max. *Asien und Europa nach altägyptischen denkmälern.* Leipzig: W. Engelmann, 1893.

Müller, Wilhelm Max and Carnegie Institution (Washington DC). *Egyptological Researches 1: Results of a Journey in 1904.* Washington DC: Carnegie Institution of Washington, 1906.

Müller, Wilhelm Max and Carnegie Institution (Washington DC). *Egyptological Researches 2: Results of a Journey in 1906.* Washington DC: Carnegie Institution of Washington, 1910.

Müller-Wollerman, Renate. 'Bemerkungen ze den sogenannten Tributen'. *Göttinger Miszellen* 66 (1984): 83–83.

Nasr, Mohammed W. 'The Theban Tomb 261 of Kha'emwese in Dra' Abu el-Naga''. *SAK* 15 (1988): 233–242.

Naville, Edouard Henry (ed.), *The Temple of Deir el-Bahari,* vol. 3. London, 1898.

Naville, Edouard Henry (ed.), *The Temple of Deir el Bahari,* vol. 4. London, 1908.

Newberry, Percy E. *The Life of Rekhmara, Vezîr of Upper Egypt under Thotmes III and Amenhotep II.* Westminster: Constable, 1900.

Newberry, Percy. 'The Sons of Thutmosis IV'. *Journal of Egyptian Archaeology* 14, No. 1/2 (1928).

Nochlin, Linda. 'The Imaginary Orient'. In *Visual Culture: Spaces of Visual Culture,* ed. Marquard Smith and Joanne Morra, 19–35. New York: Routledge, 2006.

Nicholson, Paul T. and Ian Shaw. *Ancient Egyptian Materials and Technology.* Cambridge and New York: Cambridge University Press, 2000.

O'Connor, David B. 'New Kingdom and Third Intermediate Period: 1552–664 BC'. In *Ancient Egypt: A Social History,* ed. Bruce G. Trigger, 183–278. Cambridge: Cambridge University Press, 1983.

O'Connor, David. 'The Nature of Tjemhu (Libyan) Society in the Later New Kingdom'. In *Libya and Egypt c. 1300–750 BC,* ed. Anthony Leahy, 29–113. London: University of London, 1990.

O'Connor, David B. and Eric H. Cline. *Amenhotep III: Perspectives on His Reign.* Ann Arbor: University of Michigan Press, 1998.

O'Connor, David B. and Stephen Quirke. *Mysterious Lands.* London and Portland, Or.: UCL, Institute of Archaeology; Cavendish, 2003.

O'Connor, David B. 'Manipulating the Image: Minor Arts and the Egyptian World Order'. American Research Center in Egypt Conference, 2010.

Oriental Institute. *The Tomb of Kheruef [2] Key Plans and Plates.* Chicago, Ill: The Oriental Institute of the University of Chicago, 1980.

Osing, J., 'Libyen, Libyer'. In *LÄ* 3: 1015–1033. Wiesbaden, 1979.

Panagiotopoulos, Diamantis. 'Keftiu in Context: Theban Tomb-Paintings as a Historical Source'. *Oxford Journal of Archaeology* 20 (2001): 263–283.

Panagiotopolous, Diamantis. 'Foreigners in Egypt in the Time of Hatshepsut and Thutmose III'. In *Thutmose III: A New Biography*, ed. Erik H. Cline and David B. O'Connor, 370–413. Ann Arbor: University of Michigan Press, 2006.

Parkinson, R. B. *Voices from Ancient Egypt: An Anthology of Middle Kingdom Writings*. Norman: University of Oklahoma Press, 1991.

Petrie, W. M. Flinders, Hilda Flinders Petrie and Margaret Alice Murray. *Ceremonial Slate Palettes*. London: British School of Egyptian Archaeology, 1953.

Pinch, Geraldine. *Votive Offerings to Hathor*. Oxford: Griffith Institute, Ashmolean Museum, 1993.

Pinch, Geraldine. 'Red Things: The Symbolism of Colour in Magic'. In *Colour and Painting in Ancient Egypt*, ed. W. V. Davies, 182–191. London: British Museum Press, 2001.

Plantikow, Maria and Wolfgang Helck. *Lexicon der Ägyptologie, Band I*. Wiesbaden: Harrassowitz, 1976.

Pino, Cristina. 'The Market Scene in the Tomb of Khaemhet (TT 57)'. *JEA* 91 (2005): 95–106.

Polz, Daniel. 'Bemerkungen der Grabbenutzung in der thebanischen Nekropole'. *MDAIK* 46 (1990): 301–336.

Poo, Mu-chou. *Wine and Wine Offering in the Religion of Ancient Egypt*. London and New York: Kegan Paul International; distributed by Columbia University Press, 1995.

Poo, Mu-chou. *Enemies of Civilization Attitudes Toward Foreigners in Ancient Mesopotamia, Egypt, and China*. Albany: State University of New York Press, 2005.

Porter, Bertha and Rosalind L. B. Moss. *Topographical Bibliography of Ancient Egyptian Hieroglyphic Texts, Reliefs, and Paintings. [Volume] I, The Theban Necropolis. Part 1, Private Tombs*. 2nd edn. Oxford: Griffith Institute/Ashmolean Museum, 2004

Pritchard, James B. 'Syrians as Pictured in the Paintings of the Theban Tombs'. *Bulletin of the American Schools of Oriental Research*, 122 (1951): 36–41.

Pulak, Cemal. 'The Uluburun Shipwreck: An Overview'. *The International Journal of Nautical Archaeology*, 27.3 (1998): 188–224.

Pulak, Cemal. 'The Uluburun Shipwreck and Late Bronze Age Trade'. In *Beyond Babylon: Art, Trade, and Diplomacy in the Second Millennium B.C.*, ed. Joan Aruz, Kim Benzel and Jean M. Evans, 289–310. New York: Metropolitan Museum of Art, 2008.

Quibell, James Edward and F. W. Green. *Hierakonpolis 2*. London: Quaritch, 1902.

Ranke, Hermann. *Die ägyptischen Personennamen*. Glückstadt: J.J. Augustin, 1935.

Redford, Donald B. 'A Bronze Age Itinerary in Transjordan'. *JSSEA* 12 (1982): 55–74.

Redford, Donald B. *Akhenaten, the Heretic King.* Princeton, NJ: Princeton University Press, 1984.

Redford, Donald B. *The Oxford Encyclopedia of Ancient Egypt.* 3 vols. Oxford and New York: Oxford University Press, 2001.

Redford, Donald B. *The Wars in Syria and Palestine of Thutmose III.* Leiden and Boston: Brill, 2003.

Redford, Donald B. 'The Northern Wars of Thutmose III'. In *Thutmose III: A New Biography,* ed. Eric H. Cline and David B. O'Connor, 325–343. Ann Arbor: University of Michigan Press, 2006.

Rehak, Paul. 'Aegean Breechcloths, Kilts and the Keftiu'. *American Journal of Archaeology* 100 (1996): 33–51.

Rehak, Paul. 'Aegean Natives in the Theban Tomb Paintings: The *Keftiu* Revisited'. In *The Aegean and the Orient in the Second Millennium: Proceedings of the 50th Anniversary Symposium, Cincinatti 18–20 April 1997,* ed. Eric H. Cline and Diane Harris, 39–50. Liège, Belgium; Austin, Tex.: Université de Liège, Histoire de l'art et archéologie de la Grèce antique; University of Texas at Austin, Program in Aegean scripts and prehistory, 1998.

Reid, Donald Malcolm. *Whose Pharaohs?* Berkeley: University of California Press, 2002.

Ritner, Robert Kriech. *The Mechanics of Ancient Egyptian Magical Practice.* Studies in Ancient Oriental Civilization. Chicago, Ill.: Oriental Institute of University of Chicago, 1993.

Robins, Gay and C. C. D. Schute, 'The Physical Proportions and Stature of New Kingdom Pharaohs'. *Journal of Human Evolution* 12 (1983): 455–465.

Robins, Gay. 'Problems in Ancient Egyptian Art'. *DIE* 17 (1990): 45–58.

Robins, Gay. 'Ancient Egyptian Sexuality'. In *Discussions in Egyptology* 17 (1990): 61–72.

Robins, Gay. *Women in Ancient Egypt.* Cambridge, Mass.: Harvard University Press, 1993.

Robins, Gay. 'Piles of Offerings: Paradigms of Limitation and Creativity in Ancient Egyptian Art'. In *Proceedings of the Seventh Congress of Egyptologists, 1995,* ed. C. Eyre, 957–963. Leuven: Peeters 1998.

Robins, Gay. *The Art of Ancient Egypt.* Cambridge, Mass.: Harvard University Press, 1997.

Robins, Gay. 'Hair and the Construction of Identity in Ancient Egypt, c. 1480–1350 B.C'. *Journal of the American Research Center in Egypt* 36, (1999): 55–69.

Robins, Gay, 'Birds, Blooms and Butterflies, Representing the "Natural World" in New Kingdom Egyptian Art', talk at The Egyptian Image in Context, conference, Princeton University, 17–18 April 2010.

Romano, James F. *Catalogue [of] the Luxor Museum of Ancient Egyptian Art.* Cairo: American Research Center in Egypt, 1979.

Roth, Ann Macy. 'Representing the Other: Non-Egyptians in Pharaonic Iconography'. In *A Companion to Ancient Egyptian Art,* ed. Melinda Hartwig, 155–174. Boston and Oxford: Wiley-Blackwell, 2015.

Russell, Victoria A. 'Foreigners in the Tomb of Rekhmire (Theban Tomb 100)'. Master's thesis, University of Memphis, 2007.

Sahrhage, Dietrich. 'Fischfang und Fischkult im alten Ägypten'. *Kulturgeschichte der Antiken Welt* 70 (Mainz, 1998): 137–138.

Said, Edward W. *Orientalism.* New York: Vintage Books, 1979.

Sakurai, K., Sakuji Yoshimura and Jiro Kondo. *Comparative Studies of Nobles Tombs in Theban Necropolis.* Tokyo: Waseda University, 1988.

Saleh, Mohammed. 'Das Totenbuch in den thebanischen Beamtengräbern des Neuen Reiches'. *ArchVer* 46 (1984).

Salland, Patrick C. 'Palatial Paintings and Programs: The Symbolic World of the Egyptian Palace in the New Kingdom'. PhD. diss., Institute of Fine Arts, New York University, in progress.

Salland, Patrick. 'The Grape Arbor as Solar Imagery within New Kingdom Royal Palaces', in progress.

Sanders, Edith. 'The Hamitic Hypothesis: Its Origin and Functions in Time Perspective'. *The Journal of African History* 10 No. 4 (1969): 521–532.

Säve-Söderbergh, Torgny. *Ägypten und Nubien: ein Beitrag zur Geschichte altägyptischer Aussenpolitik.* Lund: Håkan Ohlssons Boktryckeri, 1941.

Säve-Söderbergh, Torgny, *The Navy of the Eighteenth Egyptian Dynasty.* Uppsala: University of Uppsala, 1946.

Säve-Söderbergh, Torgny, Norman de Garis Davies and Nina M. Davies. *Four Eighteenth Dynasty Tombs.* Oxford: Printed for the Griffith Institute at the University Press by C. Batey, 1957.

Scheil, Jean Vincent. 'Le tombeau de Djanni'. In *Sept tombeaux thébains (MMAF 5, 2),* ed. Philippe Virey, 591–612, Cairo, 1889.

Schoske, Sylvia. 'Rekhmire'. In *LÄ* V: 180–182.

Schott, Erdmann. *Wort und Gemeinde: Festschrift für Erdmann Schott zum 65. Geburtstag.* Berlin: Evangelische Verlaganstalt, 1967.

Sethe, Kurt Helck Wolfgang. *Urkunden der 18. Dynastie.* Berlin: Akademie-Verlag, 1984.

Seyfried, K. J. 'Entwicklung in der Grabarchitektur des Neuen Reiches als eine weitere Quelle für teologische Konzeptionen des Ramessidenzeit'. In *Problems and Priorities in Egyptian Archaeology,* ed. . J. Assmann, G. Burkard and V. Davies, 219–222. London and New York: KPI, 1987.

Shaheen, Alaa El-Din M. 'Historical Significance of Selected Scenes Involving Western Asiatics and Nubians in the Private Theban Tombs of the XVIIIth Dynasty'. PhD diss., University of Pennsylvania, 1988.

Shaw, Roberta. 'The Decorative Scheme in TT 89 (Amenmose)'. *Journal of the Society of the Study of Egyptian Antiquities* 33 (2006): 205–234.

Shedid, Abdel Ghaffar and Matthias Seidel. *The Tomb of Nakht*, trans. M. Eaton Krauss. Mainz: Philipp von Zabern, 1996.

Smith, Stuart Tyson. *Wretched Kush: Ethnic Identities and Boundaries in Egypt's Nubian Empire*. London; New York: Routledge, 2003.

Smith, William Stevenson. 'The Land of Punt'. *Journal of the American Research Center in Egypt* 1 (1962): 59–61.

Smith, William Stevenson and William Kelly Simpson. *The Art and Architecture of Ancient Egypt*. The Pelican History of Art. New York: Penguin Books, 1981.

Spalinger, Anthony. 'Covetous Eyes South: The Background to Egypt's Domination of Nubia by the Reign of Thutmose III'. In *Thutmose III: A New Biography*, ed. Eric H. Cline and David B. O'Connor, 325–343. Ann Arbor: University of Michigan Press, 2006.

Spiegel, Joachim. 'Ptah-Verehrung in Theben'. *ASAE* 40 (1940): 257–271.

Strange, John. *Caphtor/Keftiu: A New Investigation*. Leiden: Brill, 1980.

Teeter, Emily. 'Feathers,' In *UCLA Encyclopedia of Egyptology*, ed. Willeke Wendrich. Los Angeles: UCLA. Accessed 26 April 2016. http://escholarship.org/uc/item/4737m1mb.

Tharu, Al Ayedi. 'The Starting Point on the "Ways of Horus"'. MA thesis, University of Toronto, 2000.

Tobin, Vincent. 'Creation Myths'. In *OEAE* II, 469–472.

University of Chicago, Oriental Institute Epigraphic Survey and Egypt, Maṣlaḥat al-Āthār. *The Tomb of Kheruef: Theban Tomb 192*. Chicago, Ill.: Oriental Institute of the University of Chicago, 1980.

Uphill, Eric. 'The Nine Bows'. *Jaarbericht van het Voorraziatisch-Egyptisch Gezelschap Ex Oriente Lux VI* 19, (1967): 393–420.

Vandier d'Abbadie, J. *Catalogue des objets de toilette égyptiens*. Paris: Éditions des musées nationaux, 1972.

Van de Mieroop, Marc. *A History of Ancient Egypt*. Chichester: Wiley-Blackwell, 2011.

Vercoutter, Jean. *Essai sur les relations entre Égyptiens et Préhellènes*. Paris: A. Maisonneuve, 1954.

Vercoutter, Jean. 'The Iconography of the Black in Ancient Egypt: From the Beginnings to the Twenty-Fifth Dynasty'. In *The Image of the Black in Western Art*, ed. David Bindman and Henry Louis Gates, 33–89. Cambridge, Mass. and London:

Belknap Press of Harvard University Press; in collaboration with the W.E.B. DuBois Institute for African and African American Research and the Menil Collection, 2010.

Virey, Philippe. 'Le tombeau d'Am-n-teh et la fonction de [hieroglyphs]'. *Recueil de traveaux relatifs à la philologie et à l'archéologie égyptiennes et assyriennes* 7 (1886): 32–46.

Virey, Philippe. *Sept tombeaux thébains de la XVIIIe dynastie*. Paris: Leroux. 1889.

Virey, Philippe. 'Le Tombeau de Rekhmare, Préfet de Thèbes sous la XVIIIe Dynastie'. Mémoires publiés par les membres de la mission archéologique française au Caire 5,1 (Paris) 1889.

Virey, Philippe. 'Tombe de Ramenkhepersenb'. In *Sept tombeaux thébains de la XVIIIe dynastie*, 197–215. Paris: Leroux 1889.

Wachsmann, Shelley. *Aegeans in the Theban Tombs*. Leuven: Peeters, 1987.

Wasmuth, Melanie. *Innovation und Extravaganzen: Ein Beitrag zur Architektur des thebanischen Beamtengräber der 18. Dynastie*. Oxford: British Archaeological Reports, 2003, 93.

Watanabe, Yasutada and Kazuaki Seki. *The Architecture of 'Kom el Samak' at Malkata-South: A Study of Architectural Restoration*. Studies in Egyptian Culture, no. 5. Tokyo, Japan: Waseda University, 1986.

Wegner, Max. 'Die Stilentwickelung der thebanischen Beamtengräber'. *Mitteilungen des Deutschen Archäologischen Instituts* 4 (1993): 38–164.

Weinstein, James M., Eric H. Cline, Kenneth A. Kitchen and David O'Connor. 'The World Abroad'. In *Amenhotep III: Perspectives on His Reign*, ed. David B. O'Connor and Eric H. Cline, 223–235. Ann Arbor: University of Michigan Press, 1998.

Weisenfeld, Gennifer. 'Selling Shiseido: Japanese Cosmetics Advertising and Design in the Early 20th-Century'. 2008. *Visualizing Cultures* website, *Massachusetts Institute of Technology*. Accessed Jan. 8, 2014. http://ocw.mit.edu/ans7870/21f/21f.027/shiseido_01/index.html

Westendorf, Wolfhart. 'Bemerkungen zur "Kammerder Wiedergeburt" im Tutanchamungrab'. *Zeitschrift für ägyptische Sprache und Altertumskunde* 94 (1967): 139–150.

Windschuttle, Keith. 'Edward Said's "Orientalism" Revisited'. *The New Criterion* 17, Issue 5 (January 1999): 30–38.

Wilkinson, Richard H. *Symbol and Magic in Egyptian Art*. New York: Thames and Hudson, 1994.

Wreszinski, Walter. *Atlas zur Altaegyptischen Kulturgeschichte*. Leipzig: J.C. Hinrichs, 1914.

Index

Figures are denoted by the use of *italics*. Notes are labelled with 'n'.